A Moscow Literary Memoir

ALSO BY R.A.D. FORD

A Window on the North 1956

The Solitary City 1969

Holes in Space 1979

Needle in the Eye 1983

Russian Poetry: A Personal Anthology 1984

Doors, Words and Silence 1985

Dostoyevsky and Other Poems 1988

Our Man in Moscow:
A Diplomat's Reflections on the Soviet Union 1989

Coming from Afar: Selected Poems:
1940–1989 1990

ROBERT A.D. FORD

A Moscow Literary Memoir

AMONG THE GREAT ARTISTS
OF RUSSIA
FROM 1946 TO 1980

Edited by Carole Jerome

UNIVERSITY OF TORONTO PRESS
Toronto Buffalo London

© Robert A.D. Ford 1995
Printed in Canada

ISBN 0-8020-0615-9

Printed on acid-free paper

Canadian Cataloguing in Publication Data

Ford, R.A.D., 1915–
Moscow literary memoir :
among the great artists of Russia, 1946–1980

Includes index.
ISBN 0-8020-0615-9

1. Soviet Union – Intellectual life.
2. Arts – Soviet Union.
3. Soviet Union – Social life and customs.
4. Ford, R.A.D., 1915– . I. Title.

DK276.F67 1995 947.085 C95-931022-3

University of Toronto Press acknowledges the financial
assistance to its publishing program of the Canada Council
and the Ontario Arts Council.

CONTENTS

EDITOR'S NOTE ix

Introduction 5
1 Bella and the Beast 17
2 Engineers of the Human Soul 29
3 The Thaw? 43
4 Zhivago to Denisovich 59
5 Backstage 71
6 Don't Frighten Me 83
7 The Dying Swan 93
8 Sonatas and Political Notes 107
9 Smell the Dust 121
10 The Party Inside and Out 135
11 Uncle Vranya 147
12 Dead Souls 159
13 A Miasma of Oblomovism 171
14 The One-Eyed Monster 185
15 Lenin Is with Us 195
16 Jungle Cats at a Tea Party 205

17 Turning Points 215
18 Lili 229
19 The Murder of Nina: The Life of Painting 251
20 Internal Exiles 273
Epilogue 287

ACKNOWLEDGMENTS 297
PICTURE CREDITS 299
INDEX 301

To the memory of
Lili and Thereza

EDITOR'S NOTE

I first met Robert and Thereza Ford in 1977, when I was sent to Moscow by the CBC to do a feature interview with the distinguished poet-diplomat. The Fords had arranged for me to share a dinner with their friends Andrei Voznesensky and Yevgeny Yevtushenko, and I had been boning up on Soviet poets and artists, as this was the side of Ford that interested me most: a Governor General's Award-winning poet who was also dean of the Moscow diplomatic corps.

Robert Ford at that time was somewhat crippled but needed only a cane to get around. With his elegant air, iron-grey hair, and six-foot frame, he was the archetypal diplomat. Thereza, on the other hand, was a compact, vivacious, unpredictable dynamo, and I was enchanted by her. Our dinner with the poets was a non-starter, as they had all been warned that it would not be healthy to consort with Canadians. It was a time of political tension between our two governments. So we had a splendid dinner in the residence all to ourselves, talking of everything from poets in the gulag to Margaret Trudeau.

One night Thereza took me to visit Lili Brik in the outrageously cluttered apartment Ford describes in this book, a living museum full of the ghosts of Russia's artists. Lili, tiny, frail, and energetic, locked onto the fact that I lived in Paris, and conspiratorially asked if I would smuggle a package back for her friend

Yves St Laurent. Thereza dissuaded her, as the items in question were documents or jewels or something I vaguely recall would have offended the authorities. My only clear memory is of Lili herself, her eyes full of both vivid life and deep sorrow.

When I read Robert's political memoirs, *Our Man in Moscow*, I was surprised to find almost no description of his life amongst the great artists who were his friends, and when I visited him in Vichy in France a couple of years ago, I asked him why. 'Oh, that's all in my literary memoirs,' he said.

These were in the form of a daily diary he had kept on and off over the years – very spare and just the bare bones of it all. I went over the manuscript, and suggested that to get it published it needed to be fleshed out a lot more – with descriptions of people and scenes, and more of his own personal feelings and reflections. In his diplomatic persona and in his official memoirs, Ford is the epitome of the reserved, careful diplomat. In his poetry, and with friends, he is quite different, a man of strong emotions and equally strong opinions who does not mince words, who is at the same time amiable, easy-going, and often very funny. Since I had been fortunate enough to know this side of him, I thought this memoir should be edited for publication, to let others get to know him too.

He immediately tackled this job in spite of being now confined to a wheelchair, and severely crippled in his hands as well. But he hand-wrote the new pages and changes. Suddenly Bella and Andrei, and Maya and Yevgeny came alive. They walk through the door with Ford and take you to those long afternoons and evenings in Moscow and Peredelkino, redolent of vodka and philosophy.

This memoir is not meant to be definitive or exhaustive, but offers intimate moments, great insight, and anecdotal wealth to our knowledge of Russian arts, politics, and history. With the Gorbachev revolution and its aftermath, the Soviet Union may have faded into the past, but the Russian nation and its newly independent neighbours remain a potent global force. We need as much as ever to understand what drives the enigma that is Russia.

Ford's political beliefs, his uncompromising loathing of com-

munism, are leavened by his intense love for the country and its long-suffering people, and by his knowledge and understanding of its rich culture. His translations of many of the great Russian poets read like poetry in our own tongue, and bridge for us an enormous gap. This memoir includes many of the poems he mentions, and many of his own, as they are the signposts of his own journey and of the Russian souls he brings alive in these pages.

I am honoured to have been able to work with such a man, to have had a part in bringing this memoir together, and editing the final manuscript that Robert so painstakingly reworked from his diary.

A Moscow Literary Memoir

A DOSTOYEVSKY CYCLE

Homage to Fyodor Mihailovich

R.A.D. Ford

'*On the Nevsky bastion silence falls.*'
Old Russian Ballad

They are all with us still,
Eccentric, improbable and yet
More real than our familiars,
As solid as the Nevsky Gate.

All the madmen of time,
All the holy fools of God,
Assemble then to celebrate
Unwillingly their sad end.

They walk like robots through
His city in the untender dawn,
Bearing no message visible,
But understood by all.

And we reach you through the years
To touch your wondering soul,
And are stronger for the word
And brave for what we heard.

Robert Ford in his office at the embassy in Moscow, 1977

Introduction

When I first saw Boris Yeltsin in full swing, after he assumed supreme power in Russia in 1991, I said to myself, 'Dostoyevsky! He's a character straight out of Dostoyevsky!'

Here was this strong, burly Siberian, pressed tightly into a well-cut suit, like a square peg in a round hole. He was giving an unusual televised press conference to four western correspondents, from France, Britain, Germany, and Italy. He alternately blustered and reasoned, justifying his renunciation of socialism and his challenge to Mikhail Gorbachev, and defending his wildly optimistic plans to modernize Russia. He was the archetype of Dostoyevskyan duality: part roughneck from the steppes, part modern politician longing to be European.

That inner tug of war between the eastern Slavophile and the western liberal is the eternal conflict in Russia, just as it is in the characters of Dostoyevsky's great novels, from *Crime and Punishment* to *The Brothers Karamazov*. The whole of Russia today is an epic drama by Dostoyevsky, being played out before our very eyes. Anyone who does not grasp this duality about the Russians will fail to see the true nature of Yeltsin, Gorbachev, or any other Russian leader and the nation at their feet.

Perhaps more than almost any other nation on earth, Russia must be understood not only through her history, but through her poetry, her literature, her dance and music, and all her great

artists. There is revealed the true and passionate nature of the people I knew from the dark days of Stalin after the Second World War, through the 'thaw' of Khrushchev, the 'stagnation' of Brezhnev, and the dawn of the Gorbachev revolution, that is yet to take its final form.

My political memoirs of those historic eras, *Our Man in Moscow*, published in 1989, are, if you like, a skeleton; this book is the flesh. It is not a definitive study; rather, it is a personal contribution to our understanding of this fascinating people, with anecdotes sometimes momentous, sometimes mundane, always revealing. The heart of it is the time my wife Thereza and I spent with some of the greatest artists of modern Russia, those stifled, striving poets, painters, dancers, writers, and intellectuals. It is about their grim history, their astounding courage, how they lived, suffered, and, ultimately, survived. And it is about their perilous hopes today.

But since I knew them personally, this is about them as people, not just icons of Russian history. I knew them as husbands and wives and mothers and fathers, as friends and colleagues, with their own problems, hopes, loves, and hates. I want to take the reader with me to concerts, dinners, and private moments, to feel the atmosphere, get to know the minds of these friends, and come to parties where vodka and camaraderie helped stave off the communist reality outside the door.

Similarly, I have included very personal anecdotes of my encounters with high officials, party hacks, and other members of the Soviet hierarchy, to afford some insight into their Russian souls.

Take Mikhail Gorbachev and Boris Yeltsin. Each illustrates in different ways the peculiarity of Russian character, which makes it so difficult for even the most expert westerner to understand the singular phenomenon which is Russia. These two men effectively made the Second Russian Revolution. Like so many devoted communists of their generation, each had become aware, in his own way, of the potentially catastrophic economic and social condition of the country, which no amount of military strength and international clout could long conceal. Both believed in Marxism-Leninism. Both believed that political and economic

reform, initiated from the top (in the centuries-old Russian tradition), could save the situation, and revive the Communist Party's control and power in a 'renovated' socialist system.

Superficially, the two men came from the same peasant provincial background but, unlike one of their predecessors, Nikita Khrushchev, both were well educated. Both were party bosses in provincial centres, Gorbachev in Stavropol and Yeltsin in Sverdlovsk (now Ekaterinburg). Both suffered from the Russian fault of impetuosity – everything had to be done from the top and quickly. Neither really knew what was going to be the result of the revolution they started. The Gorbachev revolution was not the result of pressure from the people or the intellectuals. It was an imposed revolution, welcomed by most, and particularly the intelligentsia, but not inspired by them.

I lost faith in Gorbachev when overnight he declared war on that ancient scourge of Russia – alcoholism. Vodka was practically the only source of consolation for the miseries of the average citizen. To ban it so suddenly – except for a few stores which charged exorbitant prices – even to order the destruction of centuries-old vineyards in Armenia and Georgia, was a well-intentioned but foolish act which turned almost every Russian against him. In addition, it caused a huge loss to the treasury, since much of governmental revenue came from taxes on vodka.

Gorbachev was sophisticated, intelligent, and realistic in foreign policy, but at home he was far less acute. I do not believe he foresaw that he was going to lose Eastern Europe and start the breakup of the Soviet Empire and the destruction of the communist system – in which he continued to believe right up to the abortive putsch and his final removal from power. This is something many people have still failed to grasp about Gorbachev: he was a die-hard, capital C Communist.

Yeltsin was the tough party boss of a Urals town which was out of bounds to foreigners. But I began to see him as an equally impetuous character when I heard that one of his last acts before leaving Sverdlovsk was to order the bulldozing of the house where Czar Nicholas II and his entire family were brutally murdered on 16 July 1918. It then surfaced that he had been ordered to do so by the Politburo, but I am not convinced it did not suit him.

Once in power he behaved with equal rashness in his famous leap aboard the tank during the attempted coup: part hero of 'democracy,' part demagogue.

These clues to the true natures of these two men are typical of that old Russian duality, the conflicting instincts of which have so often led to either paralysis or explosion. This schizophrenia, and other ingredients of the Russian soul, is the core of Russian literature, from the novels of Dostoyevsky to the political revelations of Alexander Solzhenitsyn. Indeed, Solzhenitsyn himself embodies the same dichotomy. In exile, Solzhenitsyn chose to live in Vermont, which most resembled his native land. In 1994 he returned to Russia, but it remains to be seen whether he can adapt to the new Russia, and whether intellectuals and writers count for anything there.

I am a longtime student of the Russian language and its culture, and as a poet myself, have translated many of the Russian poets. My wife Thereza and I shared a deep love of the arts and the literature of Russia, and hoped to be able to delve more deeply into the mystery of that vast land. A career diplomat, in 1946 I was assigned for a year to the Canadian embassy in Moscow during the period of Stalin's postwar communist hell. In 1951 I returned in time to witness the final spasms of Stalinist madness and his death in March 1953. I watched the slow emergence of Nikita Khrushchev and his efforts to end the mindless terror, to empty the prison camps, and extend a tentative hand (albeit sometimes with his shoe in it) towards the West. When I was offered the ambassadorship in 1964, it was an irresistible political challenge, one of the most important, and one of the most daunting, of all my diplomatic assignments. It was also a very special personal fulfillment.

Thereza and I liked the Russian people and felt a deep sympathy for their appalling suffering throughout their history: from foreign foes, to the deadly weight of a regime which combined all the evils of an imbecile ideology – totalitarianism, conformism, and an omnipresent secret police – with unbelievable economic inefficiency. I make no bones about my loathing for the communist system. But I also have a scholar's curiosity, and I hope a poet's sensibility.

I should note here that although for decades westerners have referred to the Soviet Union and the Soviets, you will find that I obstinately persist in calling the nation Russia, and the dominant people the Russians when I am talking about their true nature. I use Soviet only when speaking of the Marxist-Leninist deformity of that nature. There are, of course, myriad other ethnic groups in the population, but the Soviet Union was in fact the Russian Empire, a resentful collection of peoples under Russian rule. And it is those rulers and their Russian subjects and victims that are my focus here.

If I was the scholar who tended to look at things this way and that, and mull it all over, Thereza had a way of going straight to the heart of the matter. 'These people,' she said one day, 'don't know the principle of the straight line. The streets, the houses, the floors! They're all crooked. But it's not just a physical thing,' she added, 'it's a mental characteristic as well. And it goes deep.'

Churchill's famous description of Russia as an enigma wrapped in mystery has a nice ring to it, but he was clearly flummoxed, and took refuge in poetic obscurity. I always found Thereza's insights more useful.

And, as I had learned from my renowned American colleague George Kennan, at that time ambassador in Moscow and later to be the U.S. ambassador to Tito's Yugoslavia, this mystery could never be solved by dealing with the privileged bureaucrats who ran the country. Politics and the arts have always been intertwined in Russia. Both czarist and communist regimes had respect, awe, and an uneasy fear of the spoken word, or of art they sensed to be subversive. So it was inevitable that I should try to penetrate the cultural community, not just as an adjunct to my primary tasks as ambassador, but as an essential element in making political and social analyses of developments in the Soviet Union.

When I returned to Moscow in 1964 I plunged almost immediately into the world of the arts, seeking out fellow poets and writers, as well as musicians, painters, dancers, and other artistic souls. After my first contacts with writers, I made detailed records of my many conversations with them and continued to do so up to my final departure in 1980. It was not exactly a diary, and

there were long gaps in the record, caused by freezes in the cold war, internal events which made the intellectuals and artists wary of contacts with foreigners, or an occasional prolonged absence on special assignment to Ottawa and elsewhere. In 1974 my double accreditation to Mongolia required the occasional visit to Ulan Bator.

Taken together, though, my early experiences and these notes span intellectual and artistic life in Russia from the 1940s to the late 1980s: from totalitarian repression, to life and art in the splintered, chaotic ruins of a superpower.

The main stimulus for this record came, strangely enough, from Lillian Hellman, whom I first met in 1961 at a dinner party in London given by the Yugoslav ambassador, Vladimir Prica. Prica was a magnetic personality, a handsome and dashing specimen of Tito's wartime Partisan guerillas. Lillian had a weakness for such men, and it was easy to deduce that she and Prica had been having an affair. All her life she was intellectually attracted to communism, and suffered for that during the witch hunts of the McCarthy era in the United States. Her book *Scoundrel Time*, about the years when she was under investigation for 'un-American activities,' was a major chapter in American writing. Although the anti-communist hysteria was long over, it still evoked her smouldering anger.

But when she came to Moscow in 1965 for one of the Soviets' endless writers' conferences, she came up against the grim reality of her political theory. She complained bitterly about the hotel, the service, the food, the constant surveillance of very unsubtle KGB 'guides' and shadows, the glum city, everything. And she could not help but know now the fear that gripped the people, and the Stalinist terror behind it. She found Russia boring, dismal, unattractive, hopelessly inefficient, a society with which she had no real political or cultural rapport. Communist countries, like her revolutionary men, both fascinated and repelled her. But she clung to her untra-leftist views.

In 1979 she came to stay with us in Moscow, and I arranged dinners and luncheons with several Russian writers, such as Yevgeny Yevtushenko, Andrei Voznesensky, and Konstantin Simo-

nov. It did not go well. They accorded her the respect due to the author of such American classics as *The Little Foxes, The Children's Hour,* and *The Watch on the Rhine,* but that was all. Ironically, perhaps it was her pro-communist views that distanced her from those she most expected to be her natural 'comrades.' They held back, not liking or trusting her.

But she clung to her belief in communism until her death in 1984, like so many luminaries of the American left, many of whom actually spied for the Soviet Union. Perhaps more significantly, these intellectuals opted to influence public opinion in more subtle ways, in plays, films, and novels, in the universities where Marxism-Leninism was taught academically but not examined realistically. Criticism of the Soviets was regarded as playing into the hands of truly dangerous anti-communist fanatics such as Nixon and McCarthy. Unfortunately, the two extremes fed on each other. Objective accounts of the dreadful Soviet tragedy were dismissed by otherwise intelligent people as right-wing propaganda.

This side of our own intellectual history is another subtext of this memoir. In Lillian's case, one can at least partly understand it because, as a Jew in the thirties, she sought to arouse public opinion in the West to the danger of Hitler – and the logical extension of that was support of the Soviet Union, which at first stood up to the German threat. But Lillian and so many others extended this unnecessarily to a support of the Soviet system. Thereza, as usual, had a succinct explanation for Lillian's dichotomy. 'The trouble with Lillian,' she said, 'is that she was born *du contre.* Some event in her childhood, perhaps, made her decide to get her own back, and this meant being automatically against just about everything. Lillian knows deep down that this system doesn't work and would be catastrophic if applied to the West. But she wants to show she is one determined lady and can't bring herself to admit that she was wrong.'

In spite of her knowledge of my loathing for the regime, Lillian urged me constantly to write this account of cultural life in Russia. Many years later, after Gorbachev's reforms brought about the collapse of communism, and the revelations of the full extent of the national disaster it had caused, a Soviet diplomat said to

me sadly, 'If you do write about Russia, try not to make us appear too ridiculous.'

But time passed; I became involved in other diplomatic activities, including the Palme Commission on Disarmament and Security Issues. I laboured on my political memoirs, and took refuge in my first love, poetry.

Now, belatedly, I have taken up her suggestion, an urging from beyond her tomb perhaps, in these literary memoirs of my Moscow days.

Bella Akhmadulina

GOD

Bella Akhmadulina

Because the girl Nastasia
worked as a char for the old man,
and ran barefoot in foul weather
to fetch vodka for his gullet –

She had a right to a beautiful god,
in a chamber flooded with sun,
dandified, elegant, and just,
in a suit of cloth of gold.

But with the sound of drunken
hiccups, in the midst of misery,
the two blackened icons
did not look like him at all.

Yet, suddenly, plants blossomed,
the pearls turned pink, and,
like a church chorus, the simple
name of her betrothed rang out.

And he rose up by the fence,
presented her with a yellow locket,
and so was taken for a god
in all his youthful grandeur.

And in her heart was holiness,
because of a lilting song,
and wine, because of much sweet-talk,
and because of a blue shirt.

But, even then he looked deceitful,
as he took off her gauze scarf,
and at a near-by barn
caressed her weak shoulders...

And Nastasia combed her hair,
took the scarf by both ends,
and Nastasia sang and wailed,
burying her face in her hands.

'Ah, what have you done to me,
what trouble have you brought!
Why last Monday did you make me
a present of a white rose?

Ah, willow, willow, my willow,
do not wither, willow, wait a little.
What has become of my belief?
only a cross on my breast is left.'

And the rain gave place to sun,
and nothing much was happening,
and God was laughing at the girl,
and he did not exist at all.

ONE

Bella and the Beast

The vodka flowed freely and the table was heaped with western delicacies, the stuff of dreams for ordinary citizens of Moscow – plus caviar, smoked eel, and the intriguing Russian hors d'oeuvres called *zakuski*.

She stood out from the crowd, remarkable and beautiful, riveting my attention. Young, vivacious, unpredictable, with the beauty that comes from mixing Russian, Georgian, and Tartar: fashion-model features with Cossack wildness. For me she was a dream come true, though not in the ordinary sense. My dream had been to get away from diplomatic protocol and politics, to rub shoulders with the Russian people, especially writers, poets, dancers, and other artists. She was one of the finest, and most intriguing, of the poets of the new generation.

Around me swirled a vivid chatter of Russian, French, English, and the faces of some of Russia's greatest artists glowed with happy animation, at home and at ease here in my friends' old log house in the suburbs of Moscow. A warm glow spread through the room, in contrast to the cold reality outside the door: the ice and snow of Russian winter and Soviet oppression. It licked around the doors and windows, but inside, the artists found refuge.

Perhaps the house itself, a rustic relic of the past, made them relax. And it was not quite so forbidding outside as it had been

for many years. Not long ago, even such an innocent gathering would have been unthinkable. But these were the days of the 'thaw,' when Khrushchev first dared to open the curtains and let at least a little sun shine in. It was February 1964, and there were already small signs that the thaw was freezing over again, but it was hard to believe it would soon be coming to an end.

Here at last I was in the company of the men and women I had been longing to meet: the composer Nikita Bogoslavsky, the poet Robert Rozhdestvensky and his wife, a well-known literary critic. There was the poet Semion Kirsanov and his wife, and the balladeer and poet Bulat Okudzhava. And most enchanting of them all, the beautiful poetess Bella Akhmadulina. It was she who held my attention.

I was fascinated by Bella. She was dressed in a way that was tasteful and sexy at one and the same time. Her dark hair had not been subjected to the tender mercies of a Moscow hairdresser, but flowed free and natural, even if a bit on the burgundy side with the latest vogue in hair colour. As I watched, she put away a truly monumental amount of vodka without much visible effect. She spoke to me in Russian in her velvet growl. 'They,' she intoned, 'are giving me a lot of trouble these days.'

I had thought it would be advisable in this first meeting to be cautious in probing the problems of the writers, and Bella in particular. But she launched into it all immediately. 'They examine every word I write, to see if there is some hidden meaning,' she said bitterly. 'I'm having trouble getting published, and now I'm reduced to working on film scripts.'

I made commiserating noises, unsure of the ground. But like some of the others that evening, she clearly was pleased to meet a western diplomat who spoke her language, knew the artists' problems, and appreciated Russian culture. Guessing that she might have been indiscreet, though, she started talking about what a change the reinstatement of Anna Akhmatova and Marina Tsvetayeva, two courageous and tragic giants of Russian poetry, had brought to her poetic instinct. Both had written powerful verses indicting Stalin's cruel regime. Many felt that Bella herself, with the clear bell-like sound of her wordcraft and her voice, was the spiritual heir of these two heroines.

'Of course,' she said, 'we all knew their best poems by heart, but their official recognition a few years after Khrushchev dumped Stalin let us breathe again. It gave us so much hope for renewal.'

I had read some of Bella's poetry, and was enchanted by its lyrical freshness and poetic inventiveness. There were few, if any, of her poems the cultural watchdogs could classify as contributing to the construction of an ideal communist society. Bella's verses were inward-looking, slightly melancholic, and certainly far from the claptrap ordained by the authorities. To the foreigner, there seemed to be no hint of actual political dissent, but between the lines the politically aware detected an undercurrent of implied criticism and dissatisfaction. One of my favourites was a moving reverie about Siberia, an affectionate, nostalgic look back at a place of cold rivers and dark waters, where 'never did I need to utter, even once a lie.'

Then she wrote 'Rain,' a poetic manifesto of her beliefs as an artist, a declaration that not even a gun could force her to submit. 'A gun,' responds the Stalinist figure in the poem, 'yes a gun is not a bad thing, sometimes.' Because the fact was, almost as soon as Khrushchev allowed these people some freedom, he grew fearful of them, and said 'I declare war on you.' They lived on a perpetual political see-saw, with their art and their lives in the balance.

'Bella knows exactly what she is doing,' said our hostess, Nina Stevens. 'She is courageous to the point of folly.' Bella shrugged, and went to replenish her vodka.

Khrushchev's nervousness about the poets he unleashed was not just the knee-jerk reaction of a dogmatic communist, it was very typically Russian. It was a deep-seated fear of *bolata*, literally swamp or morass, a term that embraces thoughts of disorder, and chaotic mess. The same anxiety is contained in the phrase 'the time of troubles,' those graphic words associated with the reign of Boris Godunov. The Russian soul has always been torn between a desire for freedom and a fear of anarchy. And poets like Bella called upon all the powerful human emotions that created *bolata*, and they were hence to be feared perhaps even above political opponents. To actually meet such writers as we were, was not

unlike a covert meeting with guerilla fighters in a revolutionary war in Latin America.

My wife Thereza and I owed this first truly Russian evening to Edmund and Nina Stevens. Ed had been a great journalist, awarded the Pulitzer Prize for his reporting of the war on the Eastern front. Fascinated by Russia and the heroism of the Russian people, married to a Russian, the lovely Nina, he stayed on after the war, and we became close friends, together with those other wonderful American correspondents Harrison Salisbury, Tom Whitney, and Eddie Gilmour. Gilmour had also married a Russian, Tamara, a young ballerina who had been evacuated from Moscow to Alma-Ata during the war with all the Bolshoi Ballet.

The Stevenses occupied a typical Russian log house, spacious and warm, in a suburb of Moscow. Later, they managed to trade it for a house in the Arbat in the centre of the city, not far from our embassy. No one knew how they had managed this unlikely feat, and rumours inevitably flew that Ed worked for the KGB. I never found any sign of it. I think he was simply tolerated by the authorities as a useful kind of façade, to give the impression that all was not repression. Few were deceived.

Ed and Nina often invited a unique assembly of Russian friends, and fellow foreigners like ourselves who spoke Russian, to the cosy old house, welcome moments of human contact in an inhuman system.

The divorce of the beautiful Bella from the literary lion Yevgeny Yevtushenko the year before had been the scandal of the season. Already famous for his epic poem *Babi Yar*, Yevtushenko was not invited to the party, for which he was furious. Knowing that he detested Bella's second husband, Yuri Nagibin, who was with her that night, the Stevenses had been understandably reluctant to mix these potentially explosive elements.

The divorce had aroused the wrath of the Ministry of Culture, which deplored this separation of two of the greatest talents of the younger generation of poets, as tarnishing the image of communism.

'They are so stupid,' Bella said with something of a snarl, dismissing the entire Soviet apparatus. She wanted to talk instead about some of the modern English and American poets whose

names she knew: Dylan Thomas, W.H. Auden, William Carlos Williams, Robert Lowell. 'Talk to me about their work,' she pleaded, finishing yet another vodka.

I tried to explain what they were doing, how different they were from one another, but without being able to see their poetry, it was difficult to get across. 'I could give you some of their work,' I offered.

She shook her head. 'Too dangerous. And anyway, I don't know enough English. But why don't you and your wife come to a party we're having at our house next week?'

I was probably attracted to her because she reminded me vividly of Princess Tatiana Nakhichevanskaya. I had met the fascinating Tanya in Cairo, where she was married to an Egyptian bey, a remnant of the Turko-Egyptian aristocracy who ruled Egypt until Nasser's revolution overthrew the monarchy. Tanya was descended from the ruler or khan of Nakhichevan, an enclave wedged between Armenia and Iran – probably totalled unheard-of by most Westerners until it became a pawn in the present-day struggle between the Armenians and Azerbaijanis. When it was conquered by the Russians in the early nineteenth century, the czars had the Great Khan brought to St Petersburg, made him a prince, and married him to a Russian, integrating him into the Russian aristocracy.

Tanya once showed me a silver box, saved in the family's flight from the Bolsheviks in 1918, inscribed to the Great Khan and Prince of Nakhichevan from Nicholas II. It was heady, romantic stuff, and Tanya herself personified it ... but I digress.

Tanya had the same intriguing beauty as Bella, from the same Slav-Tartar mix. She also had the same addiction for vodka, and died in her late forties. Bella seemed pointed in the same direction, but was of sterner stuff. Tanya drank out of the old malaise of the Russian in the old regime: boredom. Like most of her fellow intellectuals, Bella drank from boredom, but also as a means of escaping from the interminable struggle with the petty bureaucracy and rules of socialist realism, whilst trying to write according to her inner compulsion.

She had published 'Rain' in the December 1963 issue of the *Literaturnaya Gazeta Gruzii*, a Georgian literary journal. It was an

allegorical poem highly critical of the Soviet government's attitude to culture and containing some scarcely veiled barbs at Khrushchev and Leonid Ilichev, the member of the hierarchy largely responsible for culture and ideology. The poem ended on a defiant note, implying that if artistic freedom were denied then there would be blight on the land. The poem came in for some pretty sharp criticism in the party newspaper of Tbilisi, the Georgian capital.

But the criticism let up and she turned up at a big reception given by the British ambassador for the Royal Shakespeare Company who were playing Moscow. Then she recited several of her poems at Moscow University, including a new one on Boris Pasternak, and another about the persecutions suffered by the great nineteenth-century writers Lermontov and Pushkin. Perhaps she worked on the basis of her former husband's epigram: 'In Russia,' said Yevtushenko, 'the word poet is practically synonymous with fighter.'

Her current husband, Yuri Nagibin, came up to speak with me as Bella drifted off to replenish her glass. He was a well-dressed man in his forties, cultured, polite, someone who would have fitted easily into western society. He showed a surprisingly wide acquaintance with many writers who were never even mentioned, let alone translated, in the official Soviet Union: T.S. Eliot, William Faulkner, Henry Miller, Laurence Durrell.

The source for Miller and Durrell was the now-famous *samizdat* underground press that let these lights into the darkness. We argued about Henry Miller. 'A superb writer,' Nagibin declared.

I thought he was second-rate. But Nagibin, I found out later, was a voracious reader of pornography, which perhaps explained his enthusiasm for Miller. In his own writing, however, Nagibin was always much more cautious, producing short stories and novellas that conformed more or less closely to the rules, and in consequence were only mildly interesting.

As I pondered the political and emotional forces that drove these people, Thereza found herself in conversation with the delightful poet Semion Kirsanov. A somewhat older man, Kirsanov had managed to survive in spite of the fact that his love poems and graceful lyrical verse hardly conformed to the party

rules. He won a major prize in 1951 for a patriotic poem, 'Makar Masai,' and this kept him in reasonably good standing, although his recent poetry had no ideological content whatsoever. Thereza found that he was considerably influenced by French poetry, particularly Paul Eluard and Louis Aragon. But he was more interested in demonstrating his sophistication than in discussing literature.

Kirsanov's wife was a pretty blonde some fifteen years younger than he, whom he met when she was a geology student. She said she was a working geologist now, and her specialty was permafrost. Love poetry and permafrost seemed a curious combination but apparently it worked. He was clearly mad about her.

'Robert Rozhdestvensky will be along soon,' announced our host. Kirsanov made a grimace. Rozhdestvensky wasn't entirely accepted by the others. His poetry was reasonably good, but he often composed party-line poems which appeared in the big papers and revues and brought him in a lot of money. When he arrived late, the others were barely polite to him.

Rozhdestvensky represented the other end of the spectrum from Bella Akhmadulina. He would have been capable of high-quality poetry, I thought, if he had been willing to take the risks involved in abandoning the 'correct' view. But it was not easy for any of them. One of the reasons he more or less conformed was certainly because of his wife, who, people said, constantly held him back.

Rozhdestvensky had been on an authorized trip to the United States at the time of the assassination of President Kennedy. On his return, he wrote a number of anti-American poems, implying that the political and social problems illustrated by the assassination could never happen in the Soviet Union. Other poems went on to disparage American football and Hollywood decadence. He also recited to a Moscow audience a long poem called 'Russian Specialists,' attacking the Russian émigré community in America for keeping the cold war going.

Nevertheless, Rozhdestvensky did tell the audience that America was more than Elvis Presley, beatnik clubs, and 'twisters-rockers.' He reported that he had liked many of the songs about the Civil War and the early settlers' ballads, sung to a simple

banjo accompaniment. Many people in the audience seemed genuinely surprised at this objective statement. In the 1960s many Russians thought that 'everything over there was the other way around.'

But as the pressure on artists increased, he chose the route of almost total conformity. He once or twice accepted invitations to the embassy, but cancelled at the last minute. He was constantly in print, and presumably enjoyed the privileges that accrued. On the surface, he had resolved his conflicting instincts, his Russian duality. The price he paid was a diminution of his poetic talent.

Actually, the vast majority of intellectuals were not active dissidents at all. If you had a minimum of talent, the right connections, and toed the line, you had security, the basic necessities, and the possibility of moving up the ladder to those wonderful privileges: a car, a dacha, maybe even travel. For those with a greater feeling of independence, it was actually a question of finding the difficult equilibrium between satisfying the authorities and answering an inner urge towards free artistic expression. Very few thought of outright opposition, and even fewer thought in terms of democracy. The closest these courageous people came to that was the defence of human rights – and those who did that risked ending up in the gulag, Stalin's forced labour camps.

I wondered how I, or many of us politically safe western poets, would have reacted in the face of such fearsome repression. Would we be like Bella, and those who actually paid with their lives? Or would we be ordinary mortals like Rozhdestvensky, and pay with our souls?

THREE POEMS

Anna Akhmatova

1
It's time! ... Oh, to forget Zhukovsky Street,
The white-walled house, the city's roofs and arches,
Its zoo-like din ... Away! Away to meet
The winking mushrooms and the nodding birches
of Moscow's princely, sparkling, dewy fall,
The skies remote, the leaves and grasses rustling,
And Rogachevsky Highway throbbing still
With youthful Blok's untamed and reckless whistling ...

2
Sounding the dark depths of memory,
I find a St. Petersburg night, fluid and shimmery,
A theatre box's velvet-hung gloom
Haunted by smells that are chokingly warm,
Gusts of wind from the gulf, and, just as it was,
Scornful of all the 'oh's' and the 'ah's',
That arrogant smile, growing no dimmer,
That belonged to Blok,
 our epoch's tragic tenor.

3
How right he was – the lamp, the Neva,
The chemist's shop, and a mirage:
A man, a monument erected
To mark the advent of our age ...
He glimpsed it all again the evening
To Pushkin's house he waved goodbye,
And like a rest he did not merit
Embraced death's wearing agony.

The famous monument to Peter the Great in St Petersburg

TWO

Engineers of the Human Soul

As the Red Arrow rumbled through the night back to Moscow from Leningrad, I could not sleep. It was very cold outside, and one could see nothing through the frosted windows except the dim lights at the stations where the train occasionally stopped – maybe, I mused, one of those where Anna Karenina had killed herself.

Inside, in the prewar, perhaps even pre-revolutionary, first-class sleeping car, it was warm and comfortable. No members of the proletariat in this wagon-lit. In my insomnia, I was inspired to write a poem on revolutionaries and their mad dreams of perfecting the world in their own image.

> They have an answer for the absolute
> But they are likely to drown
> In the foul water of the gutter
> But they are unaware
> Sewers even exist
> And are fatal for lunatics.

As the train rolled back the miles, my mind rolled back the years, back to my first arrival in Leningrad so many years ago. In my mind's eye, Leningrad floated in its swampy vapours before me, as it had when we first arrived there, haunted by the spirits of its past, the phantoms of the glory days of St Petersburg.

It was mid-September 1946. With Thereza, my Brazilian bride of three months, I was arriving in the Soviet Union for the first time, to take up my post as first secretary of the Canadian embassy in Moscow. It had taken eight days sailing from war-weary London, through the North Sea, the Kiel Canal, and the Baltic, on a small, cramped ship, the *Byelo-ostrov*. It was Finnish-built (part of Finland's war reparations), and intended for ferry service from Helsinki to Tallinn. So on the high seas it tossed about like a cork, with the Soviets as seasick as most of the dozen passengers. Then at last, the shadows of Leningrad.

This once great city, the Palmyra of the North, was barely visible as we glided into the docks in a miserable mix of cold rain and mist. It seemed almost a ghost town as we drove through the streets, nearly empty of traffic.

Leningrad. St Petersburg. Two names, one legendary city of history. From the days of its creator, Peter the Great, through its grim metamorphosis in Lenin's image, to its fragile rebirth today, it is a mirror of Russia's journey of the soul.

Extravagantly beautiful, mystic, but tragic from the beginning, it was built on a swamp in an inhospitable part of the country, at the cost of thousands of lives – the wrong place for the capital of a great empire, on its very edge, not at its centre. It was doomed to isolate the czar, the upper classes, and the bureaucracy, from the country itself. But Peter the Great believed that the creation of a new, rational, western-style capital was the only way to tear Russia out of its medieval, semi-oriental state.

We gazed at his statue, one of very few spared by the Bolsheviks who now ruled: Peter, standing through the years in a small park on the embankment of the Neva River, pointing towards the sea. Towards the West, that is, either in defiance, or to show his subjects the direction to take.

Peter led his armies east, west, and south and dragged his people with him, defeating Tartars, Poles, and the once-powerful Swedes. When the Swedes were forced to give up their hold on the southern coast of the Gulf of Finland and eventually Estonia, Peter gained his desired 'window on the west.' St Petersburg rose on his command, capital of his empire, symbol of his determined vision.

Years later the West German ambassador to Moscow, Gebhardt von Walter, recounted to me a story that dramatically reveals the symbolic importance of St Petersburg for the Russians. A specialist in Soviet affairs, during the war he had been appointed political adviser to the commander of the German armies on the Leningrad front. He told me he constantly advised the general staff not to underestimate the power of Russian patriotism and the attachment of the Russian people to their former capital.

Unfortunately, he said, his reports had the opposite effect. They made Hitler more determined than ever to capture Leningrad, in the mistaken belief that the fall of the symbol of Russian patriotism would quickly lead to a collapse of Russian morale. Napoleon, Hitler, and many others have learnt to their chagrin the impossibility of breaking that resilient Russian will.

Thereza and I could see all around us the devastation wrought by this latest war in a long history of conflicts, though the city itself was not quite as badly damaged as I had expected from the news we heard in London. Our hotel, the Astoria, a relic of pre-communist days, tried not very successfully to keep up appearances. The real devastation, though, was human. The terrible sufferings endured during Hitler's nine-hundred-day siege were apparent in the faces of the people. Some of the civilian population had been evacuated in the winter of 1941–2 across the only possible outlet, an ice highway over frozen Lake Ladoga. Supplies were pitifully few, and enormous numbers died of starvation before the German siege was lifted. One could still see the results of horror, despair, and near famine in the hollow eyes and thin frames of the survivors.

But we had our first experience of that indomitable spirit that first night in Leningrad, when we went to the old Imperial Theatre, the Mariinsky. Renamed the Kirov by the Soviet regime, in honour of Leningrad party leader Sergei Kirov, already the war damage to the building had been painstakingly restored. At first glance this seemed a peculiar priority. But then when we looked around at the audience and saw the thrill on their faces, the obvious enthralment with what is one of the most beautiful opera houses in the world, and the lavish, overwhelming production of Glinka's *Ivan Susanin*, we understood. And the opera itself, orig-

inally called *A Life for the Tsar*, was a sign of the Russian patriotism that fuelled resistance to the German invader.

It was the beginning of my practical education in Russian reality. I assumed when I had joined the diplomatic service in 1940 that I would eventually be posted to Moscow. I was preparing my Ph D at Cornell University on French history and political philosophy when Philip Mosely, a young professor of East European history, convinced me that, academically, Russia was the coming thing. Being already obsessed with Russian literature and in particular Dostoyevsky, I took his advice and spent my last year at Cornell labouring away at the Russian language in every spare moment. Russian was difficult, rich, beautiful, complex, and compelling.

As a Canadian, I could share easily the hardships of the Russian winter and the northern landscapes. The days were even shorter than ours, and the night interminable, but the snow, particularly the first snow, was the same, and the fir trees, the pines, the spruce interspersed with white birch trees, all reminded me of home. All that was missing was the marvellous Canadian autumn, the sudden cold, the bright blue sky, and the startling colours of the maples. In Russia, fall was a period of melancholy, the sky grey and misty, the forests black and menacing, the landscapes fading into the skyline with an undefinable feeling of sadness, as slowly the countryside drifted into winter. Then there was the familiar intense cold, and the beauty of the white universe. I loved the winter.

In my nineteenth year I had been attacked by a mysterious form of progressive muscular atrophy. The doctors gave me a year to live. Then suddenly the progression stopped and the disease has only very slowly advanced over the years. It was a devastating experience to be under a death sentence, to be pardoned, and then gradually have to adjust to the fact that my love, winter, had become the enemy to be fought. Snow and ice tripled my problem. I saw myself as the young Dostoyevsky who, for his membership in a radical literary group, was condemned to death in 1849, led out to execution, only to have his sentence commuted at the very last minute to exile in Siberia.

And here I was, albeit not in Siberia, but in Leningrad. And I

had a feeling my destiny was going to be bound up with this country.

The Leningrad Communist Party apparatus in those postwar years was harder on the intellectuals even than that in Moscow, probably because the city had a longer tradition of contact with European philosophy and literature. So-called anti-socialist decadence was that much harder for the zealots to root out. And for them, just as for Hitler, the former imperial city was an important symbolic target that became an obsession. Renaming it for Lenin was one thing; reshaping it in his image was quite another. The Leningrad party boss, Andrei Zhdanov, was a minion of that most obsessed fanatic of them all, Joseph Stalin, and he was to make the intellectual subjugation of Leningrad his mission in life.

Zhdanov was the successor to Sergei Kirov, whose assassination in 1934 had been the pretext for the launching of the Stalinist purges and the Terror. Although Kirov was actually murdered by G.G. Yagoda, the head of the NKYD, or secret police, on the order of Stalin, he was turned into an instant martyr by the propaganda machines. Zhdanov led this spasm of adulation (safe because the hero was dead). Then it was he who co-signed with Stalin the orders for the execution of Yagoda and his replacement by the equally repulsive N.I. Yezhov, who in turn was to disappear.

Leningrad became even more of a silent, terrified city, which waited from day to day for some new kind of terror to begin. It is hard to calculate the immense loss caused to Russia and the world by Stalin's decision, purveyed through Zhdanov in 1934, to 'collectivize' culture. At the first congress of the Writers' Union that year, Zhdanov spelled out the doctrine in chilling detail. 'Socialist realism' required writers to combine revolutionary enthusiasm with a 'correct' depiction of reality. This was left sufficiently vague so that only the censors could determine the orthodoxy of what was written.

The dogma of socialist realism originated in Lenin's own statement that 'art belongs to the people.' At first, in the early years of the Revolution, that meant art belonged to the artists as well. There was a tremendous vitality, audacity, and experimentalism in Russian modernist art, in music, and even in literature, led by

such giants as Vasily Kandinsky, Dmitri Shostakovich, and Vladimir Mayakovsky. They saw themselves as *revolutionary*, part of the great social experience of their nation.

The Kremlin and party bosses saw them as dangerous enemies of the Revolution, basically because they were an uncontrollable force. The Marxist ideologues wanted all art to directly and visibly applaud the Marxist state and its values. In the words of Hilton Kramer, art news editor of the *New York Times* in the 1960s, the doctrine of socialist realism was 'openly designed to flatter the state, to celebrate its leaders, to mythicize its history, and to romanticize the common life of the people.'

The paintings of Marc Chagall or the music of Sergei Prokofiev did no such thing. And worse, modernist art was incomprehensible to many of the party ideologues, including Joseph Stalin, who was reported to be furious at Shostakovich's opera *Lady Macbeth of Mtsensk*, for its grim subject matter and lack of hummable tunes, when he first heard it in 1936. Rather than examine their own intellectual shortcomings, the ideologues decided, with typical contempt, that 'the people' wouldn't understand or like this stuff either.

As early as 1922 the pressure grew on all artists to conform to the socialist path, along the lines of a group called the Wanderers, who believed in traditional forms of art, fully understandable in style and content by the masses. Mayakovsky himself, one of the great poets of the Revolution, denounced this 'heroic realism' as 'the depths of hideous banality.'

By 1934 it became official doctrine, and led to innumerable paintings of contented peasants toiling in the fields, cheerful factory workers, and worse, art and sculpture enslaved to the personality cult of Lenin. Everywhere one turned in the capital, there was his image, in stone, bronze, print, and photograph, all works of what Kramer called 'egregious sentimentality and artistic nullity,' which sums up perfectly the claptrap of socialist realism.

In fact, of course, it wasn't realistic at all, but an integral part of the great lie that was communism. Artists had to be controlled because artists had unerring instincts for truth, something the ideologues could not risk.

The authorities developed an extraordinary jargon to hide

behind. A typical critique of Shostakovich called his music 'the reactionary essence of modernism as an anti-folk end in art, reflecting the decadent ideology of the imperialist bourgeoisie.' This vague gibberish always sounded laughable in the West; but such words could condemn a Soviet artist to prison, exile, or death. The doctrine was all-encompassing and at the same time deliberately amorphous in its terminology. To defend oneself, once accused, was virtually impossible.

Writers were to become 'engineers of the human soul.' The rhetoric and the rules were deliberately vague and therefore infinitely blood-chilling. (It was somehow fitting that in 1948 Zhdanov was poisoned, a victim of his own Stalinist machine.)

These political fogs swirled about us as we arrived in Zhdanov's Leningrad. But for me it was still Peter's royal city – and equally important, it was the home of Anna Akhmatova, the queen of Russian poetry. She had been evacuated from Leningrad during the siege, but it was believed she had returned to her beloved city.

But in 1946 how to find her? There was no such thing as a telephone directory (indeed there still wasn't in 1980); and I was not so naive as to think I could ask for her address. So I wandered the streets, along the banks of the canals, haunting the mist like some desperate lovelorn hero out of Pushkin or Byron, not expecting to find her but in the hope of recapturing some of the atmosphere of her poetry, of *her* Russia.

She wrote haunting poetry of love and faith and nature, reflections of the world she grew up in, a free spirit of the intellectual elite in the last days of the czar. But she was no spoiled aristocrat; and her poems always had an undertone of gloom and suffering. She called 1913 'The Last Year,' the last before the Great War. And the last before all the lights went out in Russia. For her, the century ended not in 1900, but in 1913. And the rest of life as she knew it ended with the Bolshevik Revolution in 1917.

But she continued to write of inner feelings, becoming a voice for the voiceless when Stalin muzzled an entire nation. She was deeply loved. With her deep-set dark eyes, her almost Roman profile with the unmistakeable bump in that aquiline nose, she was more than beautiful. Her poetry gives the impression of delicacy and finesse, but she proved to be tough and resilient.

This extraordinary woman had survived dreadful horrors. Her husband Nikolai Gumilev, a poet in his own right, in the prewar years had been the founder of the Acmeist school of poetry. The Bolsheviks found his verse obscure, decadent, probably carrying some dissident message. He was executed for 'anti-Soviet activities.' Just what these were was left murky, as Acmeism theoretically was pure poetry, not political. Gumilev was in many ways the Soviet equivalent of Ezra Pound.

Then in 1934, during the terrible Stalinist purges, Akhmatova's beloved son Lev was arrested, part of *her* punishment for refusing to be mute. She spent hundreds of hours in the freezing cold with other mothers and wives, lined up at the gates of the great prison in Leningrad, waiting, hoping. She wrote of that, too, voicing their pain and despair and anger.

Lev spent seven years in the gulag before he was finally released in 1941 – to be able to fight the Germans. During the war, there was a brief relaxation of control on the artists to stimulate resistance to the invaders by playing on Russian love of country. Akhmatova returned to Leningrad as soon as the siege was lifted, but almost immediately the harassment by the literary bosses began again, and she was unable to publish anything until both Zhdanov and Stalin were dead.

In 1945 Isaiah Berlin, then representative of the British Council in Moscow, had by chance encountered Akhmatova in Leningrad. The highlight of this meeting was the recital of her marvellous long poem *Requiem*, with scarcely veiled references to the terrible thirties and the arrest of her son. *Requiem* was the memorial to all those millions who suffered so senselessly under Stalin. Word of the poem had circulated surreptitiously but, of course, it had not been, and could not have been, published.

The Soviet authorities quickly pounced on Berlin's innocent but ill-advised call on the poetess to denounce her as 'half-nun, half-harlot.' It was a brutal signal that the slightly greater freedom of expression the struggle against the German invaders had given artists was abruptly at an end.

I learned many years later that in my wanderings I had in fact passed in front of her 'apartment.' It was located on the Fontanka Canal, in the beautiful baroque palace of the Sheremetev

family, which had been transformed into a vast warren of rooms and tiny apartments. It was extraordinary that she could have survived so long. Especially in Leningrad. Stalin's Leningrad.

I was fascinated by the extraordinary group of younger poets who started writing at the beginning of our century – and appalled at their fates.

There was Alexander Blok, the Symbolist poet and author of 'The Twelve' and other poems of great intensity, who had emerged from the intellectual whirlwind of the first two decades. He had died in 1921, thoroughly disillusioned with the Bolshevik Revolution.

Vladimir Mayakovsky, poet and leader of the Futurist movement, became one of the Revolution's saddest casualties, committing suicide in despair in 1930, as the paradise he had dreamed of sank into the bureaucratic totalitarian hell of Stalin's regime. The real Terror, which was to cost millions of lives, had only just begun, but he seemed to have sensed what was coming. His ideals shattered, he chose his own way out.

Velemir Khlebnikov, the eccentric founder of the modernist movement, died in 1922 at the age of thirty-seven, for reasons which are still obscure.

Sergei Yesenin, balladeer of genius, committed suicide in 1925, unable to stand the growing bureaucratic restrictions.

Osip Mandelshtam, great and original poet, was hounded into silence and died in 1938 in the Siberian gulag, where he had been sent because his poetry was considered seditious.

Marina Tsvetayeva, a poetess of enormous sensitivity, emigrated after the Revolution and eked out a miserable, homesick life, first in Prague and then in Paris. In 1937 her husband, by then a Soviet secret agent, returned to Soviet Union. She followed him in 1939, unaware that he had already been shot. Her daughter and sister were sent to concentration camps. In 1941 she was evacuated from Leningrad to a small town in the Tartar region. A few months later, unable any longer to stand her personal tragedies, her inability to write or publish, and the tragedy of Russia, she committed suicide.

In August 1946 *Pravda* launched a vicious attack on the literary community, singling out in particular Anna Akhmatova and the

satirist Andrei Zoshchenko, both Leningrad writers. Zhdanov followed up by a personal attack on both of them, demanding that literature must serve the state, and denouncing Akhmatova's poetry as singularly pessimistic and alien to everything in Soviet thinking. His criticism effectively silenced Akhmatova and served as a warning to the entire intellectual community.

The subsequent list of victims is appalling: in addition to the poets, the novelists Isaac Babel and Boris Pilnyak, the theatrical genius Vsevolod Meyerhold, and many others, were executed or died in the gulag; countless others were driven into silence.

Lili Brik in her Moscow apartment, 1977

FEAR

(Extracts)

Yevgeny Yevtushenko

In Russia fear is dying now
Like the ghosts of olden times, though
Begging still for bread with the old
Women huddled in church doors.

I recall them, powerful and strong,
At the court of triumphant lies.
Fear floated like a shadow everywhere,
Penetrating every floor.

* * *

That day has gone, far away, and now
It is hard even to recall
The secret fear of someone's curse,
Or of a knock upon the door.

* * *

We were not afraid of work or weather
Or of fighting at the front,
But sometimes we felt a deadly fear
Of speaking even to ourselves.

Now fear is dying in Russia,
And, well, things are not so bad.
Buildings are going up without fear,
And they are real, and not imagined.

We were not defeated or dishonoured.
And in her enemies Russia,
Which conquered fear, now creates
An even greater fright.

Happily now I look and see
New fears: of being untrue to the land,
Fear of lies, destroying truth, and
Turning truth itself into lies.

Fear of boasting, of stupidity,
Fear of copying another's words,
Fear of destroying with mistrust
And of trusting oneself too much.

Fear of being happy, but indifferent
To another's cares and sorrows
Fear of being timid, cautious
Before the page, the drawing-board.

And so I write these lines,
Perhaps unwittingly too fast,
I write oppressed with fear
I have not given them all my soul.

THREE

The Thaw?

In the 1960s and 1970s Yevgeny Yevtusheko and Andrei Voznesensky were the brightest stars in the world of Russian poetry, the inheritors of the heavy mantle of those persecuted poets before them. Over the years, I was able to call them both my friends, these two brilliant, complex, and bitter rivals. Poets to Russia were as film stars to America, and they carried on in much the same way, womanizing, partying, soaring to extravagant heights and sinking deep into depressions, and through it all producing some of Russia's finest works of words.

They emerged when Nikita Khrushchev attacked the icebound doctrines of Stalin. The 'thaw' permitted a startling explosion of poetic talent. And new voices appeared – fresh, modern, daring, practically ignoring the stultifying dogma of socialist realism. Voznesensky's poetry was personal, intimate, lyrical. Yevtushenko chose a more political path, and his moving poem, *Babi Yar*, based on the discovery of a mass grave of murdered Jews in Ukraine, had a profound effect on public opinion. His powerful poem 'Fear' welcomed the end of Stalinism, and Khrushchev's courage in exposing the grim reality behind the fatherly myth. But Yevtushenko was also talking about his own fear that this liberalization was not going to last very long. And he was proved terribly right, as gradually the relentless party bureaucracy pushed Khrushchev back into the Soviet mould. 'Fear' also implicity ack-

nowledges that fundamental fear of disorder, and recognizes the Russian need for order, perhaps even his own need – hard to reconcile with this wild, impetuous character.

Yevtushenko looked and acted like the true literary lion he was: tall and blond with handsome feline features, he was bumptious, conceited, and at times arrogant, but I still couldn't help liking him. He had a layer of sophistication and an uneven knowledge of western poetry, particularly English and American. But underneath he was proud to be a Siberian, born appropriately in a tiny hamlet called Zima Junction (Winter Junction). The Siberians are a race apart: tough as the climate requires, courageous, outspoken, a bit uncouth, rather like the pioneers of Western Canada and the United States. He was immensely proud of his fame in the West, and of his popularity in the Soviet Union. His star status created endless squabbles with the officials of the Ministry of Culture, partly out of jealousy, partly because they did not know how to control him without risking a storm of protest from western countries and their own public. They seemed to consider him a kind of time bomb ticking away, never quite sure when it would explode – as in fact it did, after the invasion of Czechoslovakia.

I finally had a chance for a long talk with him in 1967 when the French film director René Clement was invited to Moscow for a one-night showing of his film *Is Paris Burning?* We were invited to supper afterwards with Clement, a number of French Resistance heroes who had come for the occasion, and Yevtushenko. To my delight, I sat with Clement and the poet.

Yevtushenko drank a great deal; over the evening, he consumed an entire bottle of vodka he had requisitioned for himself, without any visible effect.

The author of *Babi Yar* had recently had a triumphal tour of the United States and had accepted in principle our invitation to visit Canada. He stressed his wish to see something of the north 'and the Eskimos or Indians,' but above all, to meet with Canadian intellectuals and other artists.

'But I can tell you confidentially, I have already visited Canada,' he said in a conspiratorial whisper, 'for twenty-four hours.' He claimed he had met an American girl who was crazy about him,

and so determined to sleep with him that she followed him around on his tour. It was impossible to be alone, so she smuggled him into Canada at Niagara Falls, where they spent a very agreeable day and night.

I laughed, not sure if he was making it all up. 'How did you get away with it?' I asked, 'not with your passport, and you don't speak much English.'

'She told me she would do most of the talking, but if Canadian Immigration asked where I was born, I should say Pittsburgh; they would think I was a bohunk.'

He did look rather American, so it might have worked. It was the first time he had heard the word 'bohunk' and obviously he didn't know it was derogatory. When I asked what he thought of the Falls he shrugged and replied, 'Lots of water.'

I still had no idea if the yarn was true. Yevtushenko's poetic imagination at times stretched credulity. He recounted his adventures as a sailor on a schooner, hunting seals for six months in the Arctic, where he was sent as a punishment by Khrushchev after their first 'disagreement.' They were almost three months at sea without encountering another Soviet vessel. Their main distraction was ten films, all Russian except the Italian *Nights of Cabiria*, which was therefore enormously popular. It was refreshingly non-ideological, being the romantic exploits of a lively lady, Fellini's whore with a heart of gold – who became Hollywood's *Sweet Charity*.

After three months they met another Soviet sealer but could not come closer than a quarter of a mile because of pack ice. The first thing their captain asked the other ship was 'Have you any films?' The answer was 'Yes, let's trade.' The others had heard that they had *Nights of Cabiria* and insisted it be included. There was great resistance until the other captain agreed to include his one foreign film, *Les Murs de Malapaga* of René Clement. Then came the problem of transferring the films. The other captain said he was a communist who would not risk a sailor's life for films. Their captain replied that he was also a communist but as a good communist *he* believed in the role of art in life, etcetera, etcetera. Marxist dialectic in the ice pack.

Finally arrangements were agreed on and Yevtushenko gave us

a poetic description of the films being transported precariously across the ice. Clement was a little sceptical that *Les Murs de Malapaga* entered into this story. It seemed too much of a good thing. In any event it made a good tale.

Someone accused Yevtushenko of being too much of a 'coqueluche.'

'A what?'

Since there is no equivalent in Russian, there was some fevered consultation, and we came up with the Russian for 'darling of the public.'

'Well, why not?' replied Yevtushenko with bravado. 'After all, someone who has been chauffeured around Washington by the minister of defense has a right to be a ... cock loose.'

After his poetry reading in Washington attended by Defense Secretary Robert McNamara, the latter apparently did drive him to his house for a drink. It obviously made a great impression on Yevtushenko. Indeed, his whole American visit had clearly impressed him. He kept repeating at irregular intervals that he hated the Americans: 'Too rich, too busy, too much of everything, too many bombs.' But he clearly felt attracted to the informal approach of Americans, particularly students and intellectuals – and he liked their cities.

He was also enormously flattered by the attention he received everywhere and the sympathy for the Soviet Union and desire for good relations he had noted in wide circles. This puzzled him. He took as an illustration of this the film *The Russian Are Coming, the Russians Are Coming* which he said he saw a number of times. 'A wonderful film!' he pronounced, 'showing how both peoples would love each other if they could dispel the hatred and misconceptions between them. I felt very moved the way the audience applauded the film. It's a good omen!'

'A pity it probably won't be shown here,' I said.

A week before President Podgorny was due in Vienna for an official visit, posters had gone up everywhere advertising the film and the Soviet embassy had protested.

Yevtushenko replied, 'Don't think we are so idiotic as to think something like that was done deliberately. It's just part of the program to put the other side on the defensive.'

What he really meant was that it gave the Soviets a slight psychological edge, to pretend they were being deliberately insulted. This sort of tactic was a classic diplomatic weapon. But no one was better at it than the Russians, for whom duality was a way of life.

Later we got onto the subject of the level of poetry in the Soviet Union. The anthology *Poetry 1966* which I had just received contained the work of 122 poets. It could not be all good.

'Yes, yes, most is second rate, of course,' he said dismissively, 'but we have about twenty first-class poets now writing in the Soviet Union, a pretty good number.'

But there were thirty-two hundred registered officially with the Union of Writers.

'It's as bad as France,' he said, 'with its three hundred varieties of cheese.'

When asked if he considered himself the best contemporary Russian poet, Yevtushenko modestly disclaimed this title and named Andrei Voznesensky. He drew my attention in particular to a poem by Andrei in a recent issue of *Isvestiia*, dedicated to Robert Lowell. It was something of a melancholy love poem to San Francisco and the hippie life that had bewitched Voznesensky:

> Peace to your snoring,
> Great Ocean
> Peace to the ploughmen in Klin.
> Peace
> to the Temple of San Francisco,
> the floors of which, like breath,
> well-proportioned, airy,
> may sigh for me just once,
> like their country's lungs ...
> (from 'The Solitary City' trans. R.A.D. Ford)

It was indeed a first-class poem and its publication in the stodgy pages of *Isvestiia* was an indication that the literary czars recognized the value of at least some of their young poets.

When it came time to leave, Yevtushenko made a parade of telephoning to his wife to send his 'chauffeur' to pick him up.

After Yevtushenko departed, we all agreed that he was 'le meilleur commis voyageur de l'URSS' (the best travelling salesman of the Soviet Union). The Soviet government had probably come to recognize what a valuable asset he was and were prepared to tolerate his eccentricities. At the same time Yevtushenko knew exactly how far he could press his luck.

Voznesensky was the antithesis of Yevtushenko. A Muscovite by birth, slight, shy at first acquaintance, cautious, and enormously talented, he typified the Russian middle-class intelligentsia. He was to become my best Russian friend. His parents were scientists, and he himself studied architecture. He began writing poetry at an early age, and after the publication of his first book *Parabola* in 1958, he abandoned architecture to devote himself entirely to poetry – with a bit of painting on the side.

His success in breaking down the stodgy forms and themes of approved verse had let light into Soviet poetry, while at the same time arousing the distrust of the literary and political establishment. His skill in versification, his new themes, and his marvellous declamatory style quickly made him immensely popular in the Soviet Union and abroad. His poem 'In the Mountains' breathes the fresh air of those mountains, and fills the mind with colour and life, for 'Here as one loves, – one writes – boldly, with deep emotion.' Precisely the sort of thing the culture czars feared most, but could not pin down. 'What *they* regard as the ideal theme for a poem or an opera or a ballet,' said Thereza acidly, 'is Girl Falls in Love with Tractor.'

At the receptions where I saw Voznesensky occasionally he avoided close contact. When I heard that his book of verse *Anti-Miri* (*Anti-Worlds*) had been turned into a play at the Taganka Theatre, we seized the opportunity to see it.

I had read and admired the book, but the stage production was not exactly a play. The director was the great innovator Yuri Lyubimov, who had transformed the Taganka, an old, more or less abandoned theatre in a small square far from the centre of Moscow, into a marvellous source of inspiration for a public thirsty for something new. Lyubimov had told me that Voznesensky had tried experimental plays without much success. So this

was a kind of poetic spectacle, a curious mishmash of dance fragments and poetry recited or sung to the music of Vladimir Vysotsky.

The poetry was beautiful, even more so as recited or chanted by Vysotsky, a talented balladeer and song-writer. His nostalgic ballads, sung in a husky voice accompanied by guitar, reminded Thereza of the Brazilian songs of Joao Gilberto and Vinicius de Moraes. The authorities frowned on Vysotsky's work and he lived on the fringes of the Soviet system, mostly with the help of admirers who bought tapes of his songs that circulated under the counter.

Vysotsky was a truly charismatic character, who so enchanted the French actress Marina Vlady that she married him, although their married life was sporadic. He did not want to go to France, and although she was part Russian, she wanted to experience Russia but not live there, not even for him. He died at an early age in 1989.

I sent Voznesensky a translation I had made of his long poem 'Prologue with Commentary,' for the journal *Canadian Slavonic Papers*, along with some of my own poetry. As he was in trouble over the publication of 'Zarev', his long poem about Siberia, I thought it best not to try to actually get in touch. So I was surprised when he telephone to thank me in person. Overjoyed, I asked him to come to lunch with his wife Zoya Boguslavskaya. Even more astonishing, they actually turned up, and stayed three hours.

They were a bit of an odd couple. Andrei, slight and neat, was a lively character who fairly sparkled with intelligence. Zoya, a heavy-set blonde, not very pretty and rather reserved, said relatively little on this first encounter. She wrote novels and short stories, considerably less talented than her husband's work, but she had a certain success in the Soviet Union, and I was surprised to learn that an English translation of a collection of her short stories was to appear in New York shortly. As we got to know them both better over the years, we appreciated her talents more. She only seemed so stolid beside the bubbly Andrei, but she was in fact highly intelligent and well read.

Our conversation was almost entirely about literature. Politics

was avoided. But it was clear that he was not happy with the present situation in the intellectual world. To lunch at the embassy seemed like an ostentatious act of defiance of the authorities unless he had cleared it with 'them.'

I asked him about the criticism in the *Literary Gazette* of 'Zarev.'

'The *Gazette* made it look like a criticism of the writing,' he replied, 'but the intent was obviously political and obviously a warning.' He would not comment further, although he did say that he was very hard at work on a new book of poems of which the 'Zarev' cycle would be the main work. He hoped it would get published.

At the moment he was going off in what I thought an unfortunate tangent – pictographic verse, rather like the early work of Jean Cocteau. But his new surrealistic drama, *Look Out for Your Faces*, was in rehearsal at the Taganka, and he crossed his fingers that it would actually appear.

He was quite excited when I produced a first edition of *Deaths and Entrances* by Dylan Thomas, which has a number of poems composed in unusual shapes. He believed Thomas one of the best poets of our epoch. 'Partly because the Welsh temperament is less inhibited than the English and more akin to the Russian,' he said genially.

I commented that there was a distinct difference between the Welsh and Irish compared to the Scots and Anglo-Saxons. 'Anglo-Saxons tend to feel embarrassed at showing their – our – true feelings in public,' I elaborated, adding that perhaps one of the cruellest things the communists had done was to repress the wonderful well of emotion and imagination in the Russian soul.

'Oh, it's still there,' Voznesensky said. 'It may not show right now, but it's there.'

It must have been early in 1970 that he telephoned, happy to announce that *Look Out for Your Faces* had unexpectedly been approved and the premiere was that night. 'Could you come?' he asked urgently. 'It's important that you be there.'

The censors from the Union of Writers had been prowling around and condemning every aspect of it, he told me. After seeing it I could understand his fears and I was puzzled that the authorities had changed their minds.

The premiere brought out a remarkable cross-section of the city's intellectual elite. I was seated next to Lili Brik, one of the most intriguing women of the century, to whom a chapter of this book is devoted. During the intermission I met the prima ballerina Maya Plisetskaya and her husband Rodion Shchedrin; the novelist Vasily Aksyonov; the wife of the conductor Kyrill Kondrashin; and of course Voznesensky and Lyubimov.

The play was really a series of sketches based on Voznesenky's poems. Unlike *Anti-Worlds*, however, it had a fairly clear message – that individual values are worth preserving from the grey anonymity of the state. Hence the title.

In the final scene all the lights in the auditorium went on, the actors lined up at the edge of the stage and, holding up mirrors to the audience, asked them to 'show your faces.' Other scenes were equally risky. One of the most moving was the lament of poets being in 'degradation.' Another was about the poet's role in society and ended with the shooting of a poet for 'parasitism,' a clear reference to the case of Joseph Brodsky, condemned to five years' hard labour as a social parasite.

To make up for the lack of 'positive' ideological line so beloved of the authorities, Voznesensky threw in a few sops to the censors in the form of a satire on American society, and a poem to Lenin which was so exaggerated as to be obviously tongue-in-cheek. For example, halfway through this scene the action suddenly stopped, all the lights went on, and an actor with a catch in his throat announced that in that hall, on such and such a day, Lenin had appeared, adding that there was a plaque in the entrance to prove it. This was received in dead silence, in contrast with the frenetic applause throughout the rest of the play and at the end.

I was impressed that two of the poems which received the greatest applause were about America. One was about the assassination of Robert Kennedy and the other was a description of San Francisco.

Voznesensky was very happy with the public reception of the play, as was Yuri Lyubimov. He had not known until the very last moment if the performance would be permitted. A number of scenes had had to be cut to satisfy the censors, but on the whole

he was pleased with what by Moscow standards was extreme avant-garde theatre.

Though the production was not publicized or announced, news of it spread like wildfire. I suspected the Taganka was used by the authorities as a means of letting off intellectual steam. It seemed to be the only reason why *Look Out for Your Faces* was permitted. But not for very long as it turned out.

When I saw Yevtushenko again, he asked if I had seen Voznesensky's play. When I said I had, he commented, 'You're lucky because you won't have another chance to see it.' He considered Voznesensky a great poet, a pure poet, who was really totally apolitical. Unfortunately in the Soviet Union this amounted to having a political attitude.

Then came the 'Kuznetsov affair' and suddenly it was very hard to get in touch with my poet friends. Anatoli Kuznetsov had been generally considered by the 'liberal' writers as an incompetent novelist and dangerous schemer. In order to get ahead he had invented a story that Yevtushenko was planning to produce a *samizdat* magazine antagonistic to the Soviet system. Yevtushenko was immediately removed from the editorial board of the literary magazine *Yunost* (*Youth*) and Kuznetsov took his place. From this vantage point Kuznetsov got permission to attend a conference in 1969 in England – where he immediately defected. He was naturally removed from *Yunost* but Yevtushenko had not been reinstated. In England, Kuznetsov admitted that he had concocted the story.

In 1969, on behalf of the Canadian government, I had extended an invitation for Andrei and Zoya to visit Canada. In view of possible displeasure from the Soviet cultural czars, the couple were unsure if the trip would take place. But finally they did get the green light to accept the invitation. It came just after the publication in the official organ of the Union of Writers, the *Literary Gazette*, of a long and favourable review of Andrei's last book of poems, thus putting the seal of approval on his work. Since the poetry bore little resemblance to official social realism, one can only conclude that Voznesensky was considered too good a poet, and too popular, to persecute.

At any rate, Andrei and Zoya came to lunch to discuss the

forthcoming visit to Canada in a very relaxed mood, having just returned to Moscow after three weeks in the northern Caucasus. Andrei gave me an advance copy of the next number of *Yunost*, with a long poem by him which he described as his most important work to date. Zoya also had had a short novel published in the July and August issues of *Yunost*.

When I remarked that *Yunost* was becoming the Voznesensky family organ, Andrei laughed and said the reason it was suddenly publishing their works lay primarily in the defection of Anatoli Kuznetsov. Bewildered, I asked how on earth that had anything to do with it. It seemed he had been unable to get anything published in *Yunost* for a very long time because Yevtushenko was on the editorial board. He said Yevtushenko had always refused to let anything by Voznesensky or Zoya appear in the magazine.

'But Yevtushenko told me he considers you the finest Russian poet!' I said, astounded.

'I don't know why,' he said with an ironic look, 'but Yevtushenko hates me, and does everything he can to destroy me. 'After the publication of Voznesensky's new book of poems, *The Shadow of Sound*, Yevtushenko wrote a violent, almost obscene attack on it for *Novyi Mir*, which was so exaggerated it was refused publication.

I then remembered that when I had had lunch with Yevtushenko recently he had asked me why I only translated Voznesensky and not him. I replied that I would translate him if he wrote poetry I liked. He then sent me an annotated copy of his huge (forty-thousand line) poem 'Kazan University' but I found nothing very exciting in it. Perhaps, in spite of everything he said, in spite of everything he had, Yevgeny was simply jealous of Andrei.

So I learned that, as in any other country or system, a lot came down to the old human emotions: jealousy, fear, love, hate. I might easily have jumped to the conclusion that Voznesensky and his wife had been excluded from *Yunost* for political reasons, whereas it seems to have been the result of purely personal rivalry, an inexplicable vendetta of some sort from a rival poet. It sounded a lot like the halls of academe back home.

But this was scarcely a place of ivory towers. It was a nation

where academic or literary squabbles took place against a backdrop of death and terror. And they could squabble now partly because of Khrushchev's effort to relieve that terror, partly because of those who had gone before them, especially the author of *Dr Zhivago*.

FOR PASTERNAK

R.A.D. Ford

I was distracted by the ptarmigan
Whirring up sudden and dusty from
Just in front of me, so did not hear
Your voice saying goodbye.

Goodbye still, in your voice
Meaning: watch out, time is still.
And goodbye is no worse than a warning
That the months of winter steal.

I am standing with a Russian poet
And I hear him say: 'Keep watch,
You must not fall asleep, you are
Eternity's hostage in captivity

To time.' And his goodbye means
The captive's hour is coming soon.
But he too looks away at the bird
I thought a ptarmigan, insane

With fear as it flew straight up.
We forget his words of doom
And both look without expectation
For the eggs abandoned in the broom.

Boris Pasternak, Sergei Eisenstein, Lili Brik, and Vladimir Mayakovsky,
St Petersburg, 1924

FOUR

Zhivago to Denisovich

Boris Pasternak had by some quirk of Stalin avoided persecution during the great purge years of the 1930s. Paradoxically it may have been because he was *not* a party member, held no official position, lived quietly in the country, and was considered by the Kremlin as a harmless but fearless eccentric – in the old Russian tradition of the 'fool of God.' Being a harmless poet, however, did not save many others. I learned the truth about Pasternak and Stalin only years later from a woman who was a living legend of those times. But that comes later.

Isaiah Berlin met Pasternak briefly in 1945 and reported that he had already sketched out the main lines of *Dr Zhivago*, and he had great hopes of a renewal of Russian life as a result of the 'cleansing storm' that he thought the war had brought. This idea may appear bizarre to us, but I am sure that Pasternak, who lived in a curiously innocent fantasy world, believed as did many down-to-earth Russians, that their heroic defeat of the invaders would produce a different kind of communist Russia, purified by sacrifice.

The war, of course, had cleansed nothing. Inside the Soviet Union the cancer spread. And internationally, the cold war had begun almost as soon as the Allied victory was assured. Whatever wartime camaraderie still existed with their erstwhile allies was quickly scrapped by the Soviet leadership. A friendly relationship

with the capitalists was dangerous. The Soviet people were still not to be trusted, and were locked away in almost complete ignorance of the outside world for half a century.

In the case of Canada, relations with the Soviet Union deteriorated rapidly in the fall of 1945 as a result of the exposure by Igor Gouzenko, a cipher clerk in the Soviet embassy in Ottawa, of the extensive espionage network set up by Moscow to spy on their wartime friends and allies. In the absence of our ambassador because of the affair, I became a rather young chargé d'affaires.

Moscow in that winter of 1946–7 was a sad place, not so much from war damage (the rubble had long since been removed) but from the deprivations of almost every sort. Moscow and Leningrad were given preferential treatment, so it was not hard to imagine the ghastly situation in the countryside and remote towns, not to mention the labour camps (or gulags) in Siberia. But we could not know at first hand since permission to travel outside the immediate Moscow area and the old religious centre of Zagorsk was rarely, if ever, given. We caught only the occasional glimpse of reality: boxcars with wan faces at the barred windows, a column of prisoners. Their fate moved me to grim poetry.

ROADSIDE NEAR MOSCOW

Bent and heavy with rain,
Staggering in silence, profoundly
Occupied with the secret reconstruction
Of their balance, pine and tamarack
Trees, gathered in profane

Assembly to watch over the slow
Passing of the almost human-like
Column of prisoners, waiting for the snow
To fill in their tracks – strange
Judges of evil done

In many ways. Because I am not
Walking in chains, and am afraid
To look, lest by implication

Glance should be said guilty,
Unhappily turn my head

To the stale spectacle of the sun
Setting among the conifers.
And when it is gone, look down
For the column of men in vain –
In the thick arch of night

That has come suddenly,
Hobble my eyes to perceive
Nothing but the rain, turning
To snow – all that I wish to see.

The collapse in March 1947 of the final meeting in Moscow of the foreign ministers of the major wartime allied powers – Great Britain, France, the United States, and the Soviet Union – marked the final dissipation of any further pretence at allied friendship. This was hardly a surprise to most of the allied diplomats in Moscow but it helped contribute to the gloom that hung over the city. I recall the wife of an American diplomat telling me she was terrified of being in Moscow. She said she could not sleep thinking of all the millions of Russians 'out there. There are just so many of them.' I reminded her that in fact there were more Americans and Canadians than Russians. 'Yes,' she replied, 'but they are there, and I am here.'

Yet the Russians hung on with their centuries-old gift for survival. And the classical theatres, the opera, ballet, and the conservatory continued to produce what the system permitted: magnificent performances of the Russian classics, *Swan Lake, The Sleeping Beauty, Eugene Onegin, Khovanshchina*. But the productions seemed at times to be caricatures of nineteenth-century art. It was wonderful and stifling at the same time. 'If I ever wrote a book about the USSR,' Thereza remarked one night after yet another hoary old classic, 'I would entitle it, "I Hate Tchaikovsky"!'

In November I was transferred briefly to London, and then in 1949 to the External Affairs ministry in Ottawa. To my great surprise, in March of 1951 I was sent back to Moscow as chargé

d'affaires. The Korean war was raging. I didn't believe the Soviets would intervene in Korea and risk direct confrontation with the West, because even my short time in the country had been enough to convince me that the Soviet Union was in no condition, economically or socially, to risk another war.

It was strange returning to the embassy and moving into the spacious quarters of the ambassador. The entire Canadian staff was housed in a small compound. The ground floor consisted of small offices and two apartments, one for the first secretary and the other for the third secretary. The top floor was the ambassador's residence and representational rooms. A small garden provided us with some vegetables and at the rear were the garages and an old wooden house which was alleged to have survived the great fire of 1812. It was occupied by our military attaché, Brigadier General Jean Allard, one of the youngest and most decorated officers in the Canadian armed forces, and a tremendous asset to the embassy. He and his wife shared the house with a sergeant in our contingent.

For the Soviet people, the situation had marginally improved materially. But the political atmosphere was even worse. The country was in the grip of the final spasms of Stalinist madness. The story of the 'doctors' plot' against Stalin, and the preparations for a show trial, petrified the people and, as we discovered later, the communist leaders themselves. They were probably not readers of French history and the way in which that revolution consumed its own, but they were vividly aware that most of those still in the Kremlin were there because their predecessors had been shot in the 1930s.

The air was thick with terror, with the very smell of fear. Then, suddenly, they were saved. In March 1953, Stalin died.

If there was a great sigh of relief in the Kremlin, it was not apparent to the public. In fact there was a kind of mass disbelief that the leader had gone. Those who hated him, in secret, those who were true believers. Many failed to credit Stalin with all his crimes; in fact, all that was hidden from the mass of people until Khrushchev made it public.

To foreigners like myself, the most extraordinary sight was of thousands of people, openly weeping, and queuing in below-

freezing weather, to catch a glimpse of the corpse of the great leader, the Vozhd, lying in state. It was perhaps the archetypal scene of those deep contradictions in the Russian character: for many of these mourners, this must surely be a love-hate relationship of tremendous proportions. It was unfathomable.

The funeral and the laying of the body next to Lenin in the latter's mausoleum have been told too often to bear repetition here. But thirty years later, when I saw on television in rapid succession the funerals of Brezhnev, Andropov, and Chernenko, I could hardly believe that nothing, down to the last word and detail in the ceremonies, had been changed. Stagnation was truly the right word for the era of Brezhnev.

The changes after Stalin's death came slowly, but the relief and hope that the terror was over and that life might improve were as palpable as the fear that had preceded it. Then came the slow emergence of Nikita Khrushchev and his efforts to end the mindless terror, to empty the prison camps, and to extend a tentative hand towards the West. Contacts with foreigners became slightly less improbable, and travel restrictions were suddenly modified so we were able to make our first visits to Kiev, Kharkov, and Tbilisi.

The first hint of the cultural thaw came within a few weeks of the death of Stalin. The signal was an announcement in the Lomonosov University (Moscow State University) of a forthcoming lecture on modern Russian poetry, including the work of Sergei Yesenin, who had previously been proscribed. But on the announcement a bold hand had written in red pencil, 'And why not Blok?' Things were promising, but hardly rosy. Alexander Blok and many others were still forbidden.

In April 1954 the literary journal *Znamya* (*Banner*) brought out several poems by Boris Pasternak with a laconic statement that they were from a work in progress called *Dr Zhivago*. I immediately translated them. They were beautiful poems, reflecting the Russian landscape, love, the fragility of man – poems which he had written some time earlier but could never have published under Stalin. The appearance of the poems from *Dr Zhivago* gave some small hope that the novel itself and more poetry would be published. Stalin was dead. His hated chief of the secret police, Lavrenti Beria, had been executed.

Then in 1956 Khrushchev made his 'secret' speech revealing the extent of Stalin's crimes. It was the beginning of Khrushchev's campaign of reform, and a rejection of Stalin's worst excesses. And this was when *Zhivago* was finished – and immediately banned. As a result, over the passionate objections of his wife and friends, Pasternak sent *Zhivago* to an Italian communist publisher, Feltinelli. He knew the consequences for himself, and seemed indifferent to the probable effects on his family. His beautiful mistress Olga Ivinskaya, the model for Lara in *Zhivago*, had already served many years in a labour camp. Now she was arrested again but released shortly afterward.

Dr Zhivago was a deliberate defiance of the basic concepts of communist history, ideology – the whole system. The poetry could just pass because it was largely non-political, even if it did not conform to the laws of socialist realism. But *Zhivago* seemed to the Kremlin a declaration of war and it is hard to understand how Pasternak thought it could be accepted for publication in the Soviet Union.

In 1958 it was published in London, according to Pasternak without his permission, followed by his expulsion from the Union of Writers in October 1958. Under intense pressure from the KGB he refused the Nobel Prize, saying he preferred death to exile from Russia. The KGB obliged, hounding him until he succumbed to an early death in 1960. But the venom of Khrushchev followed him beyond the grave. Olga Ivinskaya was once again arrested, this time with her daughter, on an invented charge of embezzlement and sent back to Siberia.

Pasternak is, and will remain, a mystery. Was his apparent indifference to the very real chances of his arrest and execution feigned, or did it reflect a genuine innocence, or indifference? He appeared to put his art above his own fate and that of his loved ones.

And Akhmatova apparently did the same: her art was the ostensible excuse the authorities had for putting her son Lev in the gulag. What are we to make of the artist who puts his art above other lives? It is an anguished question.

I suppose from this distance we should be grateful that they put their art first, otherwise we would not have Akhmatova's beautiful poems, or Pasternak's novels, or so many other treasures

created at such cost. If Pasternak had suppressed *Zhivago* to save Olga, would it have been right? It is hard to believe that he was unaware of what would happen when he published *Zhivago* abroad. It puzzled my Russian literary friends, although in the end, they so admired his work, I think they would have sacrificed Olga to save it.

The line that truly marked the difference between Stalinism and the new era came in 1954 with the publication of Ilya Ehrenburg's *The Thaw*. This novel soon lent its name to the cultural phenomenon of the next few years – the extraordinary outburst of creativity in writing.

Ehrenburg was a talented poet and novelist who had managed to live with the regime, though skating close to the margin of safety. Alexander Tvardovsky, a good writer and poet, but noted primarily for his skilful and courageous work as editor of *Novyi Mir*, one of the leading literary monthly magazines, quickly moved to take advantage of the thaw by promoting young and talented writers who had never been published before, or whose work circulated only clandestinely.

Two of the first revelations of this hidden talent came straight out of the concentration camp. Vladimir Dudintsev's novel *Not By Bread Alone*, published in 1957, was a moral indictment of Stalinism, and immensely popular. But above all the first novel of Alexander Solzhenitsyn, *One Day in the Life of Ivan Denisovich*, was a revelation of conditions in the Siberian concentration camps. Solzhenitsyn, as a young officer in the Red Army, had fought with great distinction. An indiscreet letter had been enough to send him almost directly from the front to Siberia in 1945. He was released only after Khrushchev's decision in 1953 to pardon political prisoners accused of minor crimes against the state. But it was not until Khrushchev's 1956 speech denouncing Stalinism and revealing the existence of the huge prison population in Siberia that Solzhenitsyn was able to publish his short novel on one day in the life of a prisoner, a tale of immense power and in the great Russian literary tradition. Khrushchev obviously approved its publication because it served his political purposes at that time. But he certainly did not recognize the literary genius of Solzhenitsyn or realize his courage and tenacity.

Vasily Aksyonov's novel, *Ticket to the Stars*, was another startling

revelation of new talent. His mother, Evgenia Ginzburg, had just been released from years in the gulag which she described powerfully in one of the best accounts of that terrifying epoch, *Into the Whirlwind*. Older poets, such as Semion Kirsanov, Olga Bergoltz, Konstantin Simonov, and Tvardovsky himself, felt freer to write poetry of personal expression and emotion. In Leningrad, Viktor Sosnora, Joseph Brodsky, and others began to publish their work.

And at last Anna Akhmatova was permitted to live in Moscow. As a belated recognition of her unique place in modern Russian literature she was able to publish again some of her older work as well as marvellous new verse. But her sufferings were never referred to and she was presented as a great voice of the glorious Soviet society in the volumes published by the government.

Khrushchev's enthusiasm for cultural innovation diminished in the last years of his reign, especially after his efforts at rapprochement with the United States under President Eisenhower collapsed. Next came his foolish efforts to bully President Kennedy and the placing of missile bases in Cuba.

Original thinking and writing were necessary for the Khrushchev reforms and in a curious way both seemed to stimulate and disturb him. They certainly disturbed most of the party hacks, who did not like to see their tidy world of privilege and political and intellectual orthodoxy disturbed. The cultural ferment inspired and provoked by Khrushchev gradually declined, although it could not be completely suppressed, nor did he want it to be.

Khrushchev was a peasant with rudimentary education who, like Brezhnev, was catapulted into positions of power in the 1930s to replace so many of the old Bolsheviks killed by Stalin. But, unlike many of his generation, he had a gut feeling that led him to try in his clumsy way to open up the closed minds of his people. When he did so, he often failed to understand what many of the writers were saying and he tried half-heartedly to put the lid back on again. But compared with the era of Stalin, it was almost like a Renaissance.

Yuri Lyubimov (far right) with Andrei Voznesensky (on his left) and the cast of the Taganka production of *Look Out for Your Faces*

WHY

Andrei Voznesensky

Why do lampreys swim from Riga back
To Canadian shores, the land of their ancestors?
Why rename streets?
Build new ones, with new names.

People once lived in them and each was wonderful.
What if they come, remembering the Neva?
I will never forget you.
Or, rather, temporarily, as long as I live.

FIVE

Backstage

It was 25°C degrees under a brilliant sun with the slight haze of fine sand blowing out of the desert when we left Cairo in early January of 1964. It was minus 25°C on a long, dark winter night with a fine, hard snow heralding a blizzard when we arrived in Moscow.

We had left the Russian capital after Nikita Khrushchev had become the boss of the Communist Party and the government, ushering in the thaw. I was recalled to duty in Ottawa, then posted in the intervening years as ambassador to Colombia, Yugoslavia, and most recently, Egypt. Gamal Abdel Nasser and his Revolutionary Army colleagues there were still trying to forge a republic out of a nation pillaged by a corrupt monarchy. But since the 1956 Suez War, he had become embroiled in the relentless conflicts over Israel, Arab land, and the fate of the Palestinians. The pot was still simmering, waiting to boil over, in the hottest of all hot spots, the Middle East.

Now we were returning to what might be called the coldest of all hot spots. But the political atmosphere seemed to have risen a degree or so above freezing. The officials of the Foreign Ministry who welcomed Thereza and myself at the airport were not exactly unfriendly, as had been their wont, and I made it clear we were delighted to be back.

Back to the dowdy old embassy in Old Stables Lane in the

Arbat. The lovely cobblestone street had been paved over and the building had been painted a revolting battleship grey. Thereza's first task was to convince the ubiquitous UPDK, the organization intended to look after the diplomatic corps, to restore its traditional blue and white. She won this first of endless battles with this frustrating gang of bureaucrats.

The quarters and office space had been enlarged and modified somewhat, and a Canadian Club had been installed in the basement, where on Friday nights films and parties gave some limited relief to the staff and other Canadians, mainly the news correspondents. Jack Best of the Canadian Press, David Levy of the CBC, and the redoubtable Peter Worthington of the *Toronto Telegram* were habitués.

The staff now lived in several compounds which had been made available in the ramshackle new apartment buildings put up in recent years for foreigners. They were almost instant wrecks, but awful though they were, they were the envy of most Muscovites. The ubiquitous militiamen were still on guard before the embassy, and at the gates of foreign compounds. Surveillance by bugging devices and shadowing had, if anything, grown more sophisticated. A large part of the country was still out of bounds and travel even to 'open' cities could only be made after registering travel plans with the Foreign Ministry.

And yet the atmosphere had greatly changed for the better, both for most Russians and for the foreign community. In spite of the tiresome bureaucracy, there was a greater willingness on the part of Soviet officials to be at least polite in refusing our requests for better service.

Then came a more concrete indication of the thawing climate of these continuing Khrushchev years. The head of the Second European Department in the Ministry of Foreign Affairs invited Thereza and myself to the theatre, giving us the choice of Chekhov or a new production in the Taganka Theatre. Much as we liked Chekhov, we opted for what turned out to be a theatrical adaptation of American journalist John Reed's *Ten Days that Shook the World*, his eyewitness account of the Bolshevik Revolution of 1917.

For once the Russians were ahead of Hollywood. Warren Beatty

discovered Reed's story years later and produced an overblown and overbudget film called *Reds*, that couldn't decide if it was red or white or in between. The Moscow stage production was on more familiar territory. While the pro-communist propaganda was unappealing to us, the production by Yuri Lyubimov was original and exciting. By the standards of theatre in London, Paris, or New York, the innovations were hardly world-shattering. But for Moscow it was exhilarating. By a skilful transformation of Reed's book into an action-packed drama, Lyubimov had breathed life into it. Using posters from the actual revolution of 1917, and staging huge mob scenes, he had turned a stale theme into a revelation.

Yuri Lyubimov, who was then forty-seven, had abandoned a promising career as the director of one of the major theatres, the Vakhtangov, in 1963, to form a group of young actors frustrated at the endless stereotyped productions of the classic plays, or modern works carrying some kind of communist message the cultural czars considered 'correct.' *Ten Days that Shook the World* was very much a correct communist theme, which justified the censors approving it. What they did not like – and what made it popular – was Lyubimov's departure from the conventional type of production in the traditional theatres. It was new and different, and therefore must be subversive. That was the way the censors' minds worked.

Lillian Hellman, Arthur Miller, and Laurence Olivier, among others, had all expressed admiration for Lyubimov's productions of Brecht's *The Good Woman of Szechuan* and Gorky's *Mother*. In theory, both authors and plays were ideologically acceptable. But the touches of originality and the enthusiasm of the young actors brought them to life, and were immensely popular. They by-passed ideology, in a sense, to portray the characters as real people with real emotions, exactly what the regime feared the most. But because of the very popularity of these productions, Lyubimov aroused jealousy in the stodgy hierarchy that ran the traditional theatres, and suspicion in the Central Committee.

Going backstage, we were able to meet briefly with Lyubimov, a worried-looking man who seemed older than his years, but with the bright intelligent eyes of youth. We could not speak much in

the company of officialdom, but he expressed pleasure at meeting a foreigner who spoke Russian and was a poet into the bargain. He hoped we would come often. Without our official hosts, I added to myself.

Our two ministry companions had in fact been delighted at our choice of play because it was extremely difficult to get tickets for the performance, even for them. It seemed that they, as much as anyone, wanted to see this dangerous stuff. And they seemed equally happy to meet Lyubimov.

After the theatre these officials invited us to dinner at a Georgian restaurant called the Aragvi, popular with artists. Its cavernous room was jammed with people, most of them already tipsy with vodka and Georgian wine, and there was an atmosphere of ebullient good spirits rarely found in the usual gloomy and functional eating establishments of the city. There was even good food, an exotic departure from the norm, which came through an unofficial supply line from Tbilisi, to which the authorities turned a blind eye.

Under the influence of the Georgian orchestra, the food, and the festive atmosphere, our normally cautious hosts grew convivial, and I felt reckless.

'Since when has Canada become part of Europe?' I said to the senior officer, pulling his leg. It was just one more anomaly that the Canadian affairs were handled by one of the European sections at the ministry.

But he took it seriously, and grew sheepish, a novel display for a Soviet bureaucrat. 'It's been a terrible problem,' he confessed. 'We didn't want to lump you in with the United States, and we could hardly put you in the Latin American department. So Canada, Australia, New Zealand, and Ireland, with the United Kingdom, became the Second European department.'

I laughed at this typically Soviet invention. 'Only the Soviet Union seems to believe in the old white Commonwealth,' I replied.

He squirmed with embarrassment. 'Just an administrative arrangement,' he added lamely. That was the whole Soviet system: just an administrative arrangement. Flying in the face of all reality.

Turning to the arts, I suggested that this party would have been impossible even ten years ago, and that things had indeed changed. Now even Blok was published, Dostoyesvsky was back in favour, and, incredibly, Kafka appeared in translation. 'You've come a long way since the first timid steps in 1953,' I remarked. 'But I hope I'll see a lot more progress during this tour of duty in Russia.'

My hosts were non-committal. But I could see that they were well acquainted with Blok and his poetry, so I mused aloud. 'I wonder what would have happened to him if he had not died in 1921? Would he have committed suicide like Yesenin and Mayakovsky? Been sent to Siberia like Mandelshtam?'

There was an embarrassed silence, and we moved on to discuss repainting the embassy.

A few months later, Thereza and I returned to Lyubimov's theatre, without our keepers, to see the Brecht play. He apparently knew we were coming and sought us out to talk briefly in the grubby little cubby-hole that was his office. I was surprised at how openly he talked, particularly of the constant petty harassment to which he was subject.

'I am constantly under surveillance by spies,' he said matter-of-factly. 'They simply cannot understand why I abandoned one of the most prestigious jobs in the theatrical world to start a risky venture in this ramshackle old dump of a building. The praise I receive from abroad helps to protect me,' he went on, not with arrogance, but as a fact of life. 'Without that, they would close the Taganka.'

He sighed wearily. 'But at the same time, support from the West makes them suspicious that I have secret contacts abroad and that I'm somehow trying to corrupt the intelligentsia. Anyone intelligent has seen through them long ago. It's all a very bad joke.'

I agreed that it was hard to figure out how the distorted minds of the bureaucrats could consider *Mother* and *Ten Days that Shook the World* likely to corrupt.

'It's almost impossible for a foreigner to understand,' said Lyubimov, 'even someone like yourself who speaks Russian and has a feel for our culture.'

And that was the simple truth. Try as I might to penetrate to

the core of this Russian enigma, I came up against this dense fog of meaninglessness.

Lyubimov went on the push the limits of tolerance of the Ministry of Culture even further, above all by producing the plays of Andrei Voznesensky. Lyubimov had succeeded in departing from the rules by seeming to obey them, producing plays that were in principle ideologically sound, in practice truly revolutionary. It was like a game played backwards, something nonsensical out of Alice in Wonderland.

Before long, though, the climate of repression became more sinister again. A message came from Ed Stevens that Bella Ahkmadulina had been 'called out of town,' and the party to which she had invited us was off. I was disappointed, as her beauty and presence had haunted me as much as her poetry since that memorable party at the Stevens's rustic retreat. It was obvious that Bella was having difficulties. Later I learned that she was expelled from Moscow and was forced to stay in Tbilisi.

I was disturbed because this was a faint warning bell. Contacts between westerners and Soviet writers, or the lack of contacts, were a barometer of official policy. We could judge with some accuracy shifts in the party line when even the most daring shied away from any contact with us. Indeed, from the few fleeting and ambiguous talks I had with writers during that spring and summer of 1964, I had the impression of great uneasiness. Khrushchev had done wonders in opening the doors to new and unconventional writers, but his enthusiasm for artistic experimentation had definitely cooled.

At a party at the Romanian embassy, Semion Kirsanov said aloud to me what they were all thinking. 'I wonder just how hard we can press party tolerance,' he mused, then added, 'Look up Alexei Surkov's article in *Izvestiia*.'

The gist of this article was a vicious attack on the integrity of western writers, alleging that they were tools of imperialism who were trying to force Soviet writers into isolation in spite of all the efforts of the latter to establish 'amicable' relations with them. It did not seem to me particularly significant at first, except that Surkov was used as a hatchet-man of the Writers' Union to warn writers to toe that line.

But it was hard to tell where the line was. The second secretary of the embassy went on my behalf to the Writers' Union to try to get some books of Russian poetry I had been unable to find in a bookstore. They received her politely, but no books.

A few weeks later she was invited to a poetry reading where she met Vladimir Dudintsev, the author of *Not by Bread Alone*, one of the key books sponsored by Khrushchev in his campaign to reveal the truth about Stalin's crimes. Dudintsev was quite relaxed, and said one of the reasons there was some uneasiness in the literary community was that everyone was waiting to see who won the Lenin Prize. 'It would be a good omen if Solzhenitsyn got it,' said Dudintsev. He didn't, of course.

By now the heady days of Khrushchev's thaw were truly over. But no one anticipated the palace coup in October 1964 which overnight removed Khrushchev from all his positions, and turned him into a non-person. He remained in that limbo through the next regime, and in fact to all intents and purposes he still does. While Stalin, Brezhnev, Andropov, and even Chernenko all have their plaques on the Kremlin Wall behind Lenin's tomb, Khrushchev's body remains buried in an obscure corner of the Novodevichy Monastery.

Yet the reforms that came with Mikhail Gorbachev could never have taken place if Nikita Khrushchev had not had the courage, and the instinctive peasant intelligence, to introduce measures to destroy the Stalinist system of total repression and rule by terror.

Like most ordinary Russians, the intelligentsia reacted to the fall of Khrushchev with cautious optimism, as odd as that may sound. They had all appreciated what Khrushchev had done to liberalize the arts, but they also despised him as an ignorant *muzhik*, a peasant who used the writers primarily as a tool to destroy the Stalin myth without any real knowledge or appreciation of the artistic worth of their work.

So Khrushchev, too, was another example of Dostoyevskyan duality, two polarities in one skin. And once again, the reaction of the people was divided between fear and relief, admiration and scorn. The intellectuals were disturbed by his apparent slide back towards the accumulation of all power in his own hands, and by

his increasingly erratic and impulsive acts, in both foreign and internal affairs.

The new troika who took over had all been members of Khrushchev's team: Leonid Brezhnev as general secretary of the party, Anastas Mikoyan as chairman of the Presidium of the Supreme Soviet (president), and Alexei Kosygin as prime minister. They were a dour group. Comparing Moscow under their rule with the excitement of Khrushchev's impromptu performances, one of my staffers dubbed it simple 'Dullsville.'

The swift and secret way in which the all-powerful leader had been destroyed by his own people nevertheless created some apprehension and confusion in the artistic community. There was no early sign of which direction Brezhnev would take. In the first year of his reign there was little change. Everyone scanned and scrutinized the official press and magazines for those little nuances that signalled new policies. None had more to lose than the intellectuals if there were to be a retreat from the reforms of Khrushchev.

The official receptions I attended buzzed with cautious speculation, but no one seemed to know much about the new leadership, except for the general opinion that Brezhnev, while he looked and talked a bit less like a peasant than his predecessor, had a low regard for intellectuals and the arts. The appointment that caused foreboding, though, was that of the ascetic, fanatically doctrinaire Mikhail Suslov as the member of the Politburo and the party secretariat in charge of ideology.

Early in January 1965 Kyrill Kondrashin, director of the prestigious Moscow Philharmonic Orchestra, whom I had met a few months before, surprised me at an official reception by saying to me: 'Don't forget the past. Remember that it was Suslov who launched the campaign against "deviationists" in 1952. And you know how that could have ended if Stalin had not conveniently died.'

I nodded, chilled. Suslov's campaign had led to those 'revelations' of a plot by a number of Kremlin doctors, mostly Jewish, to poison Stalin.

'You were in Moscow then,' Kondrashin continued, 'so you know all about that. But maybe you don't know how terrified we

all were by Suslov's attack on so-called deviationists, and the arrest of the doctors. Being accused of trying to murder Stalin meant only one thing: show trial, and execution or Siberia.'

He was talking, I suddenly realized, about the threat not just to the doctors, but to himself and others like him. This man occupied one of the most important positions in the Soviet musical hierarchy, and appeared to be the embodiment of the conventional musician who always followed the party line.

'But we were lucky,' he finished, looking pale even at the thought of it all. 'Stalin died just in time.'

DON'T FRIGHTEN ME

Anna Akhmatova

Don't frighten me with a terrible fate
And the vast weariness of the north.
Today is my first anniversary with you,
And this holiday means – separation!
It doesn't matter if we do not meet the dawn,
If the moon does not linger over us.
Today I will shower you with gifts
Never seen in the world before:
Reflections of me in the water of an
Evening stream, dancing drunkenly,
A glance at the swooning stars which
Cannot halt their fall from heaven:
The echo of my exhausted voice,
Once so fresh and summer-like –
May they help you without pain to hear
The Moscow crows as they weave through the air;
May they turn the gloomy dampness of October
Into the sweetness of a day in May –
Oh, my angel, remember me, remember
When the first snowflakes begin to fall.

Lubyanka Prison, Moscow, from the courtyard

SIX

Don't Frighten Me

The dreary winter and spring of 1965–6 were darkened by the death of Anna Akhmatova. It seemed impossible, the end of someone so durable. But she had entered a clinic after a heart attack, and had died there, at the age of seventy-five. The news of her death spread quickly, a shock and a personal loss to almost all the artists of her country.

Akhmatova was a giant of Russian literature, but she could not be described, as giants often are, as towering over the rest. She was more like a guardian angel, hovering in limbo, lighting the gloom for others. One fellow poet described her as being like a stone that stuck in the middle of the stream of Soviet slush and garbage. While it could not stop the flow, it was there, solid and immovable, interrupting the flood. And when the stream of garbage stopped, it would still be there, that small immovable stone. She had been a living link to the Russian past, not just the Russia of the czars and St Petersburg, but the eternal Russia of the soul, full of passion and Slavic tragedy. She helped to keep human emotions alive in the sterile world of socialist realist automatons.

One of the major accomplishments of the thaw had been to reinstate her in the Union of Writers, to permit her to move from Leningrad to Moscow, and above all to publish again, new poems as well as a generous selection of her previous work.

But she was in poor health, never attended official functions, and avoided most foreigners. So it was impossible for me to meet this courageous woman. The only important western contact she had was with Robert Frost, and from what I picked up, it was a frustrating experience: two old and eminent poets sitting side by side with nothing to say to each other. Akhmatova, with her long life of tragedy, persecution, fear, hunger; Frost the successful, venerated poet, living a normal life of comfort in a continent of peace, buried in his own self-centred existence, and probably unable to understand what Akhmatova had gone through even if the barrier of language had not stood between them.

Now she was gone. But though her life flickered out, her light continued to flame.

It was a sad day for Russian poetry, mourned not only by the lovers of literature, but even by many who had denounced her in the press. Again, there was that Russian duality, the paradoxical contradictions in character and behaviour.

But Akhmatova's poetry is a testimony to the Russian poetic genius. Like the offerings of so many of the great Russian poets who led tragic lives, were harassed, persecuted, exiled, imprisoned, killed, Akhmatova's poetry is a monument for us in the West. It is hard to imagine how poets like Tsvetayeva and Akhmatova could produce tender, exquisite verse in this nightmare. No western poet of modern times, except perhaps Garcia Lorca, is comparable. Our problems, our struggles, have been mostly personal or financial, our most potent enemy public indifference. Poetry has become a marginal activity in western societies. For Russians it has always been part and parcel of every educated person's life. And I am sure they know a poem like 'Don't Frighten Me' by heart, and read into it their own experiences. Anna Andreyevna Akhmatova was their voice, their catharsis, and their memorial.

During that hard winter of 1965 and 1966, the fragile intellectual thaw started to freeze over again. I had gloomy news for Thereza one night after a long and depressing day. 'They've arrested Sinyavsky and Daniel,' I told her, and she stared at me with the shock that everyone felt at this grim development.

Yuli Daniel and the novelist Andrei Sinyavsky were charged with anti-Soviet activities for having published in the West, without permission of the authorities. The powers-that-be were particularly angry at Sinyavsky for having published a short novel under the Jewish pseudonym 'Abraham Tertz,' even though he was 'pure Russian.'

Daniel, on the other hand, came from a Jewish family of intellectuals. I thought him the better writer of the two, though neither of their works published abroad seemed to me either subversive or, as far as that goes, particularly distinguished. Daniel, although only sixteen when the Germans invaded the Soviet Union, served with valour in the war, and was badly wounded. He started writing poetry during the thaw, and achieved immediate success. He then turned to short stories, some of which were smuggled to the West and published under the pseudonym 'Nikolai Arzhak.'

At the end of their so-called trial on 31 March 1966 they were both found guilty. Sinyavsky was sentenced to seven years' hard labour in Siberia. Daniel got five. Sinyavsky's term was later commuted in the face of widespread protest in the West. He was eventually permitted to 'emigrate' and settled in France. Daniel served his penalty in full.

These brutal punishments had a depressing effect on the intellectuals, who had been briefly buoyed up by the release of Joseph Brodsky. Brodsky had been arrested for 'parasitism,' meaning he had no visible source of income. He had been expelled from the Union of Writers, and survived only with the generosity of friends in Leningrad and abroad. Found guilty, he was banished to the gulag. But the reaction by both Russian intellectuals and the public abroad was so strong that he was released after a year of hard labour.

When I ran into Yevtushenko at a social function, he confirmed the gloom amongst the writers. I asked him why on earth Sinyavsky had chosen a Jewish-sounding pseudonym. It occurred to me that it might have been part of his deliberate defiance of the authorities. But Yevtushenko thought this was a romantic theory. Sinyavsky believed the choice of pseudonym would actually help conceal the real identity of the author. However, since Daniel was

Jewish, and so was Brodsky, he was pretty sure there was going to be an increase in anti-semitism.

Stalinism carried with it a full measure of classic anti-semitism, nothing new on Russian soil. Czarist regimes had unleashed their forces in periodic savage pogroms in the Jewish quarters of their cities, both to give vent to this ancient prejudice and to distract the population from the pressing social ills that threatened royal power.

The Soviet regime was more democratic: it persecuted all manifestation of religion, in particular Roman Catholicism and Judaism. These represented not just doctrines to rival Marxism, they were international organizations with massive political power. Those power centres could not be allowed to exist within the Soviet Union any more than a branch office of the CIA could set up shop with a sign on the Arbat (the covert presence of spies in the American embassy notwithstanding).

The Soviets prided themselves on repressing religious observance, and on actually assimilating people of these faiths into the Marxist fold. Many of the hardliners of the old school truly believed they had eliminated religion as a relic of the past, a medieval curiosity like the Ptolemaic universe.

They were partly encouraged in this delusion by the fact that a number of prominent members of the Communist Party, and many of the intellectual and cultural elite, were Jewish. But ironically, at the same time the party continued to make the social rules so distinctive and discriminatory for Jews that this 'assimilation' was an impossibility. Officially, all Jews were to be considered Russians, and those who toed the party line at first seemed accepted. But this was not acceptance of Jews, only of those who purportedly rejected their own Jewishness.

The climate changed for the worse with the establishment of the Israeli embassy in 1948, which was tangible evidence for Russian Jews that Zion existed, and it reinforced in even the most assimilated the powerful pull of their Jewish roots. In 1966 diplomatic relations still existed between Moscow and Tel Aviv (after the brief rupture caused by Israel's war with Egypt in 1956), and it became more and more difficult for Jewish citizens to prove they were 'Russian,' for the purposes of everything from employ-

ment to housing. There were no pogroms, but the effect was just as devastating.

The stirring of interest in Israel by Soviet Jews disturbed the Soviets, and the Israeli embassy was the subject of even greater surveillance than most of the diplomatic missions. Hence we were surprised in April 1966 to be invited by the Israeli ambassador to a dinner in honour of the writer Konstantin Simonov, who was of Jewish origin, on the eve of his departure on a tour of Israel as the guest of the Israeli Union of Writers. I was surprised because Simonov was considered an example of the assimilated Jew, one who was Soviet first, Jewish last, or not at all. He was an extremely popular novelist, poet, and playwright, whose work largely conformed to orthodox standards, but surpassed these restrictions because of this talent.

Simonov was born in Petrograd in 1915 and was trained as a metallurgist, but started writing part-time in 1934. By 1938 he was a full-time journalist and in this capacity covered the battle of Stalingrad. After the war he turned to writing novels, mainly on wartime themes. But his real war diaries were banned because they contained criticism of political and military errors. When Khrushchev launched the thaw in 1954, Simonov became editor of *Novyi Mir*, but was replaced in 1958 for having published Dudintsev's novel *Not by Bread Alone.*

Although he had not produced anything of great interest in recent years, I was happy to have a chance to have a long conversation with him. Although he was my age then, fifty-one, he looked very much older, which is hardly surprising, as was the case of most Russians who went through the ordeals of the war and Stalinism. He could not speak English, but said he was able to read French.

I told Simonov one of the plays I had seen in Moscow on my first arrival in 1964 was his *Russkii Vopros* (*The Russian Question*), a drama about the emerging cold war, very critical of the American leadership. It was a first-class play but I had objected then, and probably still would, to the propaganda content.

'You may have interpreted it that way,' he responded, 'but it simply treats factually a contemporary subject, the beginning of the cold war in the United States. And,' he went on without a

pause, 'American behaviour later in Vietnam proved I was just ahead of my time and justifies any anti-American sentiment in the play.' He said he had just come from a meeting which was part of the Solidarity with Vietnam Week and he proceeded to launch into a long and eloquent denunciation of American actions in Vietnam. It was almost impossible to check this diatribe.

When there was a chance I got him off this subject and asked him about his own work. I said I had admired his wartime poetry, particularly 'Wait for Me,' one of the most popular poems of the war, which he had composed during the battle of Stalingrad. He shrugged this off as a useful exercise and said he had almost stopped writing poetry 'or almost anything else – too many committee meetings, too much bureaucracy.'

He asked me if I had liked *The Living and the Dead*, his novel about the war published in 1956. 'It was too late then, really, to write a war novel,' he explained, 'but I had to put the record straight on some things.' I had only seen the film version, which was impressive. It was a pretty frank account of the mistakes of the leadership, as well as the heroism of the Soviet soldiers.

When the subject of Sinyavsky and Daniel came up, he announced his belief that they were anti-Russian. 'But if I had been in charge I would simply have exiled them, if they preferred the outside world to Russia,' he stated pompously. This was a pretty shocking remark from a guest of the Israelis. Subsequent efforts to establish his attitude towards the existing intellectual climate proved totally fruitless. Maybe he was, after all, an assimilated Jew, I thought.

PORTRAIT OF PLISETSKAYA

(Extracts)

Andrei Voznesensky

In her very name is a ripple of applause.
It rhymes with weeping larches,
with Persian lilac,
The Champs Elysées, Advent.
There are temperatures, geographic and magnetic poles.
Plisetskaya is the pole of magic.
She twists her audience into the furious cyclone of her thirty-two
fouettés, with her spirit charms, whirls, never lets go.
There are ballerinas of silence, snow-flake ballerinas –
they fade away. She is like a spark from hell.
If she perishes, she will scorch half the planet!
Even her silence is a furious, shouting silence
of expectation, an active and strained silence
between lightning and the thunder-clap.
Plisetskaya is the Tsvetaeva of ballet.
Her rhythm is tight, explosive.

...

Every gesture of Plisetskaya is an ecstatic cry, a dance-question,
an angry reproach:
'What am I to do?'
What is to be done with this 'weightlessness in
the world of weights?'

She was born to be weightless.

...

'A genius of pure beauty,' in the tense and bustling world.
Beauty purifies the world.
Hence her world-wide fame.

Paris, London, New York lined up for beauty, for tickets to see Plisetskaya. As usual, the world is stunned by an artist who has stunned her own country.

...

Her silhouette resembles an ancient Egyptian painting.
And her name is as short as the name of a girl of our times, in tights, and as thunderous as the name of a goddess or a pagan priestess – Maya.

Maya Plisetskaya dances Fokine's 'Dying Swan,' April 1979

SEVEN

The Dying Swan

The ballet is the perfect metaphor of the Russian paradox and enigma: how can a people capable of achieving the most sublime beauty of the classical ballet be capable of suffocating it to near-death? The life of one brilliant dancer embodies this tragic duality more than any other: Maya Plisetskaya. Even her name, wrote Andrei Voznesensky, is a ripple of applause, and her presence 'combined spirit charms with a spark from hell.'

Thereza and I came to know Maya Plisetskaya as well as was possible in those Brezhnevian years. Tall, beautiful, athletic, whenever she appeared on stage she exuded a unique energy. The first time I saw her dance was like an electric shock. To be with her was to feel in the presence of a super-charged being who ignited her surroundings when she entered a room. She was like a thoroughbred racehorse straining at some imagined bit. Or perhaps not so imaginary. At one of our receptions, Maya was outspoken about the surveillance she was subjected to, worse when they travelled abroad.

'They think I'm going to defect,' she said with disgust. 'They have never got over the Nureyev affair. After all, he is the best male dancer in the world, and it was a terrible loss. It was a loss for Russian ballet, but for the *apparatchiki* all it meant was a blow to the prestige of the regime. And they get furious every time they think of all the money he is making out there.'

Even after Khrushchev let some light shine into the cultural world, ballet and opera remained under the control of die-hard Stalinists in the Ministry of Culture, and especially in Gosconcert. Gosconcert was the branch of the Ministry of Culture that controlled all foreign expeditions by Soviet artists and the few appearances by outsiders in the Soviet Union, all under the guise of cultural exchange. The real purpose of Gosconcert was to squeeze as much foreign currency as possible out of the visits of Soviet artists abroad, very little of which ever went to the artists themselves. Gosconcert also vetted them politically, making sure they did not behave in an anti-socialist way when overseas.

Above all, its job was to prevent defections. When foreign artists came to the Soviet Union, Gosconcert sought to pay little or nothing in foreign currency, to control the programs, and to limit contacts with Soviet counterparts. It was the epitome of soul-destroying Soviet bureaucracy. To come up against its officious and vicious rationales, its hypocritical ideology, and its arbitrary, illogical tyranny, was to live in a Kafkaesque nightmare.

Late in the fall of 1967 Nicholas Koudriavtsev, the Montreal impresario, came to see me with a problem he was having with Gosconcert. 'They will drive me mad!' he wailed in despair.

Koudriavtsev was a delightful character in his late sixties, of Russian origin, grossly overweight, sporting a distinguished white mustache and goatee. The Soviet officials neither liked nor trusted him, but he was the indispensable agent to do business in Canada. They pushed every bargain to the limits of tolerance but somehow both sides agreed reluctantly on terms, the Soviets muttering that Koudriavtsev was making millions out of them, whereas in fact he barely made a decent living, and suffered from ulcers brought on by the wear and tear of bargaining with them.

He was in Moscow this time to arrange appearances by members of the Bolshoi Ballet in Toronto's Maple Leaf Gardens. Straightforward enough, surely. But when I saw his melancholy face, I knew something had gone very wrong. Even so, and with my knowledge of the system, I was not prepared for his tale of woe, such a ludicrous illustration of the idiotic Soviet bureaucracy, it was almost funny.

The main attraction was to be Maya Plisetskaya, dancing a new

ballet, *Carmen*. The idea of adapting the Bizet opera originated with Maya in collaboration with the Cuban choreographer, Alberto Alonso, and his sister-in-law, Cuba's prima ballerina, Alicia Alonso. It was Alicia's dancing, and Maya's insistence, that convinced her husband, Rodion Shchedrin, to adapt Bizet's music to suit the needs of ballet. Alicia danced the role of Carmen for the National Ballet of Cuba, and it was an enormous success.

Koudriavtsev was bringing the Russian troupe to Maple Leaf Gardens and commenced a major advertising campaign stressing the role of Plisetskaya, at that time certainly the most dynamic and stunning ballerina in the world. All the details of the program had been painstakingly worked out at long distance. But when Koudriavtsev arrived in Moscow to sign the official contract, he was told that the minister of culture, Yekaterina Furtseva, had finally got around to seeing *Carmen* and had decided that it should not be shown in Canada.

I had known Yekaterina Furtseva since my return in 1964, when she was a member of the Politburo (then called the Presidium), the only woman who had ever reached such political eminence in the Soviet Union. In 1961 she became minister of culture, with an automatic seat in the Supreme Soviet. But this was a demotion from the Presidium. That same year she had a falling out with Khrushchev, and it is known that she slit her wrists in an unsuccessful suicide attempt. When Khrushchev was finally ousted in October 1964, there were many who wanted to dispense with Furtseva, along with other old Khrushchev allies. But she was wily enough to hang on to power.

I always had bad relations with Furtseva. With me she never departed from the official dogma, and in view of her political vulnerability, she was probably tougher than necessary on many issues. At the same time, I learned later, she did stand up to her awful peers to protect and help some of Russia's greatest artists: the pianist Sviatoslav Richter apparently owed his freedom to travel to her, and she stood up for his young protégé Andrei Gavrilov when the latter was seriously threatened on trump-up charges by the KGB.

In another place and another time, she might have been attractive, but by 1967 she was well into her fifties and the ravages of

surviving in the Soviet system had left their traces. Ghastly peroxide hair, groomed by one of the elite beauticians of the Kremlin, did not help much. When she was demoted from the Presidium, bitterness and perhaps fear had etched further lines in her face along with the scars on her wrists. She was a difficult woman to deal with, and her 'culture' did not run deep.

Koudriavtsev was furious at her rejection of *Carmen*. Mrs Furtseva was adamant. She was vague as to her objections, but apparently they were based largely on the attention given to Plisetskaya herself and her costumes, which were very abbreviated and erotic. This had shocked the prudes in the party. Koudriavtsev said that the show could go on without *Carmen*, but not without Plisetskaya. The whole thing would be a flop, since the advertising campaign had been based largely on her appearance.

He went off to Vienna on other arrangements, in a fury. Two weeks later he was telephoned in Vienna by Mrs Boutrava, of the Ministry of Culture, to ask him to return urgently to Moscow for 'an important meeting with Mrs Furtseva.' Rather reluctantly he did so and found himself participating in a non-stop seven-hour meeting with Furtseva, Boutrava, Plisetskaya and her husband Shchedrin, the composer, and two or three officials of the Ministry of Culture and Gosconcert.

The proceedings consisted largely of a running battle between Plisetskaya and Furtseva. Two more different women would be hard to imagine.

Furtseva pointed at Shchedrin and proclaimed him a thief for pretending that *Carmen* was his own work. 'Everybody knows it was written by a French composer, Bizet,' she exclaimed in triumph. Furtseva was partly right. The music is Bizet but very dramatically rearranged by Shchedrin for forty-seven percussion instruments and strings. But there was a lot more to it than that. In addition to her fear of doing something ideologically wrong, Furtseva was wildly jealous of the younger woman and her worldwide popularity. As if that weren't enough, Rodion Shchedrin was a very handsome and attractive man.

Plisetskaya sprang to the defence of her husband. 'You will withdraw your remarks, Madame,' she said imperiously, 'or I will never dance again – either abroad or in the Soviet Union!'

Furtseva returned her a withering look. 'That is fine as far as I am concerned, Madame,' she hissed, 'since you are too old to dance anyway, and are on the way down!'

They faced each other in a perfect fury, the lithe dancer and the weathered bureaucrat. Almost oblivious of the rest, they carried on trading insults, screams, and invective.

The unfortunate end of this tale was that Furtseva got her way and *Carmen* was removed from the program. Plisetskaya, however, had her revenge. She claimed that her husband had been insulted and thenceforth would not dance in anything else except a ballet written by him. It was a great loss to Soviet cultural prestige.

In place of Plisetskaya and *Carmen*, Gosconcert substituted the second act of *Don Quixote* with Yekaterina Maximova. Koudriavtsev warned Furtseva that this would be commercially disastrous. It was not that Maximova was not a brilliant dancer herself, but Plisetskaya's named evoked magic, and it was her the audience was expecting. Koudriavtsev had a kind of wry satisfaction in sitting with Furtseva at the premiere in Maple Leaf Gardens before a mere twenty-five hundred spectators – instead of the six thousand he claimed he could have put there to see Plisetskaya. Oddly, it was with a pang of sadness that I heard a few years later, in 1974, that Furtseva had died, possibly in a successful suicide.

Eventually I saw *Carmen* at the Bolshoi. For me, it was the only good modern ballet in the Bolshoi repertoire, but presumably it was too advanced for Furtseva. It was given a tumultuous welcome by an audience that included practically all the social and intellectual elite of Moscow.

Our circle of acquaintances in the world of dance was extended some time later to that of folk dancing. Igor Moiseyev and the famous folk ensemble he directed were scheduled to make a five-week tour of Canada. We seized the opportunity to give a dinner at the embassy for the entire group, to which we added officials from the Ministry of Culture, Nicholas Koudriavtsev, who had organized this tour as well, and at the latter's request, his American counterpart Sol Hurok, who was in Moscow negotiating the details of a tour of the United States that was to follow the Canadian tour.

Moiseyev throughout the evening was ebullient, delighted with the forthcoming tour. He knew enough about Canada to appreciate the enormous distances to be covered, and looked forward to our February weather. 'We'll be right at home,' he joked.

I often found this sense of something shared between us Canadians and the Russians, like a common childhood, almost a secret treasure, that background of northern spaces. Just as I felt oddly at home in their tundra, they seemed to feel I was a kindred spirit of some sort.

Moiseyev was a steady dollar earner for the Soviet Union and seemed to have considerable freedom of action. He told me he was quite free to work out any kind of repertoire he liked, within certain ideological limits. It was quite clear that this was an art form which created no real ideological problem for the Soviet authorities. And foreign audiences lapped it up.

During the course of the evening I had a long talk with Mrs Boutrava, who was in charge of the Canadian-American section of the Ministry of Culture. I was to have a great deal to do with her in the coming years. She was blonde, blue-eyed, sturdy though not unattractive, and cultured. While the senior officials of the ministry seemed almost desperate in their efforts to project and protect the ideology, Boutrava always gave the impression she was doing a slightly distasteful task.

She remarked on the great dissimilarity between the style and repertoires of the various Moscow theatres; not, I might add, something very apparent to me. At any rate, I said I supposed this would now be changed in the light of a recent editorial in *Pravda* calling on Soviet writers to produce real Soviet heroes according to a pattern laid down by the party. Boutrava looked at me rather startled and then said, 'Oh, Mr Ambassador, you aren't serious are you? You know we have been talking about the standardized Soviet hero for the last thirty years.'

A short time later, to our astonishment, the Foreign Ministry of the Russian Republic invited Thereza and me, together with two or three other heads of mission, to a party. (This 'Foreign Ministry' and the so-called republics that formed the Union of Soviet Socialist Republics were a bit of a joke, because of course

Andrei Gromyko was the only real foreign minister, that of the Soviet Union and the Kremlin.)

It started with a reception and conventional kind of concert in one of the foreign mansions used by the government to entertain foreign guests. But that was followed by dinner in a private dining room of the Praga restaurant, together with a number of Soviet artists. The Praga was the most elegant restaurant in Moscow, situated in the large square that led to Red Square. A lugubrious, cavernous place that housed several distinct restaurants, it was modelled on European art deco palaces, and had been preserved, like the Astoria in Leningrad, more or less as it had been before the Revolution. It was reserved for government and party officials, and it was considered a privilege to dine there. With its separate rooms for smaller groups as well, it was to become a favourite of the post-Gorbachev, newly rich mafia barons.

Igor Petrov, the main basso of the Bolshoi Opera, and Maria Arkhipova, one of its leading sopranos, whom I had seen only once in performance, acted as though still onstage. They ignored us. More approachable were two of the younger stars of the Bolshoi Ballet: Vladimir Vasiliev and his wife, Yekaterina Maximova, already the third ballerina of the Bolshoi.

Vasiliev was in his mid-twenties, short, powerfully built, blond, charming, indeed an extremely attractive personality. When he seemed disposed to talk, I asked him whom he considered the best contemporary male dancer. 'Rudolf Nureyev,' he shot back immediately.

I agreed. His defection in 1961 had been an enormous loss to Soviet dancing, and I went on to recount how he had amazed western ballet enthusiasts in both classic and experimental works. I described some of the dances in which he starred, but Vasiliev grew impatient. He knew all that.

Maximova, a slight, ethereal young woman, appeared timid and retiring, perhaps a bit apprehensive at her husband's remarks to a foreigner. She had been the favourite pupil of the great prima ballerina Galina Ulanova, who had coached her in the role of Juliet in Prokofiev's wonderful ballet of *Romeo and Juliet*. Watching Maximova dance this role, I had an eerie feeling of déjà vu, it was so evocative of Ulanova ten or fifteen years before.

It was frustrating sometimes to live in the heart of Russia and appreciate its real cultural depths as I did, knowing that many of my own countrymen had such stereotypical, two-dimensional images of Russian culture: cliché milkmaids and young men in Cossack boots, all leaping joyfully about, ecstatic about tractors.

From afar, the Soviet Union was a vast backward place with fat ladies in babushkas, bearlike men drunk on vodka, party bosses, and faucets that didn't work. That is what communism had managed to do to the foreign image of the great nation of Tolstoy in only one generation. Television viewers in North America laughed knowingly at a Wendy's hamburger ad that featured a Soviet fashion show: 'First, evening wear!' (fat cleaning leady in shapeless dress and babushka); 'Next, beachwear!' (fat cleaning lady in shapeless dress and babushka with beach ball). Actually, it was very clever, and it was hard not to laugh at it. Until the Gorbachev revolution made it irrelevant.

For those audiences, Soviet culture *was* the dancing milkmaids. The Bolshoi was an aberration, kept alive only for propaganda purposes; for many of the dancers, it was a dead thing, a stultifying museum. But the aberration was the milkmaids, the epitome of socialist realism, which took a genuine Russian tradition and bent it to political ends. The Bolshoi was truer to one of the most sophisticated traditions of Russian culture, the sublime classicism that brought us Nijinsky and Pavlova.

In less than forty years, the communist machine had erased that earlier image of Russia, the image that my father's generation had grown up with. For them, Russia was virtually part of Europe, with a monarchy linked by blood relations with the throne of England, even though the czars were still more like oriental despots. Now they had the despots, but the links to European tradition were being destroyed, ironically, because of slavish preservation of that tradition. And, like the Bolshoi, Plisetskaya and her fellow artists were stranded on small icebound islands of the old European art.

When we had visited Leningrad not long before, we had made a sentimental return to the Kirov Theatre. It was as beautiful as we had remembered. The production was, inevitably, *Swan Lake,* and the male lead was danced by Mariis Liepa, whom we had

previously met in Moscow. He noted us in the front row during one of his bows after a particularly spectacular scene, and the grimace on his face showed painfully his boredom with the endless repetitions of the classic.

When I had a chance to talk with him at a later party in Moscow, he expressed intense frustration. 'It's becoming a heavy burden to have to keep month after month doing the same stale things! I understand why dancers like Nureyev, Makarova, Baryshnikov defected. It wasn't for money,' he went on quickly, 'though everybody knows they got fortunes. It is this stifling atmosphere and the boredom, boredom, boredom!'

This lament was to be the heart of a film called *White Nights* made by Baryshnikov in the United States, with the great American jazz and tap dancer Gregory Hines. It was the story of a Russian dancer and defector to the United States, played by Baryshnikov. While he is en route to an engagement in Japan, his plane crashes in Russia and he finds himself once more in the hands of the Soviet police. Hines is a black American communist sympathizer bitter over continued discrimination against blacks in the States, even after their tremendous service in Vietnam. He had defected to the Soviet Union. They meet and change each other's lives.

A powerful central scene has Baryshnikov pleading with his former leading partner, a prima ballerina at the Bolshoi, to escape with him, to leave behind the socialist claptrap that atrophies their art, to admit it is all a horrible sham. To many westerners, this seemed like the most bald-faced anti-Soviet propaganda. To dancers like Mariis Liepa, entombed in the boredom of Bolshevik ballet, it was bitter reality.

Maya Plisetskaya was able eventually to go with the Bolshoi on a different tour of Canada and the United States, and I invited the leading members of the ballet company to a dinner party at the embassy. To my astonishment they almost all came: the four leading ballerinas, Plisetskaya, Maximova, Bessmertova, and Timofeyeva; the leading male dancers, Vasiliev, Lavrovsky, Fadeyev, Liepa, and Tikhonov; the leading choreographer, Yuri Grigorovich, and many others.

I was even more surprised since in the afternoon I learned that

Brezhnev had decided at the last minute to give a concert for the foreign guests (representatives of other communist parties) at the Soviet Communist Party Congress, and summoned the best of the Bolshoi to appear. Plisetskaya and Vasiliev danced at 6 p.m. and nevertheless came on to our party, directly from the Kremlin. Vasiliev described it as a 'royal command performance.'

Most of those present seemed extremely excited at the forthcoming tour, even the more blasé. They all talked quite openly about their prospective purchases – for the women top-quality western furs, for the men tape recorders and various gadgets. They were proud of the fact that they would be the last company to perform in the old Metropolitan Opera building in New York.

The dancers spoke with remarkably open cynicism about the controls imposed on them by the bureaucrats of the Ministry of Culture. Mariis Liepa, whose boredom had been so evident at the Kirov, was still frustrated and chafing. But they spoke with equal pride of their art and the century-old contributions of Russia to ballet.

I asked Maya who was the greatest ballerina – after her, I added diplomatically. 'Margot Fonteyn,' she replied without hesitation, 'and the best choreographer is Jerome Robbins.' She mused wistfully about how wonderful it would be if they would just let the Bolshoi produce one of Robbins's ballets.

Fadeyev gave a faint look of displeasure. He was known to be the watchdog of the group, and he sharply gave the word to depart at 11:30 p.m. Everyone rose at once, including Plisetskaya, who was now deep in conversation with me, and they trooped obediently out.

THREE OCTETS

Osip Mandelshtam

1
I'm coming, coming out of space
Into the forgotten garden of value,
And with the consciousness of reason,
Tear up imaginary constancy.

Alone I read, without people,
Your textbook – infinity –
Savage, leafless medical book,
Manual for enormous roots.

2
The hard crust of nature breaks,
The hard blue eye penetrates its law,
The ores play happily in earth's crust,
And like ore, a hymn breaks from my chest.

Deaf, weak solitary seeks,
As if by the road bent into horn,
To understand all outer space,
Profusion, the petal's voice and the rim of sky.

3
The Tartars, the Uzbeks and the Nentsi,
And the whole Ukrainian nation,
And even the Volga Germans
Expect interpreters now.

And perhaps, at this very moment,
Some Japanese is translating
Me into Turkish, penetrating
Into my very soul.

Igor Moiseyev and Thereza Ford, no date

EIGHT

Sonatas and Political Notes

Dimitri Shostakovich's fascinating opera *Lady Macbeth of Mtsensk* was forbidden in 1936 and only reappeared in the Khrushchev era as *Ekaterina Ismailova*. The prohibitions of socialist realism were applied even to music.

Russia has produced some of the greatest composers of the first half of the twentieth century: Scriabin, Stravinsky, Rachmaninov, Prokofiev, and Shostakovich. Stravinsky, Rachmaninov, and Prokofiev all left Russia but Prokofiev returned in 1934, probably under false inducements by the Soviets. He was not denounced or silenced because of the immense popularity of his music for Eisenstein's film *Alexander Nevsky*, the ballets *Cinderella* and *Romeo and Juliet*, and his opera *War and Peace* – all, of course, safe subjects. No memorable orchestral music came from him after his return to the Soviet Union. He died the day before Stalin in March 1953.

As for Shostakovich, one of the greatest composers of his time, his music was banned, but once or twice I saw him at the Moscow Philharmonic concerts, in the box at the left of the stage, peering nervously around the curtain. He was a slight, timid, introverted person. What he suffered from the constant threat of persecution, and even more by the refusal of permission to perform his works, is hard to imagine. If Beethoven suffered from deafness, Shostakovich suffered from enforced silence.

When we arrived at the Tchaikovsky Hall one evening in 1965, Kyrill Kondrashin, the director of the Moscow Philharmonic, met us at the entrance, full of the unexpected personal warmth that made life in this cold political climate bearable. We had met Kyrill in the early years, and had established a friendly relationship.

'Welcome, welcome,' he said, ushering us towards the performers' entrance. 'Here, I have made arrangements for you to use the elevator.' The main staircase was magnificent, but very long. For me, with my bad leg, the offer of an elevator was a godsend, and the kind of sudden human touch that reconciled me to the Russians, if not the system.

In true Soviet fashion, the elevator had been built to stop at landings *between* floors. There had to be that touch of inefficiency. There seemed no logical reason why the elevator hadn't been constructed to stop at each floor, but I had long since given up trying to figure out such things. There seemed to be some perverse quirk in the Russian mind, so that even the design of an elevator could not be a simple, straightforward affair. It looked like another application of Thereza's theory that they did not believe in the principle of straight lines. However, climbing half a floor was better that the whole vast marble staircase.

Since our first years in Moscow we had been regular visitors to Tchaikovsky Hall. Although the concerts were predictably conservative, the performers were among the world's best: Sviatoslav Richter and Emil Gilels, magnificent pianists, violinists David and Igor Oistrakh, cellist Mstislav Rostropovich, the Barshai Chamber Orchestra, and on and on. So we were delighted when Zubin Mehta, then director of the Montreal Symphony Orchestra, was invited by the Ministry of Culture to direct the Moscow Philharmonic in two concerts in 1964.

Zubin Mehta was, of course, an Indian but also a Parsee, that extraordinary religion originating in Persia as a worship of Zoroaster. Like the Jews from other countries, they were forced to emigrate centuries earlier and many settled in Karachi and Bombay, forming an influential diaspora. Mehta was just beginning his career as a conductor. His talent and charm helped to turn the Montreal Symphony into a major orchestra, and he went

on to become one of the leading conductors of our time. (In due course he became director of the Israeli Symphony, and I often wondered whether in fact as a Parsee he felt some distant affinity with the Jews.) But when he came to Moscow he was hardly known.

Everyone, I believe, was slightly apprehensive about how this Indian conductor of a relatively minor orchestra would be able to handle the formidable Moscow Philharmonic in a concert of western classics. Kondrashan was clearly nervous. Mehta won them all over. The audience, the members of the orchestra, even Rostropovich, who was also present, acclaimed the performance, and gathered round to congratulate their conductor.

After finally breaking away from the musicians we all set off for the Aragvi Restaurant, with Mehta still in white tie and tails. We had proposed a reception at the embassy, but he had asked for something Russian and informal, so together with the Swiss ambassador and his wife we agreed on this Georgian restaurant, which would give him all the atmosphere he wanted.

The huge hall was filled with jolly babble and the strains of the Georgian orchestra. Mehta was happy with his concert, and equally happy to relax in a truly Muscovite atmosphere. The Swiss ambassador's father had been a well-known orchestra conductor so there was no lull in the musical talk. Then the director of the Georgian orchestra came up to our table, ignored the two ambassadors and their wives, and bowed deeply to Mehta, saluting him as a fellow musician. When I asked him how he knew about Mehta he pointed to the white tie and tails and said, 'This is the mark of the musician.'

After Mehta's second concert, we went backstage to congratulate him and Mehta said rather sheepishly that he had agreed to go to a late reception at the Indian embassy. He begged us to go with him, to which we rather reluctantly agreed since the ambassador, Tiki Kaul, was an old fried. But our appearance with Mehta was not appreciated. There were only Russians and Indians present and Kaul wanted to star Mehta as the great Indian master of western music, not conductor of the Montreal Symphony. In addition, he had very pro-Soviet sympathies and was clearly embarrassed at our presence. The Russian musicians at the recep-

tion, on the contrary, seemed happy at our arrival and Kondrashin, for one, spent most of the evening talking to us.

When we had first met Kondrashin, he was rather dour and on his guard, but had quickly thawed when he found we spoke Russian, loved music, and knew a reasonable amount about modern Russian music. That night he opened up to confess how much he loved Dmitri Shostakovich, as a man and as a composer, and felt deeply that he could not play more of his music. He shrugged, implying we knew how it was. Most of Shostakovich was officially forbidden, somehow 'incorrect.' Kondrashin regretted that Shostakovich and others thought he was personally responsible for this situation. 'You will soon find out,' he said, 'how jealous people are of anyone who is a success. Even musicians,' he added.

In mid-February 1965 we made an official visit to Leningrad. Almost twenty years before we had docked there in the mist on the good ship *Byelo-ostrov*, hoping to penetrate the mysteries of Russia. Even after more years of communist neglect, Leningrad had a unique beauty. Whether during the 'white nights' when the sun is gone only for two or three hours, or in the dead of winter, it was enchanting.

The lovely old palaces, the Isakovskii Sobor (St Isaac's Cathedral), the monumental Admiralty building, the Nevsky Prospect, the fortress of Peter and Paul, and the canals all took on a rather ghostly luminous aspect when a light snow drifted down, or when, at minus 35°C, a mist rolled in from the Gulf of Finland and seemed to lift the buildings from their foundations. It reminded me in a curious way of Venice in November when the pink and yellow palaces and churches are ethereal, floating in a fog which makes it impossible to determine any division between land, sea, and sky.

The city harkened back to the days of the czarist splendour, when it was called St Petersburg. But in 1965 it seemed unthinkable that it would ever recover its original name. It had become a Soviet city, and its communist administration was still one of the toughest, even more devoted to the party line than the lot in Moscow, especially about the arts.

But they could not obliterate the past completely, and they had the sense not to touch the imperial centre of the city. At least the façades were left intact, although the interiors, except in the old palaces used as government offices, were run-down, shabby warrens with minimal effort at maintenance. (Incidentally, there is no equivalent in Russian for 'maintenance' or 'upkeep,' which obviously was never a part of the Russian concept of living.)

Our official visit included a call on the acting mayor, a formidable woman, as dour in her expressed views about the successes of communism as in her grim appearance. An attempt to call on the head of the party apparatus, appropriately named Romanov, predictably failed. The formal part of the visit ended with the laying of a wreath at the Pisarevsky Cemetery at the monument to the citizens who died during the nine-hundred-day siege by the Germans. Although this was an obligatory bit of protocol, it was a moving ceremony, a reminder of the stoic bravery of the soldiers and civilians who had died in the defence of their beloved city.

I was more than ever confirmed in my belief that it took that same stoicism to survive the current regime. That ineffable Russian strength and patient courage was the key, for everyone from stifled poets like Bella Akhmadulina to any ordinary citizen in this open-air prison they called the Soviet Union.

When the diplomatic niceties were over, Thereza and I were free to savour the special beauty of this unique city in its winter garb. We went to Tsarskoe Selo, now called Pushkin, not far from the city, to visit the marvellous summer palace built by Catherine the Great and so deeply associated with Nicholas II, the last czar. It had been badly damaged in the war and barbarously ruined by the Germans before they retreated. We were the only visitors that very cold dark day. The curator took us through the palace room by room showing the damage and how it had been repaired. In fact, even twenty years after the war, the work had not been completed and it was fascinating to watch the artists and workers painstakingly restoring the interior to its former splendour. There seemed to be a word for 'upkeep' of at least this kind of artistic treasure.

We also attended an unremarkable concert at the Leningrad

Conservatory. The administrator came to talk to us in the interval, and at once asked when Glenn Gould was coming back. Everyone remembered the stunning concerts given by this great Canadian pianist in Moscow and Leningrad in 1957. I had seen the Gould phenomenon myself at his first American performance at Carnegie Hall with Leonard Bernstein in the spring of that year. He was totally unknown then, but the audience was electrified.

I was at that time head of the European Division of External Affairs in Ottawa, and helped arrange for him to tour the Soviet Union soon after, smoothing the way with the temperamental Gould and the no less temperamental Soviet embassy. This was not easy. The Soviet army had just carried out its bloody crushing of the Hungarian revolt, and relations were extremely strained. Gould, though, was indifferent to the political implications of performing in the Soviet Union at that time and was eager to go. External Affairs decided to encourage and help the tour.

The visit was a spectacular success. After that, Gould began his long retreat into seclusion. He never returned to the Soviet Union, and soon declined to appear on the concert stage at all. But on the basis of only those two concerts in Moscow and Leningrad in 1957, Russian musicians and music-lovers spoke about him with mystic awe, then and now. It was not only that he performed 'decadent' modern composers like Krenek and Berg. There was that undefinable aura of genius to which the Russian reacts instinctively.

This made the Soviet smothering of genius even more cruel and obscene in a people that valued it so highly. Of course, in every nation there are those who appreciate shining talent, but rarely have I seen this passion burn so deep and so wide as in Russia.

Over the years I developed an acquaintanceship with the composer Nikita Bogoslavsky. He was well known in the Soviet Union for his popular songs, operettas, incidental music for films and plays, and some semi-classical music, of which the best is a chorale suite based on Tvardovsky's poem 'Tyorkin in the Other World,' considered anti-Stalin by the regime but not by others.

He seemed to have carte blanche to accept diplomatic invitations and to travel abroad. With his good French it was not surprising that he was president of the French-Soviet Friendship Society, which meant that he was considered a reliable member of the communist *nomenklatura*.

When I gave a luncheon for the Canadian singer Monique Leyrac, who had been invited to give a series of concerts in Moscow, I invited Bogoslavsky and his wife. They accepted with alacrity and he, at any rate, was perfectly at ease. This was a more or less official occasion, officially acceptable. But I never expected to be invited back. I knew the limitations on Soviet contacts with foreigners and their limited resources for entertainment. But the following day he phoned to ask us to dinner, to our surprise and pleasure.

They lived in one of the huge apartment buildings put up by Stalin after the war on the Katelnicheskaya Quay. It was one of the most fashionable apartment buildings in Moscow and many successful artists lived there, including Maya Plisetskaya and Andrei Voznesensky. It bore little remblance to the ramshackle, dirty, and crowded apartment buildings into which the diplomats and most Soviet citizens were shunted. The courtyard contained a garage and filling pump and was absolutely clean – not a sign of the junk that littered most Soviet apartment courtyards. The interior of his apartment, although badly lit, was spacious, and the floor of imitation marble was spotless. The elevator was the type used by the Ministry of Foreign Affairs Building, slow and ponderous, but it actually worked.

The apartment contained three rooms and a small entrance hall, a kitchen, a terrace, and a maid's room, complete with maid. The space was enormous by Soviet standards. Every corner of the sitting room, hall, and dining room was lined with books, except for one wall of the sitting room taken up with three elaborate illuminated tanks containing a very good collection of tropical fish. There was also a piano. In addition to all this, he had a limousine and chauffeur. But he and his wife, it seemed, slept on sofas in this sitting room. The bedroom was occupied by their fourteen-year-old son Andrei.

Bogoslavsky was a good-looking man of fifty-three, refined in

his personal tastes, very well dressed, usually in foreign suits, shoes, ties, and shirts. His wife Natasha, on the contrary, looked like a typical Russian peasant, although she was one generation removed from the country. But though her features were solid, they lacked that rural coarseness. Still, built like on oak tree and unfashionably dressed, she was a total contrast to her elegant, cultured husband. Natasha spoke only Russian.

They offered us Sandman sherry, Italian vermouth, whiskey, and other imported drinks, and we sat down to an enormous and interminable banquet.

Over dinner we discovered that Natasha was in fact highly intelligent, and she sparkled with good humour. At one point, she unexpectedly announced with a laugh that her husband was a count, and her parents, who were peasants, had disposed of his parents during the Revolution. That is why he had married her, twelve years ago. This sounded an unlikely reason for wedded bliss, even by the peculiar standards of Russia. Thereza's theory was that she was the party watchdog on the unpredictable 'Count.' It turned out that her father was Cossack, and Nikita's parents were killed by Cossack cavalry fighting for the Bolsheviks, but not necessarily by her father. She was speaking figuratively, a bit of family black humour.

Carrying on in this casual vein, Bogoslavsky discoursed on the tendency of Russian artists to change wives with rather startling rapidity. Natasha was not his first wife. 'She used to live two floors above this apartment,' he related. 'Prokofiev lived in between and complained that I always passed his door going up and down without visiting him.' And he laughed uproariously. Who Natasha was formerly married to or what happened to the former Mrs B. was never mentioned.

The only other guest that evening was the sculptor and painter Yuri Vasiliev, who said very little. After dinner Bogoslavsky showed some slides he had taken of Vasiliev's work. He had the most up-to-date American slide projector with remote control, which he said quite calmly had cost him $350. And in addition he had a German projector. Vasiliev finally piped up, 'Bogoslavsky is a millionaire.'

Bogoslavsky was in fact the financial and artistic patron of

Vasiliev. Many of the Soviet intellectuals and writers who became rich patronized artists working on the fringe of the official Soviet artistic world. Bogoslavsky did not lack for money either in roubles or foreign currency.

While many members of the diplomatic corps speculated on the role of Bogoslavsky, mystified by his freedom of access to embassies and ease of foreign travel, I never believed that he was a KGB informer, as some surmised. All of the most popular writers and artists who stuck to the party line, or at least did not openly contest it, enjoyed immense privileges, including accommodation, cars, travel, high rouble salaries, and royalties and foreign currency. Bogoslavsky was unique in that he was of aristocratic origin, and not obviously, at any rate, occupied in building the socialist state.

But even the most rigid of the ideologues saw that *some* popular entertainment was necessary. Bogoslavsky's music was immensely popular, and not subversive. And he was careful not to support any of the dissidents. Speaking good French, well travelled, and a bona fide artist, mingling at embassy parties, he was therefore useful to the authorities as proof of 'normalcy' in Soviet society.

Bogoslavsky talked about the war, telling us he had risen to the rank of colonel and had been wounded three times. 'I wrote some of my best songs then,' he recalled sentimentally. As a matter of fact he still kept the rank of colonel – which was another reason he was occasionally suspected of serving in that other branch of the Soviet services, although there was no proof.

As the meal progressed and the alcohol flowed, he expanded from casual to indiscreet. At one point he turned to me and said: 'You were in Russia before. Would it have occurred to you as possible then that you could sit down like this with a Russian family – as friends? We would have been on our way to Siberia the next day.'

He then launched into a long diatribe against Stalin, and more particularly against Zhdanov. 'I cannot tell you what I suffered at the hands of that man,' he cried. 'Zhdanov! He did this,' he spat, pulling at his hair, 'turned it completely white! I am not a vindictive person but my one political ambition is to change the name of the town of Zhdanov back to the original Mariupol.'

All of a sudden, my lurking suspicions seemed absurd. This couldn't be an informer. But now none of the rest made sense. Like everything else in this country, it was all a mass of contradictions under the surface.

Natasha said bitterly that her father had been arrested in 1946 and had spent eight years in a Siberian concentration camp. She had managed to spend three months with him there in 1947. The fact that he had fought for the Revolution meant nothing. His arrest was at a time when thousands were sent to Siberia for absolutely nothing. Natasha's peasant face mirrored suddenly all the inextinguishable pain of her people. Then she became reluctant to speak about it and quickly changed the subject.

We got on to the question of China and the Cultural Revolution there. All three expressed themselves with great vehemence on the subject, viewing with horror and contempt the absurdities of the happenings in China, but also confessing complete ignorance of Chinese history, Chinese culture, and the motivations of the Chinese leadership. Bogoslavsky said at one point that he did not think the Red Guard movement could continue much longer before there was a movement of revolt; he was sure there would be a bloody civil war. Although he was a member of the Communist Party, his way of life, his interests and ambitions, for himself and his country, obviously had absolutely nothing in common with the Chinese Red Guard's efforts to impose an absurd cult, the mystique of Maoism, to enforce continuing revolution, and to reduce everyone to poverty-stricken egalitarianism. In this he was typical of most classic Marxist-Leninists, who loathed Maoism.

There was a large photo of Yevtushenko in the dining room. Bogoslavsky said he was very fond of the poet, but found in him perhaps too great a tendency to self-dramatization. He preferred Yevtushenko's former wife Bella Akhmadulina, and lamented that she was drinking herself into an early grave. 'It is an obsession,' he said, 'a disease all too many Russian poets have succumbed to.'

There was also a photo of a very good-looking boy in what seemed to be a scene from a film. It turned out to be his son from his first marriage, and Andrei was then produced – a very aristocratic-looking youngster who spoke quite fair French. He

had been chosen to play the role of a younger brother of Lenin in a film. I asked him what was the name.

'Oh, *Mother of Lenin* or *Father of Lenin*, something like that. It was one of those films,' Bogoslavsky said. Young Andrei said he got paid eight thousand roubles for his part in the film. He had bought the most expensive television sets he could find for his grandmother and several friends, a few gadgets such as transistors and tape recorders for himself, and with the rest had invited all his friends to a tremendous banquet in a restaurant, which he had paid for himself. This led to a conversation on the high cost of living, although no one referred to the poverty of the proletariat.

Eventually Bogoslavsky saw us to our car. An enormous limousine, it was attracting considerable attention, but he did not seem at all concerned, nor was he perturbed by the fact that his neighbours in the adjoining flat watched our departure from the doorway, with silent interest.

SUDDENLY

Simeon Kirsanov

Suddenly
I am the same age
As you:
I am the champion of bicycling,
Boxing, hiking,
And – everything!

Leaving our footsteps on the sand
For the archaeologists, and the centuries,
We rush to the edge of the tide
And plunge into the ocean.
We decide to cross the strait.
Beside us swims – a vertical
Interrogation mark in the sea,
Or a chessman's knight,
On which you came into the world.
You, dressed only in hair and beads,
Thrust your slight form into the depths.

I, in my aqualung,
Fight off the sharks,
And seek you in the multi-coloured depths.
Oh, how new it is to be
The same age as you.
There is only us
And our underwater love
Among the coral reefs and rocks.
We dive again!
And swim among the fish,
Medusae, needle-fish, and stars!

And your rosy arms in the depths
Are swept like seaweed
Into mine.
Suddenly
I am the same age
As you.

The festive demonstration in Red Square on 7 November 1975,
during the celebrations of the 58th anniversary of the
October Revolution

NINE

Smell the Dust

The year 1968 started badly and ended worse. In January the KGB cracked down. Three prominent dissidents, Alexander Ginsberg, Yuri Galanskov, and Vera Lashkova went on trial for activities hostile to the Soviet Union. They had been advocating greater respect for the rights of citizens, allegedly guaranteed in the Soviet constitution. In Czechoslovakia the same groundswell was known as 'communism with a human face.'

The farce of a trial, and the savage sentence of hard labour passed on them, seemed to act as a spur and catalyst in the development of Andrei Sakharov's move in the direction of outright opposition to the regime.

In April my father died and we returned for his funeral in London, Ontario. When we returned to Moscow, it was clear that the Dubček economic and political reforms in Czechoslovakia were arousing great expectations among the Russian intellectuals, and increasing apprehension on the part of the authorities. The party mandarins feared that the dangerous ideas of the Czech reformists could spread to the Soviet Union and undermine the regime. Hence Brezhnev's decision in August to intervene militarily. The tanks rolled in, and Soviet armour crushed the fragile flowers of the Prague Spring.

The bloody repression of Czechoslovakia had an immediate effect on the Soviet intelligentsia, most of whom simply dropped

out of sight, except for Yevtushenko and Sakharov, who spoke up against it. But the signs of a tougher line in Moscow were obvious and from August on there was no chance of meeting writers, nor would it have been safe for them if I had tried.

The chilling effect on the artistic community was intensified by continuing ripples from the Ginsberg, Galanskov, Lachkova trial, and by barely veiled threats in the press that the same treatment would be meted out to anyone who got seriously out of line. The main targets of Soviet wrath were Alexander Solzhenitsyn and his supporters.

But in him the Soviets found themselves facing someone as tough and determined as they. He had spent eight years in the gulag, and was only released in late 1953 during Khrushchev's first efforts to rid the country of the worst features of Stalinism. Solzhenitsyn's account of his experiences, *One Day in the Life of Ivan Denisovich*, was the last of his works to appear officially in the Soviet Union. His novels *Cancer Ward*, *The First Circle*, and *August 1914* were published abroad, but were not available to the Russian people. Their contents, however, were known to most of the intelligentsia, who also knew he was busy on another book. Hence the KGB pressure and harassment was increased, not only on the novelist himself, but more ominously, on Andrei Sakharov, as he defended the writer against the efforts to silence him.

One of the mysteries of the years 1968 and 1969 was why Solzhenitsyn was still free, above all after the huge success of *Cancer Ward* and *The First Circle* in the West. Nothing could have been more damaging to the leadership than these two books. But, given the impression that the party hardliners were out for his blood, it looked as if they would be prepared to risk further denunciation from the West by charging him with anti-Soviet activities. He was not, of course, exactly free, since he did not have a permit to live in Moscow, and was living in miserable condition in Ryazan, a small provincial town about 150 kilometres southeast of Moscow.

Ironically, it may have been the crackdown on the Czechs that saved him. I suspected the main reason that he was not arrested was because Brezhnev did not want another serious quarrel with the West after the tensions caused by the invasion of Czechoslo-

vakia. In addition, a number of left-wing and normally pro-Soviet intelligentsia in the West had protested the repression in Czechoslovakia, and this would have increased if the KGB had persecuted him publicly. I had the feeling they would wait until the popularity of *The First Circle* had died down, and then gradually increase the pressure on him.

Every Soviet citizen was obliged in principle to have a job, and belong to an official organization, be it a collective farm or the Composers' Union, exclusion from which not only meant exclusion from the social welfare system, but deprivation of means of livelihood. Solzhenitsyn had been expelled from the Writers' Union. It formed a concentric circle, with the All-Union Writers' Union at the centre. Cities such as Kiev and Leningrad had their own unions, as did each republic. For a professional writer membership in one of these organizations was essential; otherwise they had 'no visible means of support' and were therefore 'social parasites,' the crime for which Joseph Brodsky was sent to Siberia. Membership, on the other hand, had privileges – royalties, access to foreign currency shops, foreign travel, good accommodation, and eventually, the pinnacle, a dacha in the writers' colony of Peredelkino.

In the midst of all the political headlines, people's lives carried on, with a drama all their own. The beautiful Bella Akhmadulina and her husband Yuri Nagibin split up in a spectacular eruption of unsocialist realism. Nagibin, who was a bit weird even by Russian standards, still lived with his eighty-five-year-old mother who, having survived as an aristocrat all those years of revolutionary change, apparently felt the world, or at least her son and daughter-in-law, owed her everything. She was quite a Tartar, so to speak.

Bella understandably found living with the old lady bad enough, but worse, Nagibin would lock Bella up in his dacha near Moscow with his mother, and disappear himself on regular expeditions in search of women and vodka, both of which he found in easy abundance. Bella in turn, when she could escape, embarked on the same path of love affairs and alcohol which increasingly diverged from his. The climax came in the spring of 1967, when they came together on a collision course in the Writers' Union.

I never got the full details of this affair. Writers who had been there were discreet, but I gleaned enough to discover that a great deal of vodka on both sides sparked a slanging match, which included accusations by Bella that Nagibin was his mother's baby, and that his sex life was ambiguous. Nagibin replied that her sex life was common talk in some circles, and if it had not been for him, she would never have been published. He meant he had given her political protection, but she construed it as an attack on her poetry – and that was too much for Bella, who spat at him that he was a toady and hack.

The whole scene was so scandalously resounding, they did not need the urgent recommendation of the Executive Committee to separate. They apparently got back together twice, but it was hopeless.

Not long after, I ran into Nagibin at a dinner given by the Egyptian ambassador, Murad Ghaleb, whom I had known very well when we were in Cairo. He had invited Thereza and myself and some Russian intellectuals. The evening was to be in the nature of an experiment, to see if the intellectuals were really as frightened of contact with westerners as has been the case for most of the previous year. The answer was – almost.

Because he represented the socialist revolutionary Nasser, and spoke Russian fluently, Ghaleb had more contact with Russians than most diplomats. In addition to Yuri Nagibin, he had invited Sviatoslav Richter, the pianist, and three other less well-known writers and artists. All accepted but, in the usual Russian fashion, only Nagibin and his new wife turned up.

She was an unremarkable redhead, a specialist in translating technical journals from English into Russian. But her English was strictly for textbooks. The couple was accompanied by someone called Misha, who was unknown to Ghaleb and was introduced simply as a friend of Nagibin. He was, however, quite clearly, his watchdog. When I asked Misha what he did, he replied he worked for the Communist Party. When I said, 'Don't all of you?' he just shrugged.

But the presence of both his wife and the gimlet-eyed Misha did not prevent Nagibin from talking about both Bella and literature. Their personal battles notwithstanding, he had a great admiration for Bella's poetry.

He admitted to having to be extremely careful in the past year and he had had some difficulty with some film scripts after his film, *The Chairman*, produced three years previously and initially praised, ran into unexpected criticism. But apart from this he refused categorically to talk actual politics or to make any comments on the present atmosphere. So we kept to Russian literature. The extremely limited knowledge he had of modern literature in English surprised me. He had never heard, for example, of Lawrence Durrell. When I explained what Durrell was doing he was even less interested, dismissing it as 'irrelevant.'

The writers he was familiar with were all in some way political, either committed in the communist sense or friendly to the Soviet Union. C.P. Snow, for example, he greatly admired and also John Steinbeck, Ernest Hemingway, John Dos Passos. It struck me as particularly sad that an active writer in the Soviet Union should be so cut off from the mainstream of modern English and American literature.

This made all the more remarkable the feat of a man like Solzhenitsyn. Nagibin, after all, had been permitted a certain amount of contact with the West and had been able to absorb something of western culture. But Solzhenitsyn, apart from his years in concentration camps, lived mainly by himself, largely in Ryazan. He knew no foreign languages and had to draw solely on his own genius and his background to produce his novels.

As the evening wore on, Nagibin began to show the effect of a huge consumption of alcohol. It was sad that someone as mediocre as Nagibin had managed to ruin the life of someone as splendid as Bella, at least that is how it appeared at the time. Or had the system made him mediocre and destroyed her? It was probably a combination of all these things. Stating the obvious, perhaps, but too often we put politics and passions into separate categories, and forget the intricate tapestry they weave together. But Bella, inside her fragile exterior, was not easily destroyed.

I saw Bella occasionally at receptions, still beautiful, but ravaged inside, and showing the signs of heavy drinking. Then came a memorable evening when she attended a small dinner at the embassy, together with Semion Kirsanov and his wife. Bella was depressed, but never mentioned the problems she had had with Nagibin and his ghastly mother. Instead, she began, without any

prompting, to recite her poetry in her throaty voice, tears occasionally streaming down her face.

We were mesmerized. Deeply moved, we sat in momentary silence. The depth of emotion here was the antithesis of the shallow, enforced 'reason' of the communist world just outside our doorstep. And surely it was likely that in almost every home in Moscow, in the Soviet Union. Here was the true Russian soul, crying out in pain, loving and living with an intensity that was almost unbearable. And that was precisely what the system wanted to stamp out. The system was the antithesis of the people it pretended to be serving. At the same time, these poetry recitations in a very small group, in the highly charged emotional Russian manner, made me slightly ill at ease, perhaps a question of my own national temperament.

Kirsanov rose finally to drink a toast to the poets of the world, and succumbed to the temptation to recite some of his latest poems. He was beginning to show his age, but was full of good spirits (in both senses of the word), and still madly in love with his young and beautiful wife. They were love poems, and he addressed them to her. She looked bored, and slightly embarrassed.

I felt equally embarrassed, but retained my diplomatic demeanour and Canadian cool. Andrei Voznesensky often complained to me that he never knew how I reacted to his poetry or to events. Another Anglo-Saxon would probably have no trouble reading my response, but Russians were used to this exaggerated emotionalism, at least where music and poetry were concerned.

I wondered if they had always been this hysterical. I thought perhaps they were so extravagant about personal sentiments because the repressive system prevented their showing their true feelings on social and political questions. The way the Russians exploded emotionally on these issues, after the Gorbachev revolution made it possible, proved my point.

On another evening that fall of 1968, the atmosphere in the Stevens's home was warm and ebullient, shutting out both the early winter and the realities of Red Russia.

There were Bulat Okudzhava, the poet; Andrei Volkonsky, the composer and harpsichordist; Yuri Vasiliev, the painter and sculp-

tor; Nikita Bogoslavsky, the composer; and Nikolai Dupak, the director of the Theatre of Drama and Comedy.

There was also a singer, known by everyone only as Galia. An attractive blonde, half Estonian, half Russian, she sang to her own guitar accompaniment, her voice gliding through the familiar minor chords of the Slavic soul. The old Russian popular songs were always common at nostalgic soirées of White Russians in the West. They were melancholy, pessimistic, personal – and frowned on by the regime as being insufficiently positive.

But oddly enough, the atmosphere on this evening was still relatively relaxed. After the preliminary shock over the brutal suppression of Czechoslovakia, and the dissipation of their hopes of reformism spreading to Moscow, the intellectuals had adjusted to the facts of life under Brezhnev. The fate of Solzhenitsyn and Sakharov was a constant worry, and the vicious sentences of the three more vulnerable writers were a constant reminder of the brutality of the regime.

Everyone was a little stiff at first, but they all gradually relaxed as the evening advanced and Galia's songs worked their melancholy magic. Melancholy makes Russians happy. They're at home with it.

Galia worked as a flutist in one of the smaller Moscow chamber music ensembles. In contrast to her music, she was obviously making an effort to imitate western models in her clothes and coiffure: a short skirt, sexy red blouse, and hair cut short and bobbed à la Twiggy. Putting aside her guitar, she wanted to talk to Thereza about the latest trends in the West, everything from literature to fashion. I wonder how many people in the global village have this modern form of schizophrenia: deep devotion to their own culture, and envious yearning for an imagined western paradise.

I wandered over to get acquainted with Andrei Volkonsky. His family was aristocratic and had lived in France since the Revolution. He himself was born in Paris and studied music with Nadia Boulanger. A good-looking young man with fair hair and an air of insouciance, he looked like a French student who had just drifted in from the Latin Quarter of Paris. He told me he had come to Moscow with his father about ten years ago, at the age of twenty.

He was a little obscure about the reasons for his coming, but I had the impression that he had felt he had little chance of making a living in the West composing the type of music he wanted, and performing ancient music on the harpsichord.

'My first years in Moscow were very difficult,' he told me, as we lounged by the fireside. He was abstemious, for a Russian, but devoured a vast number of *zakuski*. 'I was under constant suspicion; advanced contemporary music was unacceptable in Moscow. It still is,' he shrugged, 'but I continue to produce it and hope some day it can be performed.'

His fellow composer Nikita Bogoslavsky interrupted. 'Volkonsky is an extremely good composer,' he stated. 'He has a future, in my opinion.'

As far as the performing arts were concerned, Volkonsky did make the grade with the authorities. He had developed a position as the leading Soviet specialist on Renaissance music and gave frequent solo concerts on the harpsichord. He was even permitted, to his great delight, to form a small orchestra which also presented concerts of ancient music.

Volkonsky went to great lengths to justify his return to the Soviet Union and spoke disparagingly of the intellectual atmosphere in the West. But in the end what seemed to excite him most was the fact that movement towards greater intellectual freedom in Russia was taking place in an ambience of danger and stress. On the other hand, what seemed to bore him was the success, even excess, of liberty among artists in the West. Therefore his case was unique. It was also puzzling that a man of his background and education, producing a music akin to Hindemith, should be permitted to live and work in Soviet Union.

Nikita Bogoslavsky was also from an aristocratic background and spoke perfect French. In the spring he had travelled to Spain, an unlikely country for a Russian to be allowed to visit in 1968. It was clear he could not have gone without official approval, and equally strange that he could have received Spanish permission, since there were no diplomatic relations between the two countries. The Spain of General Franco was one of the worst enemies of the Soviet Union. Bogoslavsky was vague about the

circumstances. But he enthused about Spain, where he had busied himself studying Spanish gypsy music, which he found to be closely related to that of Russian gypsies. He lamented the closure of the Gypsy Theatre by Stalin twenty years before.

In a place like the Soviet Union, it is easy to grow very large suspicions from such little acorns. Could he have been studying something else for somebody else? A simple trip, unremarkable for any westerner, was a matter of mystery and intrigue in that Marxist-Leninist workers' paradise.

He was induced to play some of the tunes from a musical film he was working on – light and amusing stuff, but rather dated. In fact it sounded very much like musical comedies of the early 1930s, harmless political entertainment that may have been the reason the authorities gave him so much freedom. So much freedom, in fact, that he was nicknamed Nikita the Second, which he did not find amusing.

Bogoslavsky introduced me to Nicolai Dupak, the director of the Theatre of Drama and Comedy. I had been told that, after Yuri Lyubimov, the director of the Taganka Theatre, he was the most original of the Moscow theatre directors and producers, with a reputation for daring and originality in his small, out-of-the-way theatre. This originality must be heavily qualified. I had seen one comedy of manners he produced, and it was vaguely amusing but scarcely original. He was the first to agree that in comparison with experimental theatre elsewhere, even in Belgrade and Warsaw, Moscow was far behind.

Slightly tipsy, as most of the Russians in the room were by then, he elaborated: 'Look,' he said, sweeping his arm about to take in the gathering, 'we're still in the nineteenth century here. I couldn't dare do even what the Poles and the Yugoslavs are doing. It's shameful! But we have to survive within the system, giving a little push here, a little push there. I am pushing as hard as I can. But it would be foolish to try to go faster before the situation is ripe.'

'And when will that be?' I asked.

He shrugged his shoulders in that typical Russian gesture signifying ignorance, resignation, and impotence. 'Who knows?

We're hoping that first maybe some western avant-garde productions will come to Moscow. That would be wonderful,' he finished wistfully, draining his drink.

I said it was improbable that the Ministry of Culture would agree. And they vetted everything.

'Yes, I know,' he replied, 'but we keep trying. Maybe someone will slip up. They are all so stupid that often when you put the message between the lines, they just don't get it. On the other hand,' he continued, refilling his glass, 'they are capable of clamping down on everything overnight. How can you know? I could turn up at my own theatre tomorrow and find it closed. For repairs.'

I told him that reminded me of an official who asked me why we sent out invitations to receptions two or three weeks in advance. 'Why?' I countered, 'Is there a problem?'

'Oh, no problem,' he answered. 'You see, I get an invitation today, say, for something in two weeks. Right now, it looks like a very good idea. But maybe in two weeks I won't be in the mood to go. Or maybe I'll be dead.'

Dupak laughed. 'Typical Russian, grim humour. But I have a feeling things will get better.' And he moved on to join a happy group by the food table.

But when I saw him again only a few days later, he was downcrest, deflated.

'Nothing will ever change,' he stated.

'What has happened?'

'Nothing. That's just it. Look at the MKhat, our famous Moscow Art Theatre. It used to be the best in the world. But this, our great classical theatre, is dead. It is dead. It can do nothing but repeat its ancient triumphs. There is a limit to the number of times you can see *The Seagull* or *A Month in the Country*. You can practically smell the dust.'

I concurred sadly, and told him that I had recently seen a production at the MKhat of *Anna Karenina* which had been identical down to the last detail to the production of 1952 except for a different Anna.

'Well, that's precisely the trouble. They are stifling us all.' Then he brightened a bit. 'Nobody can touch the MKhat; it's a sacred

cow. But I can assure you that in the other theatres there is a growing restlessness. We want to experiment, to restore the great Russian theatrical tradition.'

Then he signed resignedly. It was like waves of emotional futility, first a crest of hope, then a trough of despond, then a crest, then another slough. 'But we are so out of touch,' he said. 'We have to reinvent everything – if they will let us.'

The cover of *Kater sviazi*, a volume of poetry by Yevgeny Yevtushenko, showing the poet's inscription to Robert Ford

A STREETCAR NAMED POETRY

Yevgeny Yevtushenko

I entered the streetcar of poetry
 (like a social welfare office –
full of people and papers)
not through the front entrance,
but hanging on the step.
I balanced adroitly on the buffer
with my hand
 on the door,
and when at last I slipped inside –
I could not believe myself.
I always made way for the old people.
Never hid from the ticket-collector.
Never trod on anyone's toe.
And when they stepped on mine –
 I never complained.
Somebody forced his way into the tram, as if it were paradise
full of his worst enemies,
changing the mob logic of those inside.
Passengers grumbled morosely,
 burying their noses in their papers,
like brood-hens in corn.
'The tram's not made of rubber ...
 Stop knocking!
Don't open the door, conductor.'
I am with those
 who have come to build and sweep,
not with those
 who say: 'No admittance.'
I am with those
 who want to get inside the tram
when they are not permitted.

This world is hard, like Moscow in winter,
when the snow blows through its streets.
Trams are made of rubber.

 There are seats!
Open the door,
 conductor!

TEN

The Party Inside and Out

An intimate dinner again at the house of Nina and Ed Stevens. It was March, still bitter cold outside in the party snows. Yevtushenko was there, his first 'public' appearance in a long time. He had been in deep trouble with the authorities over his protest about the occupation of Czechoslovakia, and since then he had avoided contact with foreigners, and had gradually been working his way back into a more acceptable relationship with the authorities. The Yugoslav ambassador and Nikita Bogoslavsky were also there, and we relaxed in the warmth of the strange Russian-American house, and the relative security of long acquaintance.

Yevtushenko leaned over his armchair to speak to me confidentially. 'I'm sorry I haven't been able to see you for some time,' he said, 'but you did well not to try to see me. It would have been an embarrassment. And impossible anyway.' Once again, I felt the oddity of a poet who perforce had to act and react like a spy.

The American poet William J. Smith had got Yevtushenko into a lot of trouble during his visit the previous spring. Apparently, after being taxed for some time about American involvement in Vietnam, Smith had replied that he was no less an American patriot for opposing American policy in Vietnam than Yevtushenko was a Soviet patriot for criticizing Soviet policy in Czechoslovakia. Yevtushenko was immediately called in and hauled over the coals after an exhaustive inquiry into his contacts

with Smith, whom in fact he had not met. It was a shock to Smith to discover how much damage a pretty ordinary remark could cause.

Yevtushenko had spent the previous few months researching for a poem which he had just completed. It was very long, two thousand lines, and the theme was irreproachable – the student underground in Kazan University during the youth of Lenin and his brother Alexander. 'I signed a contract with *Novyi Mir* for it,' he said without enthusiasm, 'but now I wonder if it will even appear. Any suspicious reader would find many dangerous ideas between the lines.'

I said as far as that went even the Communist Manifesto was treated by the Soviet leaders as an inflammable document. I would have thought even with Lenin as a respectable cover, his theme would create problems for the censorship.

Yevgeny nodded. 'Tvardovsky would have taken a chance but so much had changed at *Novyi Mir* since he was replaced as editor in 1963. My chances of publication are rather slim.'

In general, however, he said his position was getting a bit better. A new collection of poems was published, but in such a small edition that it sold out at once. The difficulty was that he was too 'political' but that was his nature and he could not help it. Nor could he help loving and admiring Solzhenitsyn. 'That is a great writer and a desperately honest, single-minded man with a great sense of duty,' he proclaimed.

Everyone admired him; even the party hacks who tried to destroy him had a secret admiration for his courage. Yevtushenko said that it was totally untrue that Solzhenitsyn had hired a lawyer in the West to protect his rights, as reported in the western papers. He had no way of doing this, no contact with the West, and no access to his royalties. I asked if he was in Moscow now. When Yevtushenko hesitated, I added 'or rather near Moscow,' at which he smiled. I was thinking of the story which I had heard recently that he was staying at the dacha near Moscow of the cellist Mstislav Rostropovich.

On another occasion, Yevtushenko turned up at a luncheon given by the Australian ambassador in honour of a visiting Australian poet, Rosemary Dobson. Her visit was part of an Australian-

Soviet cultural exchange, and reciprocity for a tour of Australia by Yevtushenko two years previously. 'It was a crazy place,' he said to me. 'It's like Siberia and your Canada in a way – huge spaces, lack of discipline, spirit of adventure, harsh climate. But just the opposite, too.'

I was surprised he thought Canadians undisciplined. Foreigners called Toronto 'New York run by the Swiss.'

'Well,' he amended, 'I was really thinking about the West. I would love to go to that place ... ' He searched his memory and came up with ... 'Yellowknife. I love that word.'

I wanted to get off this subject and onto literature. But Yevtushenko was suddenly preoccupied by the questions of China and Vietnam.

'I hate the Mao regime because it is essentially a form of Stalinism. And I am really afraid of China, because they have the atomic bomb, and could eventually get us into a major war.' After a reflective pause, he went on: 'I almost feel that war with China is inevitable. It's something I feel in my bones. It's a continuing nightmare for me.'

I disagreed, but said I could understand his fears as a Siberian. I had been in Khabarovsk, thousands of kilometres from Moscow, right on the border of Manchuria, and one could see that the people felt apprehensive, isolated. 'And after all,' I added, 'just the population of Manchuria alone is bigger than all of Siberia – and growing.'

'Exactly,' he replied, 'that's just what I mean.'

He thought Vietnam was an example of how things could get out of hand and develop a momentum of their own. He said almost everyone claimed to want to end the war, including the Soviet Union, and yet it went on. He was obsessed with the idea that a war with China would evolve just like that.

Yevtushenko had written a very patriotic poem about the blood on the snow on the banks of the Ussuri River, where Chinese and Soviet frontier troops in Eastern Siberia had clashed. Henry Shapiro of the newswire service UPI, who had a private and unexplained feud with the poet, told me Yevtushenko had come out with this poem because he had a good feel for timing and for keeping his balance sheet straight with the regime. However, I

had the impression Yevtushenko had produced the poem because he felt a very strong and genuine patriotic emotion about the battle on the Ussuri. It is a kind of gut Russian reaction to the 'Yellow Horde.'

In July of 1968 the Department of External Affairs finally authorized me to extend an official invitation to Andrei Voznesensky and Zoya Boguslavskaya to visit Canada. When they arrived to discuss it all over lunch at the embassy, Andrei wrote on a piece of paper 'No politics please' – evidence of the more repressive atmosphere following the Czech intervention. Both Andrei and Zoya were enthusiastic about the idea of going to Canada. Since his last American tour the previous year, he had not been out of the country, and now he talked animatedly about an evening of poetry he spent with Mrs Kennedy, whom he referred to as Jacqueline.

Voznesensky had received a request from Harrison Salisbury of the *New York Times* to write a poem to celebrate the moon landing. He had thought about it a long time and finally produced a 'concrete poem' which consisted only of three words 'A Luna Kanula,' which roughly translated means 'the moon is gone.' Accompanying this palindrome, which can be read in either direction, he had a commentary in English explaining that the moment man set foot on the moon then the whole concept of the moon in literary symbolism would disappear.

'It's ingenious, Andrei,' I said, 'but not very serious.'

'Better not to get too deeply involved in the significance of the moon flight,' he said simply. The watchdogs could easily misinterpret it.

Andrei and Zoya invited us to dinner at their apartment. They lived in one of the special buildings set aside by the party for the Soviet 'rich.' Although they were indeed well off by Soviet standards, the apartment was very small and poorly furnished by any western criteria. It was, however, decorated with a Chagall lithograph with a special dedication to Voznesensky by the artist, a Miro reproduction, and a Carlo Levi drawing. There were masses of books all over the place. The atmosphere was very pleasant and relaxed, with large quantities of the usual Russian *zakuski*, and a wide assortment of western and Russian drinks.

But I brought a chill to the festivities when I asked Zoya innocently, 'By the way, who is Shtockman?'

Zoya blanched. Shtockman was the author of an extremely crude and violent attack on her latest novel in the June and July issues of *Yunost* after it had been held up for over a year. Zoya began pouring out the story. The attack had made her life miserable over the last week. They had no idea who Shtockman was, but discovered that the *Literary Gazette* had tried to get someone from the usual group of critics to do an attack on her novella, and all had refused. Someone unknown to anyone in the normal literary circles had then written the savage piece. Andrei said he hoped it was simply a result of jealousy. They personally, and the *Literary Gazette*, had been receiving thousands of letters of praise for the novella. However, he had the sinking feeling that the attack had been ordered from fairly high up, and this was what worried them sick.

Zoya said that someone had it in for her. She had just learned that permission to go to Canada with her husband had been refused. When she asked why, she was simply told not to inquire, that the decision was irreversible.

'It's primarily directed against Zoya,' said Andrei, 'but it could also be a way of getting at me.'

It was true that they perhaps did not dare to attack him directly. He added that things were relatively better for him than they had been a year ago but at the same time they could be relatively worse next year. 'How can anyone tell in this country?' he asked rhetorically.

At this point we all heard a rather strange humming noise in the apartment. This put Zoya into a state of panic. She began whispering that this noise was new; what could it mean? It was clear she thought it was a bugging device. We lapsed into a rather uneasy silence and after a while it stopped.

The evening ended on a rather gloomy note with Voznesensky expressing a philosophy of extreme fatalism, indeed pessimism, not only about the future of letters in Russia but also with regard to foreign affairs. He thought that sometime another war was inevitable, that the big powers would just stumble into it and then the bombs would go off. When I argued that I thought the leader-

ship both in Moscow and in Washington was sufficiently intelligent and realistic to avoid this, he just shrugged and said he didn't think so.

I went to Ottawa in October 1969 for the official visit to Canada of the Soviet foreign minister, Andrei Gromyko, the cagey old fox who had so far survived several regimes and purges. The visit went well, which reassured the Soviet government about Canada, and boded well for the Voznesensky visit. So when we got back to Moscow, Andrei and Zoya had no hesitation in coming for tea.

Andrei showed an unusual willingness to talk about delicate matters. He compared the brave activity and attitudes of Solzhenitsyn to that of Anatoli Kuznetsov, the editor of *Yunost*, whose defection still rankled. Solzhenitsyn, on the other hand, was stubbornly continuing to resist the entire establishment. 'A man like Solzhenitsyn is doing more for the cause of writers in the Soviet Union than anyone else,' Andrei said.

He found it curious that when he wrote *Cancer Ward* Solzhenitsyn was suffering from cancer but suddenly the disease had arrested itself. He was now quite fit and had resumed his work with fervour, writing a new novel. (A few years before, Solzhenitsyn had thought that he had a very short time left to live and this accounted for his feverish work on *Cancer Ward* and *The First Circle*.)

And just after Solzhenitsyn was expelled from the Union of Writers, Voznesensky's permission to visit Canada was cancelled. He and I believed this was not just a coincidence, but part of another tightening of the screws.

The contradictions in this country were at times totally baffling. There were numerous rumours circulating that the KGB was manoeuvring to put Solzhenitsyn into a position in which they would have an excuse to discredit and destroy him. Their bizarre plan was to pick a manuscript in which he truly indicted the Soviet system, and get it published abroad. Then when it was published in the West, the Soviet police would have the excuse to strike.

Their minds were sufficiently distorted for this to be believable. Solzhenitsyn was so revered by the Soviet intelligentsia that the KGB might think any sacrifice warranted if it brought about his

discreditation in the eyes of the intellectuals. There is a word in Russian for this sort of twisted logic and duplicity: *vranya*. It is almost untranslatable. It means more than a simple lie, for which they have a perfectly good word already, *lezh*. *Vranya*, on the other hand, is more than that, it is a whole system of lies. It existed before the Revolution, as a method of communication between individuals: a person says something they know is a lie, but they know the other person knows it as well, but neither says so. They carry on knowing that they are both lying. But the Bolsheviks had developed this as an essential foundation of communist rule. Everything was a lie, with most people not believing a word the party said; neither did most party members for that matter, but there were enough fanatical true believers that everyone had to go along with the lies.

This cultural habit, elevated to political weapon, was a particularly insidious form of what Thereza enunciated as the 'crooked lines' theory of things Russian. It drove us to distraction. Often, during official sessions with Gromyko, I was sorely tempted to reply, 'You're lying, you son of a bitch!' But I resisted. We all had to play *vranya*.

About this time someone passed to me a seven-page typed *samizdat* written by Solzhenitsyn entitled 'An Easter Religious Procession.' It was very nationalistic in its evocation of the glories of the true and great Russian past. I felt it might well have been the work of a provocateur.

Yet on the other hand there was the strange case of Andrei Amalrik. In the West he published a book called *Will the USSR Survive until 1984?* It was hard to understand how so many Soviet intellectuals were in jail for fairly minor offences, when Amalrik was apparently still at liberty after publishing a prediction that the whole system would collapse. And in addition he painted a picture of a 'democratic movement' which was a kind of political alternative to the Soviet system. Amalrik could hardly have written and published it all without the KGB knowing about it. I could only surmise that perhaps the KGB wanted to create the illusion abroad of an opposition movement in the Soviet Union, which could serve as an excuse for a purge of intellectuals if the authorities decided one was required.

The mystery of Andrei Amalrik was partly cleared up by the news that the KGB had arrested him and it was rumored he was already on his way to Siberia. It would be familiar terrain for him, since he had already spent a year there in 1965 accused of parasitism. He wrote an account of his experiences in his book *Involuntary Journey to Siberia*.

The cases of Amalrik and Andrei Sakharov, who was increasingly outspoken in his criticism of the authorities, were linked in some way. I heard that two years before, Amalrik had passed a copy of Sakharov's essay *Reflections on Progress, Peaceful Coexistence and Intellectual Freedom* to a Dutch newspaper. It had circulated underground in the Soviet Union.

The authorities were clearly playing some devious game with Amalrik. We did not know at that time that Solzhenitsyn had finished the first volume of *Gulag Archipelago*, which was published abroad the following year. The police were obviously tracking him and needed an excuse to close in for the kill, particularly after he received the Nobel Prize for Literature in 1970.

But as far as Amalrik was concerned, presumably he had served his purpose and the KGB put him out of circulation. His trial took place in Smolensk, one of the many cities forbidden to foreigners. The result was a forgone conclusion.

After six years in Siberia, he was allowed to return, but was threatened with internal exile again when he attempted to resume his activism. Harassed, he finally left the Soviet Union in 1976, and died soon after in a car accident.

Athletes in Red Square on 7 November 1975, during the celebrations of the 58th anniversary of the October Revolution

NOT ABOUT DEATH

Bulat Okudzhava

To die –
means also knowing how
to choose taut sails
for the meeting with the sky.
Good, if you choose yourself,
worse, if others help you.
To die –
means also knowing how
to live
and not confuse the flash
of recognition
with the smile of slander,
and to have time
to put that penultimate touch
on the picture,
the penultimate rhyme.
To die –
means also knowing how,
no matter what constant, stubborn
knocks one's life deals out ...
To seek absolution?
What a little thing for
the happiness of eternity.
What? Sins?
The poems remain.
And their outrage at the world goes on,
asking no indulgences.
If there were sins ... perhaps,
but there are no sins ...
There is only motion.

ELEVEN

Uncle Vranya

'Davai, Bulat ...! Let's hear your latest!'
It was another soirée at the Egyptian ambassador's. Thereza and I were the only foreigners present. Some of the party-goers, feeling expansive, had taken up the cry to get Bulat Okudzhava to recite, or better still, to perform his poetry with his customary guitar accompaniment. Across the room, I saw him slouched against a door jamb, a slight, dark figure with brooding eyes. Clearly in a bad mood, he curtly refused to recite.

Okudzhava was half Georgian, half Armenian, with a reputation as an unorthodox poet, and enormously popular, even though he had published only one small volume of verse and a novella. In fact, he was very shy and retiring, and when I was introduced he at first reacted nervously. But when I told him I was a fellow poet, and had translated him into English, he relaxed and opened up a bit.

Always curious to know how the machinery of the regime worked in the artists' world, I asked why the publication of his poetry had been refused.

'I could probably get some of it published in a small edition,' he shrugged, 'but none of the ones I prefer. So I just carry on without formal publication.'

'But how do you live then?'

'I get along.' Then he added that it wasn't important to be

published as long as the people who counted got his message. He sounded like Jack Kerouac.

'I suppose you are referring to Voznesensky and Yevtushenko,' I said a little stiffly.

'Yes, and others,' he replied. 'Don't waste your time with those conservative poets. They are not bad, but to get published and rich, you have to toe the line. The really interesting work is being done underground.'

This wasn't much help to me. It was almost impossible to lay your hands on copies, to find out what kind of experiments they were making.

'I can recite lots of it to you,' said Okudzhava. 'And much of it circulates on tapes or in the *samizdat.*'

I said I had to have a visual image of poetry. The balladeer tradition had died out in English. 'With some exceptions, like Leonard Cohen. And he's a Canadian.'

'That's the difference!' he said. 'We love spoken poetry in Russia and always have. Look at the thousands who go to hear Yevtushenko or Voznesensky recite. But everyone in Russia knows a lot of poetry by heart. That's the only real way. Looking at those lines on a page ... well, that's just half a poem.'

This was surely one of those keys to the Russian soul that I was searching for. This universal love of the spoken rhythms and passion of poetry was a clue to the depths of feeling of these people. And a sign of a kind of ancient sophistication almost vanished in my own culture. It was hard to imagine the hockey fans lining up by the thousands to hear me chant my verses about Lake Huron. An evening of poetry reading conjured up visions of a motley little group of enthusiasts in a small church basement. True, Harbourfront in Toronto had brought literary readings out of the basement and onto the stage, but poetry was no threat to Hockey Night in Canada. Here, it was the equivalent of a major concert.

I went on to ask Okudzhava what he thought of Joseph Brodsky, since it seemed to me they both had been influenced by the San Francisco school of beatnik poetry. (Brodsky at that time lived in Leningrad.) Surely Okudzhava and Brodsky must have had a good deal in common, since Okudzhava had no evident

source of income, and his way of life and his poetry must have been as repugnant to the cultural policemen as that of Brodsky. I was unprepared for Okudzhava's strong reaction.

'Brodsky is a show-off,' he exclaimed, 'and I have never got any inspiration from the West, from beatnik poets. The good, original poetry being written today is steeped in the experimental verse of the early revolutionary years. *That* is the base for real Russian poets. It's come a long way from Blok or Mayakovsky, and we have to go on experimenting. But not like Brodsky. We look to our *own* past!'

This was a curious comment about a fellow poet who had suffered arrest for pushing too hard against the party formula for literature, a fate which could easily have been Okudzhava's at any time. I wondered later if there was some latent anti-semitism in this, or whether he thought Brodsky's open defiance of the notorious Leningrad party bosses endangered him and other poets who were also trying to write non-conformist verses, but keeping their heads down.

I never did meet Brodsky. Although he had been released, he was subject to constant harassment by the authorities. But support for him by western intellectuals also continued, and was such a source of embarrassment for the Soviets that they let him accept an invitation by W.H. Auden to attend the London Poetry International, in 1972, which also coincided with President Nixon's visit to the Soviet Union. He was then invited to be poet-in-residence at the University of Michigan in Ann Arbor, and the Soviets put out the story that he had gone into 'voluntary exile.' He won the Nobel Prize for Literature in 1987. Since 1972 he has made his home in the United States and even in 1990 expressed no desire to return to Russia.

After our discussion about Brodsky, Okudzhava lapsed into silence, and responded with only ambiguous gestures when I tried to get him to elaborate on this thesis that Russian poetry had to be based on its Russian roots. This seemed like old-fashioned Slavophilism of the kind Solzhenitsyn was later to develop. But he would not be drawn out.

The celebration of the ninetieth anniversary of Stalin's birth on 21 December 1970, and a long article in *Pravda* on that occasion,

renewed speculation about a re-emergence of Stalinism. A sharp increase in criticism of Solzhenitsyn and other writers also led to growing uneasiness in the intellectual community. Until Khrushchev, Stalin was a god-like figure in the eyes of most Russians. For a disturbing number, he still was. I was in a position to judge it over a long term. Having seen Stalinism at first hand, it was easier for me than for many other observers of the Soviet scene, no matter how able or well informed, to assess the political climate in those years, in terms of 'Stalinism,' a term that was bandied about with increasing inaccuracy.

When we use that term we mean a specific form of government in the Soviet Union in which all power was concentrated in the hands of one semi-oriental despot. It meant above all terror – a terror directed against the people, the intelligentsia, the Communist Party itself, his closest collaborators, against the army, the church, the Jews, even against his own relatives. ('Uncle Joe' Stalin was a far cry from Chekhov's Uncle Joe, in his play *Uncle Vanya*. And the nickname metamorphosed into an entire system, hence I allow myself to pun in this chapter title.)

These are the specific aspects of the Soviet system which can be identified with Stalin himself. All the other features of the system which would seem repellent to us, and indeed to most Russians, were part and parcel of the society laid out and generalized by Lenin, developed by Stalin, and continued to all intents and purposes by Khrushchev, Brezhnev, Podgorny, and Kosygin, and their successors up to Gorbachev.

What was changed from the original Leninist system was the concentration of total and arbitrary power in the hands of one man, and the distortions and aberrations this produced. And the reason measures were taken to prevent this recurring had very little to do with the system as such, but with the preservation of total power by the Communist Party. The arbitrary acts of Stalin were undertaken for the purpose for preserving his *own* authority, and the membership of the Communist Party suffered as much from his paranoia as did the population as a whole. The leadership in the 1970s was united about one thing – its determination not to let this happen again. Its motives were mixed. Some of the political hierarchy, no doubt, were always opposed to the indis-

criminate use of terror; some thought it simply uneconomical; but all realized it made the position of any person in authority highly uncertain.

Under Stalin's successors this required stricter control of the secret police, and measures to make it difficult, if not impossible, for any member of the hierarchy to gather the power of the police in his own hands again, in a bid to oust his opponents. That required drastic measures, as Khrushchev realized: in other words, the total destruction of the image of Stalin. The problem for Khrushchev, and even more for his successors, was that the hopes and expectations of the Russian people, of the lesser nationalities, and above all of the intelligentsia, were far greater than the leadership of the Communist Party felt it could afford to permit, without endangering its own total grasp of power.

Accepting therefore that very little of the essential nature of the Soviet state had changed, it was possible in 1970 to put the idea of a revival of Stalinism or neo-Stalinism into more accurate perspective. In my opinion, there was no prospect of a return to absolute rule through terror. This was too dangerous for the people who wielded power, and none of them had the compelling charisma and ruthlessness achieve it.

What this meant in practice was simple: accept the system, with or without enthusiasm, and make no serious attempt to tamper with it. Introduce minor reforms occasionally, yes, but make it clear that reform did not mean the regime was going to tolerate any real manifestation of independence of thought or, of course, opposition. These would be suppressed as ruthlessly as always. In other words, it was only the methods that differed at different times. This applied to the arts, politics, economics, and science. The price in the arts was a return to an appalling level of mediocrity. The distressing thing was that the huge mass of the population was totally unaffected by this. Even the bulk of the intelligentsia probably accepted without too much questioning the need for discipline and conformity. It was all the more surprising, therefore, that there was a handful of intellectuals prepared to risk their careers, imprisonment, and possibly their lives to protest against the system.

Around this time there were increasing references to Stalin in

the Soviet press, but this also had to be seen in the right perspective. In the first place almost every intelligent Russian, whether a 'liberal' or not, felt embarrassed abut the failure to find a means of properly placing Stalin in history. He had ruled the Soviet Union for almost thirty years, and in March of 1970 had been dead for seventeen. Most people felt the time had come to explain what had happened. He had obviously existed; it was impossible to ignore a man who held the fate of so large a part of the world in his hands. Therefore I concluded that most Russians were not automatically alarmed at references to Stalin and his historical role.

What did frighten them was the implication that any favourable reference forecast the possibility of a return to Stalinist methods. Therefore, as I said before, nuances in the official press were often interpreted as indications of what was to come.

The Russian people had some reason to be afraid, not of terror on the grand scale, but of a revival of the influence of the police in everyday life, and of the petty informer. The more original spirits were depressed, if not frightened, by that bleak prospect. The danger was that the small but ambitious elements in the police and the party bureaucracy would use a more permissive attitude to Stalin to behave like little Stalins in their own spheres. There had been a considerable retreat from the brief thaw of the early Khrushchev era, although at present it was not a return to Stalinism as such.

At one of the receptions that are the staple food of diplomacy, I had a long conversation with Leonid Ilichev, deputy minister of foreign affairs in charge of Eastern Europe. He had been a member of the party secretariat entrusted with control of ideology, but for some unexplained reason was demoted to the foreign ministry. There had been a sigh of relief from the intelligentsia when he left the secretariat, because of his hardline, neo-Stalinist views, but it boded no good for the intelligentsia of Eastern Europe.

To my surprise, Ilichev said he knew I had published a new book of poetry (*The Solitary City*), though he had not seen it (and in any case he did not speak English). He claimed he was interested in it because he liked poetry, and also because of my translations of Russian poets. I expected he might be critical of my

choice of contemporary poets, but on the contrary he praised Yevtushenko and Voznesensky, only remarking that the latter's verse was 'difficult.'

'Some of the others, though, Kirsanov, Okudzhava, and Akhmadulina, are, in my opinion, very uneven,' he went on. 'And I cannot agree with western critics that Anna Akhmatova is a great poet. She writes *Kamernoe Stikhotvorenie* (chamber verse). Barely worth bothering about.'

I said Akhmatova was considered in the West a great lyric poet, and in every country where Russian is read and appreciated, including his own; but it was a matter of taste. There were other Russian poets I had not translated, such as Tvardovsky, whom I recognize as good poets but who had no personal appeal to me. He said he personally liked Tvardovsky.

I said I was surprised he admitted to liking Tvardovsky in view of the latter's 'liberal' views. Ilichev admitted he was a 'conservative' but this did not prevent him from liking a man's work.

'Does that apply to Solzhenitsyn?' I asked.

'That's another question. It's become largely political. As far as I'm concerned, his work is uninteresting, but that's not the point. He is determined to make his work a political campaign, and that cannot be tolerated.'

I suggested that it was the Soviet authorities who had made it political by forcing him to publish abroad. And then by persecuting him, they simply aroused controversy in the West, even in left-wing intellectual circles, which was hardly in the Soviet interest.

Avoiding direct comment on this, he said that western commentators had greatly exaggerated. 'Solzhenitsyn was expelled, quite rightly, from the Ryazan Writers' Union and the RSFSR union, but not from the USSR Union of Writers.' I expressed some surprise but he insisted that this was what had happened. In fact, Solzhenitsyn *had* been expelled from the latter as well.

Then he changed the subject. 'Have you read Vsevolod Kochetov's new novel? You should. It gives a true picture of what the majority of writers and artists feel in the Soviet Union.'

I had glanced through it when it had recently appeared in the conservative literary magazine *Oktyabr*. Kochetov was a hack, whose work was reminiscent of Stalinist novels. Ilichev had on

several occasions glorified Stalin to me. But this time he went on to say that the publication of 'conservative' work did not mean there was not room in Soviet journals for things which could never have appeared a decade ago. He mentioned that many of John Updike's short stories had been published in Soviet magazines, and now they were starting to publish some detective stories – Dashiell Hammett and Georges Simenon for example. The conservative Leningrad magazine *Neva* (very ideologically correct) had recently published an American detective story the name of which he could not remember. When I expressed astonishment, he added with a grin that it had enormously increased the circulation of *Neva*.

'Still,' I replied, 'I don't think that a detective story is a particularly good example of modern western literature and in most cases it's pure escapism. In any case, how does it fit into the contemporary Soviet view of literature?'

Ilichev replied that obviously not everything could be fitted into a strictly dogmatic interpretation of socialist realism. They would continue to publish some things which were not entirely orthodox. But they would never permit the publication of anti-Soviet works.

'But the difficulty is deciding what is anti-Soviet,' I needled. In Stalin's day even the inoffensive but beautiful lyrics of Akhmatova and Pasternak had been proscribed. Now they had been published. But perhaps next week someone would decide they were again anti-Soviet.

He shrugged. 'Your system and mine are really too different for you to understand why certain things have to be done.'

GARDEN

Marina Tsvetayeva

For this hell,
For this delight,
Give me a garden
For my dying years.

In my dying years,
In my troubled age,
Years of toil,
Years of sweat.

In my awful, aging
Years – give me
Some warm years
And a cool garden.

For a fugitive,
Give me a garden:
Without anyone,
Without a soul.

Garden: Not a step!
Garden: Not a glance!
Garden: Not a smile!
Garden: Not a cry!

Without an ear,
Give me a garden.
Without perfume!
Without a soul!

Say: 'You've suffered enough –
Take this garden, alone, like you!'
(You too, will not stay!)
'Take this garden, alone, like you.'

Such a garden for my dying years!
'This garden? Is it perhaps the other world?'
Give it me for my dying years,
For the absolution of my soul.

Vasya Katanyan and Maya Plisetskaya, 1982

TWELVE

Dead Souls

In the early 1970s the arts had little to cheer about. One fall evening I gathered together at our home a stellar group that included Maya Plisetskaya and her husband Rodion Shchedrin, Simeon Kirsanov the poet and his wife, and not least, the legendary Lili Brik and her husband Vasya Katanyan, the cinema director. Lili at eighty still radiated the beauty and personality that had made her the mistress and inspiration of the great poet Mayakovsky, and this was her birthday party. Lili gave a thank-you speech saying it was the first time since the advent of communism that this sort of party could take place. It was a rare, I think unique, occasion in Moscow which I feared was not likely to be repeated.

During the dinner I made a little speech to that effect, noting how truly extraordinary it was to have at one table such a collection of talent, including one of the greatest ballerinas in the world, possibly the greatest poet of this generation, Voznesensky, and one of the greatest of the previous generation, Kirsanov. Andrei had travelled to Canada; I hoped Maya would now as well. Plisetskaya said she had been called that very morning to the office of the administrator of the Bolshoi to be asked why she had been invited to the Canadian embassy. She said it was in honour of Voznesensky, who was going to Canada. The administrator said there was no need for him to go to Canada, and none

for her to go to the dinner at the Canadian embassy. She said both Voznesensky and she were friends of mine and that was good enough for her. This was the kind of idiocy these poor souls had to cope with day in and day out.

Plisetskaya was most outspoken, and talked bitterly of the heavy-handed conformity still imposed on the ballet and opera performers, choreographers, composers, directors. The Stalinists still held the classics in their iron grip.

I asked if she saw much of the money which she and the Bolshoi Ballet made abroad. 'Only a few dollars really,' she replied, 'but occasionally Gosconcert relents and suddenly releases some foreign funds for us.' In fact she came to the party in a Citroen sedan. In passing I mentioned that Thereza knew Molly Parnis, the New York dress designer, who had told her that she had sent Plisetskaya a dress but had never heard if it had reached her. Plisetskaya said unfortunately the dress was sent to her care of the Bolshoi Theatre and was confiscated by the administration. Just the previous week she had been about to leave for West Berlin for a ballet festival when she was told her trip was off.

'I was to dance *Swan Lake*, which I thought sufficiently inoffensive ideologically, so I could not understand what had happened – until someone whispered to me that Nureyev was also going to be in Berlin. Then I understood.'

Plisetskaya also referred to the defection of the ballerina Natalia Makarova, the star of the Kirov Ballet in Leningrad. 'Everyone knows why she left. It was not political. It was just pure artistic frustration!'

But that, she said, would have no effect on those who controlled cultural policy. It seemed almost impossible that the two best ballet companies in the world, the Kirov and the Bolshoi, should have to go on year after year frittering away their talents in endless repetition of the classics. 'We're like dead souls,' she said, 'dancing mindlessly.'

There were a few promising young ballet stars coming forward, she said, from the Leningrad and Moscow schools. Occasionally there were arid years and then there would be a great harvest of talent. But she thought also that in the younger generation there was less dedication to the terribly hard work required to

become a great dancer. A horrifyingly large percentage just dropped out.

Plisetskaya was not very optimistic either about the chances of the atmosphere in the arts improving. Indeed, she thought it was likely to get even duller and greyer. In her opinion the one bright spot was Voznesensky, who by his sheer genius and courage managed to create poetry which had nothing to do with ideology or socialist realism. I asked her what she thought of Solzhenitsyn but she said she preferred silence on that subject. Later on, however, Katanyan volunteered that the Soviet literary world, even those who opposed Solzhenitsyn's political views, recognized the true voice of greatness in his work.

Plisetskaya, who is Jewish, mentioned to Thereza a recent vicious anti-Zionist declaration naming her and other artists. She had protested but no one had paid any attention. She also said that when she was at the Ministry of Culture recently she was told that Nicolas Koudriavtsev, the Canadian impresario who was recently in Moscow, had been informed that a Bolshoi Ballet group which was to tour Canada next spring could no longer go because Plisetskaya did not want to go. It was the first she had heard of the subject at all.

She recounted the troubles her husband had had in getting his ballet *Carmen* produced, and how it was changed three times before it was eventually and very reluctantly approved. Shchedrin had temporarily given up writing music for the stage. He had been 'instructed' to write music for a ballet based on *Anna Karenina* and he had tried but he could not complete it. The idea of producing another nineteenth-century ballet was too much for him. His most recent work was twenty-eight preludes and a fugue for piano.

Kirsanov, who at my urging had been the Soviet representative at the Canadian gathering of poets in Expo '67, was relatively quiet during the evening. He looked as if he was beginning to tire of the job of keeping his young wife happy. She was taking pleasure in showing off an elegant costume she had bought in London. She told us she had chosen science as a profession and concentrated on the study of ice – reasonable for someone who had grown up under Stalin, she said.

Lili Brik was perhaps the happiest person there, even though

she had recently been attacked maliciously and stupidly by some Soviet magazines who claimed she had been little better than a prostitute who had played no serious role in Mayakovsky's work. The real reason for the attack, she said, was the role her sister Elsa had taken in encouraging her husband, the French Communist poet Louis Aragon, to denounce the Soviet action in Czechoslovakia. Lili's story was so fascinating, I have reserved it for an entire chapter later.

Maya was right. The opera and ballet continued to be boring beyond belief, although magnificently performed. That spring we had dinner at the West German embassy with some of the stars of the Stuttgart Ballet. They were appalled by the sterility of Soviet ballet, and equally affected by the fact that the Soviet dancers and choreographers realized it was lifeless. It gave them considerable pause, to imagine being deprived of freedoms which they took for granted, without which their art would die.

Oddly, the Soviet Union produced some of the most original, innovative and popular artists in another sphere, the ballet on ice of figure skating. It was a paradox why the art that was so ossified on the ballet stage bloomed on the ice. Perhaps this was in large part because the ballet and opera, even through the Khrushchev thaw, remained under the absolute control of the Stalinists in the Ministry of Culture, who saw their mission rather as museum curators, guarding fragments of history. But figure skating came under the aegis of the Sports Union, and in sports, winning was everything. Whatever the West was doing, they would do it better, even if that meant distinctly unstalinist innovation, beauty, and daring. The pinnacle was perhaps the sublime artistic achievements of the Protopopovs, the husband and wife pairs team. This excellence continued right through 1994 to the poetry on blades of Ekaterina Gordeeva and Sergei Grinkov. Ironically, many of the best skaters owed their ethereal grace, precision, and flexibility to the ballet; some came from the Bolshoi itself.

That spring in 1972 I met some of the Soviet skaters at a dinner I gave in their honour before their departure for a competition in Calgary. Although all of the skaters were very young, they were quite self-assured. The men's singles silver medallist, Andrei Chervukhin, a handsome, fine-featured young man, was obviously

the most independent-minded and the only one who drank a glass of champagne. He said flatly that this was his last year in competition – unless 'they' forced him to continue. This, in spite of the presence of the two coaches and a formidable woman from the Sports Union. He said he had more important things to do in life. When Thereza remarked that he looked as if he were of aristocratic origin, he blushed scarlet and changed the subject.

Most of the skaters complained of the discipline to which they were subjected. When I told Marina Rodnina (of the world pairs champions) that our Canadian champion, Karen Magnussen, told me she had great difficulty in devoting more than a few hours in the morning to practise, she sighed and said their average was six and that this went on for eleven months of the year. They had special school classes and their examinations were arranged to take account of world competitions. Another skater added that on the other hand they had lots of privileges, such as access to dollar shops and above all foreign travel. When I ventured that this all sounded highly professional (they are all supposed to be amateurs), she just shrugged her shoulders.

We were puzzled at a certain frostiness in the air at the dinner. It seemed that Marina Rodnina and her partner had become estranged during the Olympics in Sapporo, Japan. The latter had apparently fallen in love with a Miss Smirnova, who was the female partner in the number two couple in the Soviet team, and had spurned Miss Rodnina. True, alas, all too true. He married Miss Smirnova the day before our luncheon but, not knowing this, we had placed the two ladies opposite each other. He refused to leave his bride and sat beside her while Miss Rodina alternately glared and feigned indifference. It did not stop them all winning first and second places in the pairs competition at Calgary.

Little had changed in the ballet world when two of Canada's finest dancers, Karen Kain and Frank Augustyn, visited Moscow some years later on a cultural exchange. A dinner party for them, in fact, turned out to be a great deal more difficult to arrange than the one I had held for the Bolshoi dancers going to Canada some years back. I approached the director of the Bolshoi, Giorgi Ivanov, to secure his cooperation. The next I heard was a call

from the chief of protocol of the Ministry of Culture, Vladimir Starozhilov, ostensibly hurt because we had not first approached him. We submitted a list of names for him to vet. He replied that the party was approved in principle and he would let me know in due course 'who was permitted to come.' I seldom saw the control and censorship principle spelled out quite so blatantly as this.

In the end he vetoed quite a number of dancers, including Maya Plisetskaya and her husband. Plisetskaya phoned to apologize with a transparently lame excuse. I later heard from Voznesensky that she had been told that 'she need not go.' It seemed extraordinary that one of the world's top ballerinas could not attend a party in honour of Canadian dancers performing at the Bolshoi because of pretty party bureaucrats.

In the end the party was total confusion. The Canadian dancers were in Kiev, due to arrive in Moscow at noon the day of the dinner. At six they phoned to say they still had not taken off because of fog and had to come by train. Obviously they could never make it. The Ministry of Culture, we later discovered, then phoned to the Bolshoi dancers to tell them not to come to the embassy. Many came anyway, including Mariis Liepa. Though supposedly the director of the nation's pride, the Bolshoi, Giorgi Ivanov did not know about all the delays and ministry's interference, and kept saying he could not understand why such and such a dancer had not turned up 'since it had been approved.'

Ivanov was formerly deputy chairman of the State Committee on Television and Radio, and he seemed to know very little more than a well-informed layman about ballet. He looked and acted like a KGB-oriented administrator – which he probably was. Liepa was happy because he had been trying for three weeks to see Ivanov without avail. 'The previous director,' Liepa informed us aside, 'was fired because most of the staff ganged up on him and he did not have sufficient party support to resist. Now we all regret it because Ivanov is a conservative dogmatic. He's a fanatic for conformity.'

Liepa reported that the mood in the Bolshoi was dreadful and was dominated by petty personal quarrels and internal politics. This was not unheard of in the West, of course, but here it was darkened by more sinister politics. The choreographer, Yuri

Grigorovich, had no imagination. The few new productions, such as *Ivan the Terrible*, were poor, but Grigorovich rejected all suggestions and opinions. He was preferred by the authorities largely because his ballet *Spartacus* was politically acceptable and popular abroad. Liepa was barely on speaking terms with Grigorovich. At a recent special ballet evening honouring the choreographer's sixtieth birthday, the only major dancer excluded was Liepa.

'That was because I had an affair with Grigorovich's wife,' he said with a shrug. Grigorovich was married to the ballerina Natalia Bessmertova, but Liepa claimed he was a covert homosexual, and was having an affair with a male set designer; Liepa's theory was that he exaggerated his jealousy to conceal his own peccadillo.

'Now the Bolshoi is going to Paris without me,' Liepa went on. 'I knocked on the usual doors, nothing. Finally I got to see Demichev.' The austere minister of culture was now also a candidate for the Politburo. Peter Demichev sent orders to include Liepa. Ivanov reluctantly agreed but they had rearranged the program in Paris so that the two ballets in which he was to dance would be performed on consecutive nights, and he was given an exit visa for only four days. He therefore refused to go.

But how on earth could he have influence with someone as powerful as Demichev? 'Simple. I'm sleeping with Brezhnev's daughter. As a matter of fact I'm having breakfast with her tomorrow. "They" are afraid to be too nasty to me.'

Liepa was worried that the young dancer Nadezhda Pavlova was being brought on much too fast, largely for political reasons. She was from the Perm Ballet School and had won the Moscow Ballet Festival gold medal in 1973. The following night we went with Ivanov to the first performance of Pavlova in *Spartacus*, and even he had to admit that she was too young and too green for the role.

'And even the floor at the Bolshoi needs renovation,' lamented Liepa, 'and nothing is done.' The wooden floor of the stage was rotten, as Karen Kain could attest, and many of the sets were old and falling apart. The corps de ballet was getting worse and there was very little enthusiasm, particularly since the new ballets were so dismal. 'Now they've got us doing this thing called *Angara*.

We're expected to dance about building a dam in Siberia,' Liepa cried. 'It's bloody awful!'

At the Kirov, thirty-six of their male dancers had died. 'Suicide,' said Liepa. 'They just couldn't take it any more. I don't mean mass suicide like those crazies in America. But many deaths in recent years.' He cited frustrations, boredom, and perhaps above all harassment for homosexuality, which was considered a crime in the Soviet Union.

I saw Liepa a few months later dancing *Swan Lake* with the Kirov Ballet in Leningrad. After the ballet he came to the front of the theatre, still in his costume, to say hello and apologize for having once again to dance this old ballet. Shortly after that he had a heart attack and disappeared for some time, leading to speculation that he had committed suicide. Over the years Liepa's restlessness resulted in fewer roles. He drank a good deal, and died in 1989. But he left the best possible legacy, a son Andreas, who has become a talented dancer. Andreas has also accomplished a feat which in his father's time would have been totally inconceivable: while performing and living in the West he established a permanent base of operations with the Kirov in Leningrad.

IN THE MOUNTAINS

Andrei Voznesensky

Here, as one breathes, one writes –
Free, and with full heart –
As the heavens blaze
And as the ploughed land rings.

I am giddy from the heights,
And from the highway, blinking
In the sun, the road workers stand
Like half-naked Gods.

And the girls with cherries
And wild berries in their hands –
Like simple Grecian
Goddesses and Bacchantes.

In the sun their noses are peeling,
Like the painting in frescoes.
Here as one loves – one writes –
Boldly, with deep emotion.

1977, at the dacha in Peredelkino:
Vasya Katanyan, Robert Ford, Lili Brik, and Thereza Ford

THIRTEEN

A Miasma of Oblomovism

Thereza and I would often make a pilgrimage to Pasternak's grave. It lay near a lovely old church in Peredelkino, the woodland retreat of the literary elite. The church was washed in the pastel colours typical of Russian architecture. I was always moved by the sight of the grave, on which nearly always a few bedraggled flowers has been laid. In winter one occasionally found a single paper flower. It prompted me to poetry, 'The Grave of Pasternak.'

> The wind withers
> At the windows of the voices,
> Tapping gently, then lost
> In the infinite space.
> The snow is convent pure.
>
> In the first light
> Of Peredelkino
> He lies alone with one
> Paper flower, faded, wet,
> Staining the snow.
>
> The voices can be heard again.
> And the windows reopen.

Through the pine trees one could glimpse the dacha where Pasternak had lived from before the war until his death. Despite *Dr Zhivago* and other inflammatory work, he had miraculously held on to it. There was a great scandal at Peredelkino because Pasternak's family had refused to vacate his dacha, and the authorities did not have the courage to risk world-wild opprobrium by expelling them, even though it would be in accordance with regulations.

In 1972 Andrei Voznesensky and Zoya finally acquired a dacha in Peredelkino. Profits from their last books made it possible to buy the bottom half of a new cottage. Andrei could will it only to Zoya, or an immediate relative if she or the relative were a writer. Otherwise it would revert on his death to the Writers' Union and he could only sell it back to the Union.

The grounds were a mess. But it stood in its own acre of pine woods and the Pasternak dacha could be glimpsed from the main window. The dacha itself, although absolutely new, was a nightmare. The steps were uneven, the windows did not close properly, the curtains were crooked, and the heating system was so deficient that we spent most of the time wrapped in our overcoats. One door, leading to an open veranda, had been completed in stained glass, 'like Chartres,' Andrei naïvely explained. He was so enchanted with the dacha he was designing a ceiling of stained glass with hidden lights to illuminate it.

There was very little furniture: a big bookcase on one wall, a huge table around which we spent the entire day, and a number of posters and drawings including a Chagall, a Tishler, and a poster from Paris advertising Maya Plisetskaya.

We arrived at eleven in the morning, and almost immediately the food began arriving (and continued intermittently until five in the afternoon when we staggered away). After experimenting with various wines, and even Japanese saki, our host in a typical Russian fashion dismissed them all in favour of vodka. Most of the food was fetched by Zoya from the nearby Writers' Union canteen, but the soup and hot dishes she prepared herself. Towards the end of the gargantuan repast the subject of carp arose. Yes, carp. Thereza mentioned that she liked carp, upon which Zoya rushed into the kitchen and reappeared with a carp

A Miasma of Oblomovism / 173

all ready to be baked. A chorus of arguments finally dissuaded her from cooking it then and there.

Apart from the dacha itself there were many signs of affluence, relative to the normal Russian standard: whiskey and other items from the dollar shops (Andrei said he got the occasional hard currency transferred from his foreign publishers on condition that it is transformed into 'certificats' which could be used to purchase foreign goods in special shops), a Volga car, Cardin slacks and sweaters on both of them, a very fancy artificial fur coat on Andrei, a television set, and a modern kitchen.

We talked of Russian literary emigrés, especially the strange case of Stalin's daughter. Svetlana Alliluyeva had married an Indian and turned to religious mysticism. After her husband died in 1966, Svetlana obtained permission to take his ashes back to India, and then defected.

'I hear Svetlana wishes to come back to Moscow,' Andrei informed us. Certainly the Russian emigrés had difficulty in adjusting themselves to life outside of Russia. But that Svetlana wanted to return after her dramatic and emphatic rejection of the place was news indeed.

'In any case,' said Andrei with candour, 'where else but here can you live well and do practically nothing? It's impossible for a poet in England or France or the United States to live and work only as a poet. They all have to do something else. But even bad poets in the Soviet Union are assured a reasonable living, as long as they don't get in trouble.'

'In trouble' meant being sent to Siberia. Andrei admitted he lived well, but insisted he worked hard at writing good poetry. And he travelled around the country giving lectures and recitals. The latest were at the Institute of Theoretical Physics and the Atomic Energy Institute. There was an audience of about eight hundred in one and more than a thousand in the other, showing the Russian love of poetry, even among scientists. He pulled out of his jacket pocket a fistful of slips of paper on which questions had been written for him to answer.

Inevitably the subject of Solzhenitsyn came up. Andrei asked me what I thought of *August 1914*. The book was to be the first in a trilogy on the First World War on the Eastern Front, up to the

Revolution. I had found it curiously antiquated and formless. I thought it a pity that Solzhenitsyn had concentrated on writing a historical novel of one of the turning points in the First World War, the battle of Tannenberg. However, *August 1914* was a bestseller everywhere in the West. In the Kremlin, it was causing apoplexy. 'It makes everything Russian look stupid, inefficient, superstitious, and hopeless,' Andrei explained, 'whereas all the Germans are painted favourably.' Needless to say it was not published in the Soviet Union. *August 1914* also implied that if the czarist army had been more efficient it could have beaten the Germans and therefore the Revolution would not have taken place. This, of course, was in direct contradiction to Marxist ideology – that the Revolution was an inevitable evolution, not just an accident of history.

I mentioned that Arthur Miller and some other American writers were trying to transfer their dollar royalties to Solzhenitsyn. Surprised, Andrei said, 'But Solzhenitsyn doesn't need the money. Some of his royalties come to him in the form of hard currency or "certificats." '

So Solzhenitsyn's fellow writers felt that he was not suffering materially. Of course, spiritually it was another question.

During the long languid day other names came up. Our old friend Simeon Kirsanov had died a few weeks ago, leaving his young and beautiful widow. 'She only married Kirsanov to get permission to live in Moscow,' Andrei said drily. She was a geologist graduate of Moscow University and horrified at the prospect of field work in Yakutia. One could hardly blame her. She did become very fond of her husband and the literary circles in which he lived. However, she was not losing time in adjusting to new circumstances. Gossip had it that she was having an affair with the American leftist folk-singer, Dean Reid. Other rumours said Reid's girlfriend was Marina Vlady, the French film star who married the Soviet balladeer Vysotsky.

'A little unlikely,' mused Andrei, 'since Marina Vlady only comes to Moscow at irregular intervals to enjoy the peculiar pleasures of living with a Russian husband.'

'What are those?' I asked.

'Nothing erotic, but she is of Russian blood and she enjoys being kicked around by a man for a change.'

He told me that Bella Akhmadulina was now sick and unhappy, drinking too much, changing husbands too often. He was afraid she would drive herself into an early grave. This had happened to Ivan Kharabarov, a brilliant young poet who had died last year because he was unable to find a way to express himself adequately without offending the literary hacks. 'He just sat down,' Andrei said, 'and deliberately drank himself to death.'

Relations between Yevtushenko and Voznesensky had deteriorated rapidly in the political stress of the early 1970s. The subject arose that afternoon in Peredelkino; it always did. Yevtushenko had made his obeisance to the renewed repression by the regime with some ritual poems on Vietnam, and the sins of the American invaders.

'I wouldn't mind Yevtushenko trying to play the game of the government,' Andrei said archly, 'if he were a better poet.'

He then told a story about an attempt by Yevtushenko to infiltrate into the Taganka Theatre a reactionary member of the Writers' Union called Safronov, about whom 'everyone had suspicions.' He recounted a rather bizarre episode when Yevtushenko brought Safronov to a party in Lyubimov's office, upon which Lyubimov, followed by all present, walked out.

This kind of manoeuvring and scandal-mongering seemed an integral part of the rather closed intellectual circles, not unfamiliar to those who have lived in university faculties in the West. There was a good deal more gossip about who was sleeping with whom and so on, but hardly worth mentioning.

When Thereza and I were in Paris over Christmas some French friends had remarked to me that in French intellectual circles it was considered that both Voznesensky and Yevtushenko had sold out to the regime. I told Andrei I had pointed out that the two cases were very different. Voznesensky had never taken part in any political activities. His poetry was certainly not socialist realism but was so good that the regime dared not do anything about it. Of course, Andrei liked the good life and would be foolish not to accept the amenities that went with literary success. This did not mean that he had changed his political position, which was basically that the important thing was to write the kind of poetry he wanted to. For this purpose he obviously could not openly

oppose the regime. Yevtushenko, however, did engage in a dangerous and delicate dance with the political czars: one step forward to denounce the invasion of Czechoslovakia, one step back with something to pacify them. After some moody reflection, Andrei agreed that I had summed up the situation fairly well.

Voznesensky was a comfortable man, 'bien dans sa peau' as the French say so well, at ease in his own skin. Yevtushenko was a restless creature, full of coiled energy. One morning in 1973 he telephoned me at seven o'clock to say that he had to see me urgently – that day, just five minutes, it had to be now. He stayed over an hour. He wanted my help with the Union of Writers for permission to accept an invitation from York University in Toronto.

'It's the best invitation I've ever received!' he enthused. Yevgeny was always like that, permanently in superlatives. He was to be poet-in-residence, 'like a Canadian student,' for six weeks with no obligations. He could travel at York's expense anywhere in Canada. And he would give one recital at Maple Leaf Gardens in Toronto – that huge arena more usually the venue for hockey, wrestling matches, and rock stars. He would receive a minimum of $10,000 and much more if the Gardens sold out.

'But keep that a secret from the Union of Writers,' he warned conspiratorially. He was fired with the notion of going into the Canadian forest and getting the feel of the big woods – though lord knows, there was plenty of that right at home.

I asked why he needed our support. He gave a long and involved justification of his position and a refutation of recent criticisms in the western press accusing him of selling out. 'It baffles me how the position of writers in the Soviet Union can be so misunderstood abroad! I never made any secret about being a patriotic Russian and a supporter of the Soviet society!' He meant that he supported his *country*, not its communism.

'And I have spoken out more often than many others, including,' he added pointedly, 'your friend Voznesensky.'

After a pregnant pause, he went on. 'And I have contributed to literature *and* helped liberalize things for writers! Of course I don't put myself in the same league as some others. But only a very few can do that and get away with it.' He was obviously referring to Solzhenitsyn.

'Me, I prefer to work within the system rather than spend my time in futile silence!' he finished with a flourish.

I sympathized with this attitude, commiserating that I had heard French intellectuals say that he was 'vendu au système.' And he went off into another long harangue about the insensitivity of those living in the West who understood nothing at all of the calculations which had to be made by a writer living in the Soviet Union who loved his country, loved living, and still wanted to write 'something he was proud of.'

He was particularly indignant over a recent *Time* story about his recital in Singapore. This very negative piece talked only of a hostile group which queried him about his role in Soviet politics. There was no word in the story about his successful recitals all over southeast Asia, including sold-out halls in Singapore for the first time in the history of that city. But this was no longer news and *Time* was a news magazine. Yevtushenko, though, was convinced that even some of the top American journalists were working for the KGB. That's what happens to the human mind in a world of secret police – it begins to see conspiracies everywhere.

Yevtushenko got back to the dreadful Union of Writers. 'It's a body of old women,' he spat, 'who spend half their time in jealous examination of the privileges of others – like cats scratching on the soul. You must help make them let me go to Canada!'

It seemed they had already approved a few other foreign trips for him, and this was perhaps one too many for them. But they weren't famous for being susceptible to crooning from western diplomats.

'You remember how long it took to get Voznesensky there and how difficult it was?' he explained. I said I did indeed.

'I came to the Union of Writers for a meeting a few days after Voznesensky was received by your prime minister. Georgi Markov, the secretary of the Union, who is a real son-of-a-bitch, admitted that he had opposed the trip, but he had just received a report on the meeting between Prime Minister Trudeau and the poet and he saw he had been wrong.'

Yevtushenko imitated how martinet Markov saw the light: 'Of course,' he pontificated, in Markov's pompous tones, 'Mr Trudeau had not meant to honour Voznesensky but to honour the Union of Writers, and this is something we greatly appreciate.'

This extraordinary statement, Yevtushenko added, was received with laughter and guffaws. But it showed how much importance the Union of Writers attached to the reception of their members abroad.

'So I wonder if it would be possible, if I go to Canada, to meet the prime minister?' said Yevtushenko with disarming ingenuousness. He mentioned, somewhat gratuitously, that he had been received by President Nixon at the White House for over an hour. Yevtushenko then produced a new book of translations of his poetry, and inscribed it 'To Mr. Pierre Trudeau with love to Canada – Siberia of American continent – from my Russian Siberian heart. Yevtushenko.'

This constant drama over foreign travel, and the strenuous contortions of the writers to pry loose the precious permission, was a bizarre tragi-comedy, like all of life in the workers' paradise. It was also another paradox in this looking-glass world: the politicians had managed to elevate the poets to the status of political dignitaries by repressing their poetry. How many other nations' poets could seriously ask for an ambassador to arrange tea with the prime minister?

Yevtushenko kept up the effort relentlessly. A few months later he called to say he had to see me urgently 'for five minutes only.' As usual, he stayed for an hour and a half. Agitated and angry, he seemed an irresistible force of nature. He stormed impotently about the Union of Writers, Russia's unique immovable object.

'I'm living in a miasma of Oblomovism!' he ranted, waving his arms. (Oblomov, the hero of a novel by Goncharov, spends his entire life lying around in bed spinning wonderful plans, and never gets to do any of them.) 'It's like one huge *bolata* (morass),' he said, slumping into a chair.

It seemed there had been a conference of Asian writers in Alma-Ata, and since Yevtushenko was a Siberian he could conveniently be labelled an 'Asian writer.' Therefore the government had insisted on his taking part. 'Of course I was born in Asia,' he said, 'but I'm not exactly an Asian. I'm a Siberian – which is a kind of uninhibited Russian.'

Furthermore, he intended to stay at home to work in the establishment of a new literary review. He had the idea of a new maga-

zine which would help young writers, giving them an outlet for their work, and encouraging criticism. It would be a quarterly to start with, to be called *Workshop*.

'There is no place for young writers to get published now unless they are totally traditional. *Novyi Mir* and *Yunost* are unreadable now,' he argued. There was no longer anyone like Tvardovsky, the former editor of *Novyi Mir*, who for many years had helped to publish the new poets after Stalin's death, including Solzhenitsyn himself.

The big problem with *Workshop*, of course, would be the censorship. 'A few years back when I was on the editorial board of *Yunost*,' he said, 'before that son-of-a-bitch Kuznetsov denounced me as an imperialist agent – and then he defected to England, the bastard! – everything had been authorized except for a series of poems by a young writer. I was the only editor on duty, so I called the censor and asked for clearance. There was some humming and hawing and then she asked what *I* thought.

'The poems are very beautiful but rather sad,' I replied.
'Ah,' said the censor, 'just what I thought.'
'So what?' I asked.
'So should we publish them?' the censor queried.
'Why not?' I said. 'After all, you're not happy all the time, are you?'
'No,' she admitted. Then, after a pause, 'perhaps you could convince the poet to write a couple of happy poems as well?'
'I can't do that,' I told her, 'and if we publish the sad poems the poet will be happy and his next poems will probably be happy ones.'

'It was absolutely moronic,' he finished. 'I was reduced to talking that kind of gibberish.'

The censor was tempted by his persuasive blather. But in the end she refused to take a chance. 'And now,' he added gloomily, 'things are even worse, believe it or not.'

At the Alma-Ata conference, he went on, a group of officials arrived from Moscow to persuade the Soviet participants to sign a letter condemning Sakharov and Solzhenitsyn. He said he had refused indignantly. He returned to Moscow and was called to the Union of Writers and asked to explain why he had refused. He

said his position had always been clear and needed no explanation. The secretary of the Union then said, 'Suppose you were editor of a magazine, would you still refuse to sign?' In spite of the veiled threat, Yevtushenko said the answer was still no.

But finally they let him go to Canada in October, where he was a huge success. And he did indeed meet Prime Minister Trudeau. The Union had told him not to mention it to me, which he thought was idiotic.

Some years later he gave a select few journalists a fuller explanation of the apparent special status that provoked so much suspicion of his relations with the KGB. Whenever Yevtushenko travelled abroad, his fees were to be held by them in a special personal account for him. The KGB would then dole out bits to him as he needed it, which was of course very little in a society that cared for all of one's needs ... and meanwhile they would take good care of his money themselves.

SIBERIA

R.A.D. Ford

This northern wound laid bare
To the unpractised urgent hand
Cries in the crystal night
To the heart and the bludgeoned head.

Salt in the open veins,
Terror in the dusk, the dead,
The dead with open eyes,
Under the frozen pines.

Lili Brik and Vladimir Mayakovsky, St Petersburg

FOURTEEN

The One-Eyed Monster

Yevtushenko was always springing surprises, keeping people permanently off guard, perhaps even wary of his eccentricity, his artistic humours. This included the powerful chairman of the State Committee on Radio and Television, Sergei Lapin, a surprising fellow himself, being more affable than most in his high position. At a luncheon for the visiting president of our own network, the CBC, he arrived late, apologizing profusely. 'It's on account of your friend Yevtushenko,' he said.

'Good God, what has he done now?' I asked.

'Oh, nothing much!' Lapin replied, 'he just refused to leave the State Committee offices without seeing me. And what do you think he wanted? He tried to persuade me that Soviet TV was making a terrible mistake insisting he give poetry recitals when he is really an actor! And he wants to perform in a serious play.'

It sounded exactly like Yevgeny, and I said he probably believed it all. 'You'll have Voznesensky too. He wants to be a song-writer or a theatre director.'

'Well,' Lapin went on, 'he said: "I have the soul of an actor buried here inside me, and you must help me to let it out!"'

I could not help laughing, but that wasn't all.

'And what role do you think he wants to play?' Lapin went on.

'Hamlet?' I suggested.

'No. Cyrano de Bergerac, for heaven's sake!'

I gathered the answer to Yevtushenko was negative. Lapin was busy putting the finishing touches to the radio and TV programs for the New Year. All he needed, it seemed, was the final personal consultation with Brezhnev and Kosygin when they returned from the Vladivostock summit with American President Gerald Ford.

'For a New Year's show? Brezhnev himself?' I asked in some surprise.

'Oh absolutely. There will be an audience of over a hundred and fifty million people. It's most important. And Brezhnev takes a very keen interest in TV. He likes to screen everything before any show is finalized.'

No book about a nation's arts and culture would be complete without at least a mention of the one-eyed monster in the nation's living rooms: television. In the Soviet Union, that nickname had very special overtones. It was alternately sinister and absurd. In its early years, of course, it was predictably boring, doctrinaire, and heavy-handed. It improved somewhat in the mid-seventies with the appointment of Lapin. Voznesensky agreed with this assessment. Lapin, he told me, was close to Brezhnev, a television fanatic. When Brezhnev visited Berlin in 1974 he asked Lapin if there was anything on TV that night. The only thing of interest was a rebroadcast of a Canada-USSR hockey game on East German television after midnight. Brezhnev consulted his doctor, who agreed to let him stay up to two in the morning to watch it.

Andrei also credited Lapin with coming to his personal rescue. At one of our interminable Russian lunches, Andrei showed me a blow-up of a photo of himself reciting and lecturing at the podium of a cultural conference in 1963 – with the Politburo on the dais behind him. Khrushchev was standing and shaking his fist. He interrupted every couple of minutes for a half hour. After shouting him down, Andrei finally had to give up. (I give a more complete description of this curious episode in my book *Our Man in Moscow*.) Then Andrei pointed to Brezhnev in the photograph and said that he was the only one who did not applaud Khrushchev. 'Brezhnev,' he said, to my astonishment, 'is a lover of poetry and can even recite reams of Yesenin by heart.'

While I tried to digest this stunning piece of Russian dichotomy, Andrei rushed on. For eight years after that conference

Voznesensky was forbidden to appear on Soviet television. 'Lapin went to Brezhnev personally and got this decision reversed.'

The great television event of 1975 was the Apollo-Soyuz space flight. There was considerable puzzlement about the extent to which the Soviet authorities had gone out of their way to stress American-Soviet cooperation. One writer remarked on the cynical way in which leading Soviet television and press commentators had shifted from the violently anti-American line to one praising things American. He cited in particular Valeri Zorin, perhaps the most viciously anti-American TV personality in the days before the rapprochement between Washington and Moscow. He said that Zorin's programs had had no effect whatsoever, at least on the intelligentsia, and he doubted that very many ordinary people paid much attention either. There had been numerous jokes about Zorin when he changed his tack after the first Nixon-Brezhnev meeting in June 1972.

The decision to show Apollo-Soyuz live caused endless problems, according to a friend of Andrei's who wrote for television. It was the first time such a live telecast had been undertaken. The producers were frightened that something would go wrong and were invariably ill prepared for the unexpected. When President Ford telephoned direct to the cosmonauts and astronauts, the logical thing would have been to link Brezhnev up with them, but they were paralysed by fear of doing the wrong thing. In any case, there were so many bits of red tape to disentangle to get Brezhnev's approval that in the end nothing was done. Even Andrei Kirilenko, the member of the Politburo who was running the shop, realized it was a dismal failure. But the TV studios received huge numbers of letters from across the country from people worried that the United States might appear to come out of the joint mission better than the Soviet Union. This paradoxical chauvinism grew out of that fierce national pride that transcended politics, suffering, and repression.

The same TV writer said it was obvious that the Soviet equipment and everything else was so much more primitive than the American that he wondered why on earth there had been so much publicity about it. He also said the space flight disaster a few years before was common knowledge, despite all publication

bans. Apparently there had been tremendous pressure on the space centre to copy the American feat of sending three men into space. The Soviet spaceship could really only carry two cosmonauts comfortably but they forced three into the ship. This was too small for moving about and when they started to come down there was not enough space for them to get back into their pressure suits, so that the astronauts simply burst when the ship re-entered the earth's atmosphere.

Not long after I learned that Sergei Lapin was being kicked upstairs, due to 'problems' at the network. He was promoted to irrelevance as chairman of the Presidium of the Supreme Soviet of the RSFSR – a purely honorific position. After his departure Soviet television became unbelievably boring again. One official I spoke with explained that I should realize it was primarily directed to the *kolkhozniki* (collective farm workers). Out of the two hundred and seventy million Soviet citizens there were only a few million who could be considered intellectuals; so television had to be pitched to the masses, not the intelligentsia. I countered with the argument that they made even more serious errors in that case. How could they have the chairman of a Volga Valley farm boast about the great successes of Soviet agriculture, including the production of potatoes, as he had recently, when there was not a potato to be bought in the markets of Moscow? And this was something which every Russian knew. He looked very embarrassed but did not deny either the scarcity of potatoes or the aridity of television.

For a long time I had been prodding the Union of Writers to give some recognition to Canadian literature. Suddenly and without prior notification I received two copies of the literary monthly *Oktyabr* for August, containing a section entitled 'Canadian Poetry.' This consisted of translations of two poems by myself, 'Trans Canada,' by F.R. Scott, 'Christmas Eve in Toronto' by Raymond Souster, 'The Dark Around the Light' by George Bowering, and Harold Griffin's 'Lovesong.' Oddly, in my first poem the sentence 'That is the trouble with our north' was inexplicably omitted. But then in the Soviet Union even the word 'north' was loaded. To the best of my knowledge this was the first

time that Canadian poetry had appeared in Russian translation. *Oktyabr* was a very conservative journal but one of the most widely read in the Soviet Union. (It was later taken over by liberals under Gorbachev.)

In order to boost circulation of the orthodox journals, many of them now had to include translations of mystery stories by well-known western writers such as Agatha Christie and Rex Stout. The editors obviously hoped that the readers then leafed through and read some of the other deadly dull but ideologically sound material.

At a small reception in 1975 I managed to have a long conservation with Igor Mosaevich Itskol, a Soviet specialist in Arab language and history, and formerly married to one of the daughters of Nikita Khrushchev. He was a bit vague about his current posting but I gathered he was connected with the Tass Agency. His father was Jewish and his mother Tartar. So we talked a good deal about Jewish and other ethnic minority problems in the Soviet Union. Itskol said he did not consider himself particularly Jewish, and he was neither a Zionist nor religious. Nevertheless he could not help but be interested in the problem because he was officially a Jew as far as the Soviet authorities were concerned and was so described in his passport.

Itskol said in many ways the 1967 Arab-Israeli War had done a great disservice to Soviet Jews. Surprised, I listened closely to his rather unusual reasoning: if it had not been for that, the process of assimilation of Russian Jews would have continued and he thought this was the only solution. He then proceeded to outline the terrible restrictions under which Jews lived during the czarist regime and pointed out that not one major Russian figure in any field of intellectual activity – music, painting, literature, science, politics, medicine – in the nineteenth century was of Jewish origin. (I suggested that he forgot Blok but he said that Blok really came at the very tail end of the czarist regime and only worked during the twentieth century.) When restrictions were lifted after the Revolution there was the fantastic burgeoning of Jewish genius in Russia and he ticked off an extraordinarily long list of Jews who had made major contributions to the intellectual, musical,

literary, and political life of the Soviet Union. But, he went on, none of them really thought of themselves as anything but Russians and it never occurred to any of the writers to use Yiddish, or even less likely, Hebrew. They were thoroughly Russian and it could not have been otherwise.

I suggested that it was precisely this assimilation that many Jews feared and that, while the 1967 war did stop this process, perhaps the majority of Jews were pleased that it produced a revival of interest in their identity as Jews and in their religion. I recalled that I was in Moscow in 1947 when Golda Meir arrived as the first Israeli ambassador after the establishment of the state of Israel, and that this had evoked an enormous revival of interest by Soviet Jews in their Jewishness. Itskol agreed that this argument was valid but then said it was only a good argument in the abstract because it was apparent, given the Soviet system, that, first, only a tiny fraction of the Jews would be permitted to emigrate and, second, for those remaining it would be harder than ever to maintain their identity as Jews and equally hard to become Russians.

As an Arabist Itskol went to Jordan just before the 1967 war and managed to cross through the Mandelbaum Gate into the Israeli part of Jerusalem. He claimed to have been greatly disillusioned, as a Jew, by his brief sight of Israel. What he objected to, he said, was the discrimination against the Sephardic Jews from Arab countries and the Middle East. And the sabras, or nature-born Israelis, did not coincide at all with his idea of what a Jew should be. I said his idea of a Jew was obviously a cultured Russian. He allowed that I could be right, but he still felt that no one except a fanatic could really want to live in Israel.

Itskol also saw a stirring of religious feeling among the Russians, above all the young. There were perhaps not so very many who dared practise the Orthodox religion regularly, but an increasing number were interested, went to church occasionally, got married in church, and had their children baptized. There was a vague kind of longing, he believed, particularly among the young, for values which transcended Marxist materialism. 'Take your friend Voznesensky,' he said. 'He is a deeply religious person and for those who understand, it comes clearly through his poetry.'

Connected with this, Itskol said, was a deepening attachment

to conservative thinking. Russians, even intellectuals, with some important exceptions, have always been profoundly conservative, and this was as true today of the so-called revolutionary Marxist leaders as it was of the czarist aristocracy. They hated the idea of anything new because it might upset the lovely life they had constructed for themselves. The strange thing, he went on, was that even those who were bitterly opposed to the present setup were equally conservative. When they thought of destroying the edifice it was to go back, not forward. Solzhenitsyn, for example, was a marvellous writer but he was hopelessly inept when it came to creative political ideas. And according to Itskol, he was not atypical. When I expressed surprise, he insisted that he knew what he was talking about.

Itskol ended the conversation by recounting the anecdote which was circulating in Moscow during the Twenty-Fifth Congress of the Communist Party. A minor functionary from a Urals town came to Moscow for the first time and applied for tickets for any performance at the Kremlin Palace of Congresses (normally used as a concert hall but the locale of the Twenty-Fifth Congress). He was told there were no tickets available. Day after day he asked and finally the ticket-seller said, 'There won't be any tickets. Don't you know the Congress is meeting?' He answered, 'Oh, I realize now. Musical comedies are always sold out.'

The painter Sergei Parazhanov, Tbilisi, 1981

RECOLLECTIONS OF SIBERIA

Bella Akhmadulina

You say – one shouldn't weep.
Indeed perhaps one shouldn't
Weep – into cold rivers seek
To plunge. One should strive

To survive in dark waters,
Escaping through one's fingers.
Give one's self the rare liberty
Of that other distant shore.

And not in vain I sweetly
Longed for Siberia, that far
Land where secretly and meekly
I saw before me the flowers fade.

How can I find a way to tell
You what was happening to me?
Memory has cast a silvery
Glow on everything.

Baikal's deep and secret waters
And through its slow moving stream
The omul swims spreading
To the light its glittering plume.

And those huts, and wooden sheds
half-hidden on the banks,
and brightly coloured locusts
quickly dying in my hand.

And white-striped miracle and wonder
the chipmunk shoots up suddenly,
with a sharp and secret air
fixing his gaze on me.

I was tempted and I was tortured
by the depth of those running streams.
Cut like diamonds, the water of the Kizil,
and like fire, cold and clean.

But I remember most of all
back there, in the fields of rye,
never did I need to utter
even once a lie.

FIFTEEN

Lenin Is with Us

By 1970 it was no secret that Solzhenitsyn was living in the Rostropovich dacha at Zhukovka, the musicians' summer colony near Moscow. Up until then Mstislav Rostropovich, probably the world's finest cellist, was one of the approved elite. He had met Solzhenitsyn in 1968. Both were great admirers of the composer Shostakovich, and the cellist was overwhelmed by the talent and courage of the writer. In 1969 Solzhenitsyn got to a small village near Moscow where Rostropovich and his wife found him living in a shack, and invited him to move into a small cottage on the grounds of their dacha in Zhukovka.

This was considered by the Soviets as an affront on two counts: Solzhenitsyn living in the Moscow area without a residence permit and without official means of support; and Rostropovich harbouring an anti-Soviet element in one of the most coveted of the various prestige summer colonies.

So started the persecution of Rostropovich and his wife, the singer Galina Vishnevskaya, who fully supported the courageous stand of her husband. First Rostropovich was barred from travelling abroad for concerts; then he was inexplicably given permission to make a foreign tour. Next he wrote a letter to the authorities in support of Solzhenitzyn, and was summoned by the minister of culture, Mrs Furtseva herself at that time, to explain. I was told the interview was extremely stormy, leavened by the great cellist's wry wit:

Mrs F: Explain your letter, Tovarishch Rostropovich.
Rost: That would be pointless, as you are a party functionary and therefore not likely to understand questions pertaining to culture.

The exchange went like that until an exasperated Furtseva pulled rank.

Mrs F: In the future you will confine yourself to concert tours within the Soviet Union.
Rost: Since when did playing in the Soviet Union become a punishment?

Solzhenitsyn was counting on using Rostropovich's Moscow apartment for receiving the Nobel Prize. But he clearly wrecked his chances of receiving the prize in Moscow by inviting Hedrick Smith of the *New York Times* and Robert Kaiser of the *Washington Post* to a long interview, and this infuriated the authorities. The favourite speculation was that Solzhenitsyn did this deliberately, to embarrass the Soviet government even further. He certainly succeeded. He probably also succeeded in complicating the life of Rostropovich, though the latter did not seem to mind.

Looking back at 1971, it is clear that the award of the Nobel Prize to Solzhenitsyn resulted in a determination by the ideologues in the party to tighten the screws, and to enforce the rules of socialist realism in every sphere of artistic activity. The defections of Kuznetsov and Makarova inflamed them even further.

To make matters worse, it was all happening just in time to spoil their festive plans for Lenin's birthday party. All musicians were ordered to contribute to the hundredth anniversary of Lenin's birth. Somebody was composing a symphony-cantata called 'Lenin Is with Us,' based on a poem of Mayakovsky, something that promised to be a truly crashing bore. I heard that two hundred composers and writers were at work on compositions for the comradely jubilee.

A high-ranking Composers' Union *apparatchik* wrote in *Pravda* about the necessity of Soviet music assuming a propaganda role in this time of two ideological worlds, and called upon the composers and musicians 'to contribute to the struggle for the

human soul as expressed by the optimistic views of the future contained in Lenin's ideas.' In November the journal *Kommunist* also stressed the need for ideological vigilance in music. It accused the West of beaming offensive decadent radio programs into the Soviet Union and described jazz as 'an anesthetical narcotic destroying faith in the lofty ideas of mankind.'

Persecution of other writers continued. Vladimir Bukovsky went to trial at the beginning of 1971 and was given a savage sentence. But at the same time Larissa Daniel, the wife of the writer Yuli Daniel, was permitted to return to Moscow; in the oldest of Russian traditions, she had accompanied her husband in his exile to Siberia. No one was sure if she was brought back, or came back voluntarily. The Writers' Union expelled two unfortunate writers, Alexander Galich and Yevgeny Markin. The former had a small reputation for satirical songs and poems; the latter was the only member of the Ryazan Writers' Union who voted against the resolution to expel Solzhenitsyn. It all had anti-semitic undertones, Galich being accused of encouraging Jews to go to Israel and being addressed during his trial as 'Ginsberg.' The case for the prosecution was put by Yuri Zhukov of *Pravda*, himself Jewish. More Russian duality and paradoxes, everyday stuff in this surreal world of socialist realism.

A plenary session was held in December 1971 of all the creative arts unions. 'Vigilance Against the Imperialist Ideological Onslaught' was the main theme. The final word on Solzhenitsyn was provided by the secretary of the Union of Writers, Georgi Markov, who congratulated the Ryazan branch for having 'demonstrated its political maturity by giving a correct interpretation to Solzhenitsyn's anti-social conduct.'

Peter Demichev, now an alternate member of the Politburo in charge of the arts, made a violent condemnation of any deviation from the established norms. It appeared to be the party's final word, with the clear warning that no liberties would be tolerated. 'Ideological slackness' had led to the unrest in Czechoslovakia, he said. Most disturbing was the violence of his attack on the West, which he claimed was attempting to use the arts as a means of 'wasting away the socio-political foundations of socialism.'

Demichev's ideological gibberish epitomized the kind of dan-

gerous nonsense that drove the Russian intellectuals to despair. He claimed that at the present time a new danger existed in the Soviet Union: with the improvement of standards of living and additional free time, citizens might fall into an unacceptable bourgeois pattern of life if proper ideological influence was not brought to bear on them. Proceeding from this assumption, Demichev spoke of the requirements for Soviet art based on a more sophisticated approach to the 'new Soviet man,' who was no longer a 'common everyday man devoid of character.'

For a while little else happened. Then Natalia Gorbanyevskaya, a poetess and one of the signatories of an appeal for a United Nations probe of Soviet human rights violations, was charged with anti-Soviet slander. Another dissident, Victor Krasin, was arrested. In early February of 1972 *Novyi Mir*, the last remaining liberal journal, underwent a major shakeup in its editorial board with the addition of five conservative members. Two weeks later we learned that Tvardovsky had resigned from the board. And the Soviet government announced its decision to withdraw its membership from the European Community of Writers, an organization set up ten years earlier for an exchange of East-West ideas. It had made a sharp attack on the expulsion of Solzhenitsyn from the Union of Writers.

It was evident that the party had chosen now to disregard western public opinion completely, despite its previous sensitivity to bad publicity. Whether it was all part of a growing neo-Stalinism was unclear. I thought it more likely the leadership wanted to ensure that nothing would mar the jolly Lenin celebrations. But the situation appeared bleaker and darker than it had been for some time.

I later ran into Yuri Nagibin at a reception. He was slightly tipsier than usual and his watchdog seemed to have disappeared, so I was not surprised to hear him unburden himself. 'I'm afraid they are going to resurrect Stalinism – not with one Stalin, but dozens of little ones,' he said, his fingers imitating the legs of a centipede. 'They enjoy so much telling people whose talents they envy what to do and what not to do.'

I asked him who 'they' were.

'Oh, *they* have always existed in Russia,' he said. 'Right now it

was the bureaucrats in the Union of Writers and the ideologues in the party secretariat and everybody else that had a word about literature and publishing. 'The trouble is,' he went on, 'that we all enjoy our privileges. We live so much better than the so-called working class and nobody wants to give it up.'

He complained about trying to reconcile literature with ideology. 'They don't really demand any more that you write about the happy peasantry, and the happy coal miners in the Don basin,' he said with heavy irony, 'or the happy prisoners in Siberia. But there has to be something in what you write that makes them think you are being positive. And as for me ... ' He apparently realized that he was talking too much and rapidly moved away.

For any of the writers to figure out how to write well and still meet the requirements of some faceless bureaucrat – who was in turn afraid of approving something someone higher up would condemn – was a dreadful strain on the nerves. And a battle with the Union of Writers, even on a less intense scale than Solzhenitsyn's, meant losing publishing rights and the privileges associated with being an acclaimed writer. It was hardly surprising that so many Russian artists, sensitive souls driven to distraction by this evil nonsense, took to the bottle.

It was therefore with considerable surprise that we received a dinner invitation in December 1973 from the Argentine ambassador, Leopoldo Bravo, and to find that the guests of honour were Rostropovich and Galina. Bravo had been a streetcar conductor when Juan Peron appointed him ambassador to Moscow in 1952 at the age of thirty-one, and he had returned to the same job twenty years later. He was an ardent Peronista and undisputedly pro-Soviet. Rostropovich had declined invitations to the French embassy, and to ours. But whatever the reason for their appearance, it was a delight to see them again. They were not only superb musicians but vital, charming, intelligent, and immensely courageous people.

Rostropovich was in a good mood, as he had received permission to go to Paris the following day to give a concert in celebration of the twenty-fifth anniversary of UNESCO, something acceptable to the gnomes of the Kremlin. He also had permission

to continue for two days to England to see his friend Benjamin Britten, who was gravely ill. Neither he nor Galina mentioned Solzhenitsyn, of course, and I thought it better not to embarrass them by referring to his own troubles, which were not lessened by the *New York Times* describing him in a recent editorial as one of the big three of Soviet dissent.

When Zoya Boguslavskaya returned from Paris in January 1974, where she had launched the translation of her novel *Sept cent roubles nouveau,* she and Andrei came to dinner. She had had her rather awful dyed blonde hair redone by a Parisian hairdresser, was completely outfitted in French clothes, and was hardly recognizable. Her enthusiasm for France was unbounded.

There had always been some suspicion that Zoya was in a way the party watchdog over Andrei. This seemed to be quite idiotic as she had more trouble with the censors and the Union of Writers than Andrei. But Harper and Row were bringing out an American edition of her novel in the spring. Although the novel was criticized on its appearance as portraying some less savoury sides of life among the Soviet intelligentsia, possibly the Soviet authorities decided that on the whole that it might help to distract attention from Solzhenitsyn.

Andrei was very interested in Yevtushenko's visit to Canada and hardly bothered to hide his jealousy. He had heard, however, that Yevtushenko had complained of a partly empty hall somewhere and that in general the visit had not generated the interest that his had done. When I assured him that this seemed to be true he was relieved, because he liked to think that Canada was his special territory.

The year marked an extraordinary period of departures and defections of Soviet intellectuals. In February 1974 they finally expelled Solzhenitsyn. It was a relief that he was not jailed again. He was so absolutely and totally Russian that I was sure he considered being expelled from his country a real moral punishment. Leaving Russia would have been torture for him.

Then Andrei Sakharov was deported to internal exile in Gorky, in Siberia. The KGB mistakenly thought to silence him by isolating him from the outside world.

Next Rostropovich defected while on the visit to England in May. Shortly afterwards I was in England on my way to a meeting of NATO specialists on Soviet affairs at Sezimbra, Portugal. I decided to drive up to Cambridge to see my old friend Sir Duncan Wilson, former British ambassador to Moscow and at that time Master of Corpus Christi College. Wilson's daughter was a cellist and had studied with Rostropovich in Moscow, and it was Wilson who met Rostropovich on his arrival to London and spirited him away to a private hideout for a week. Rostropovich had only left the Wilsons a few days before I arrived in Cambridge and the family was still reeling from the impact.

Apparently when Rostropovich arrived he had taken fourteen tranquillizers and was in a semi-drugged state. Wilson managed to keep the inevitable press conference to the absolute minimum. The cellist quickly got back to normal. But normal means 'Russian normal,' which Wilson believed was going to lead to quite a few problems. In the first place Rostropovich, although very western superficially, was essentially very Russian. He had no practical sense at all, was indifferent to questions of agents, programs, itineraries and, of course, money. He had been used to having everything done for him by Gosconcert, and to leading the rather pampered life of a famous artist in the Soviet Union. Wilson thought he would have great difficulty in adjusting to a new system and also in realizing that there was not an endless supply of cash in the West. Already he was talking of buying a house in St John's Wood, a Mercedes, and so on.

The Soviets took Rostropovich's passport, but they gave permission to Galina and their daughter to join him. In March 1978 their Soviet citizenship was revoked.

Rostropovich proved to be much more adaptable to the ways of the West than his first contacts led his friends to believe. He slipped comfortably into the role of a star, both as a conductor and, above all, as one of the finest cellists since the war.

FORGIVE ME!

Andrei Voznesensky

From the dry, rattle-like dahlias,
And perhaps too in my sleep –
I hear the echo of a trite phrase: forgive me,
For some reason addressed to me.

Some line must have stuck in
The audio-archive of my memory.
I've never been to America. Why 'forgive me'?
Why torture me in this un-Russian way?

As if the soul, like a repentant jokester,
Departs, discarding you like underwear.
As if you, the master, torment your
Dog, and then beg its pardon.

But there must be someone to blame
For those years that were killed,
The flesh and blood sold for a kopek.
And I repeat again and again: forgive me –
My own sign, addressed to myself.

Андрей Вознесенский

ВИТРАЖНЫХ ДЕЛ МАСТЕР

Милым чудесным — Роберту — прекрасному поэту! и его Музе-Терезе — с любовью —

Москва
„Молодая гвардия"
1976

*Андрей Возн[есенский]
28 июня 1976*

The title page of *Vitrazhnykh del master*, a collection of poetry by Andrei Voznesensky, inscribed to Robert Ford by the poet

SIXTEEN

Jungle Cats at a Tea Party

Andrei Voznesensky came back from North America full of stories of hippies, exotic Russian emigrés, and Jacqueline Kennedy Onassis.

He had finally got his passport and permission to accept the long-standing invitation to visit Canada. He went in the fall of 1971, and was a great success, without political incident. Reassured, the Soviets then let him go the United States as well. When he returned he was, not unnaturally, full of the extraordinary gesture of Pierre Trudeau, who had invited him to the prime ministerial residence for a tête-à-tête luncheon.

He was a little disappointed that he had received less publicity in the American press. Publicity in the West, unless it was obviously embarrassing, was a help to Soviet writers. It simply made it more difficult for the Soviet authorities to bother them. But his relations with the Union of Writers were 'okay' (he used the English expression). In San Francisco he had arranged to be put up in the spare bedroom of Laurence Ferlinghetti's City Lights Book Shop which he described as 'very hippy.'

It was interesting for me, after my years of viewing the Russians through my microscope, to hear how one viewed us. 'People wandered in and out all night,' he reported, clearly enchanted with the freedom, 'smoking marijuana, making love, or just sitting around talking. But I still prefer Vancouver. I think perhaps San

Francisco is an American Vancouver,' he said without a shred of irony.

Most Russian writers, except the party hacks, would willingly sacrifice their privileged security and affluence for the excitement of the western type, he avowed. But he was not very clear what exactly he meant. Not amorous freedom, he admitted. There was no lack of sex in the Soviet artistic world, where exchanges of spouses were common.

He had arranged somehow to include the University of Nevada in his tour and stayed in Las Vegas, through the generosity of unnamed persons, at Caesar's Palace. Las Vegas had fascinated him – the desert, the isolation, the dedicated gamblers, the 'gangsters,' and the casino itself. He rose from his chair to pace out in our room the size of the bedroom he had been put in and of the enormous bed. He described the small gamblers at work on the slot machines. He was taken to the spot above the gambling rooms where television cameras control the action. 'Obviously,' he said knowingly, 'the whole operation was run by gangsters.'

'How could you tell?'

'I am sure I can tell a gangster from an honest citizen,' he huffed. And there, on the edge of Las Vegas, was a perfectly normal university and students who had read his poetry. He had some difficulty in sorting out the paradox.

In New York Jacqueline Kennedy Onassis asked to call on him. They met at the Algonquin Hotel, without Mr Onassis. Andrei said he decided to make fun of her, starting out by saying he was sure she wanted to see him because of his poem on the death of Jack Kennedy – a truly Russian idea of 'fun.' But she said graciously, not at all; she just liked his poetry. When he asked her to name a poem, she at once recited excerpts, in English translation, of his poems, including one about San Francisco, and the poem translated by me which was in *Time* magazine a while back. He was much impressed.

He was also inevitably drawn into the Russian emigré colony in New York through Tatiana Yermoleva, now almost eighty, who had been the great passion of Mayakovsky (when he was not involved with Lili Brik). She had been a statuesque beauty. When Andrei met her she was married to an editor of *Vogue*. Through

her Andrei was introduced to Alexander Romanov, who was second in line of succession to the imperial throne.

'Very amusing and very Russian,' Andrei reported, as though that explained the man completely. Romanov told some stories about Vladimir Romanov, the immediate heir to the throne, who was living in Madrid. A Soviet soccer team was in Madrid to play a Spanish team.

'I asked which he would support, and he replied: "Ours, naturally." When I asked which was ours he said, "the Soviet." '

'Later it occurred to me to ask what he would change if he became czar. "Nothing," he replied. "It's a good conservative system." '

Twenty years later this same grand duke was buried next to his royal ancestors in St Petersburg. If anyone back in 1972 had even in his wildest fancies suggested that this might occur, and that Leningrad should have recovered its original name, he would probably have been put in a psychiatric hospital.

All of this gave me some insight into the tremendous difficulties Russians have in adjusting to life abroad. They are so quintessentially *Russian*. Andrei was right. That Dostoyevskyan duality that I had begun to recognize as a fundamental trait of the people and the nation made them quirky at best, psychotic at worst. Bad was good and good was bad. The Americans with their Jeffersonian mindset, and the French with their relentless Cartesian logic, were utterly foreign in outlook. The Russian émigrés mingled in those societies like exotic jungle cats at a ladies' tea party.

Thereza had a window view of the dynamics of Russians abroad when she visited Paris that fall, at a dinner party with French friends and Andrei Sinyavsky and his wife. Sinyavsky's 'trial,' which I referred to in an earlier chapter, had been one of the showpieces of Soviet political repression. Thereza described Mrs Sinyavsky as a tense, unfriendly woman, obviously ill at ease – and terribly homesick for Russia, in spite of having just bought a house with a garden in a Paris suburb and a car. She seemed very fond of her husband, and inordinately proud of him.

There were some other Russians present, including Prince Nicholas Viryubov, and a man called Radighin. He was about forty, and quite good-looking, a former inmate of a concentration

camp, and before that a captain in the Soviet merchant marine. A typically eclectic Russian background.

'How could writers write in the Soviet Union?' was a conversational theme. Sinyavsky said in a quiet monotone, 'One must suffer to produce.'

Thereza described Sinyavsky as quiet, badly dressed, unsure of himself. 'It was hard to tell if he was presenting a picture of someone totally at peace with himself,' she said, 'or someone thoroughly disenchanted who had in fact practically given up the struggle.' He had a defect in one eye and an opulent reddish beard; with a French beret he could have been mistaken for any lower middle class Frenchman. But Sinyavsky was the epitome of the lost Russian soul. He said over and over how much he would like to go back to his homeland.

'I can see no life for myself outside Russia,' he said, in the same tones one might use to say 'It's raining outside.' And practically in the same breath he would state that he saw no improvement possible in the Soviet internal situation, and no hope in the foreseeable future. He had not learned any French and seemed totally uninterested in learning very much about the outside world. He exuded a feeling of complete hopelessness. Then he turned around and said that he saw no reason why he could not continue to write, even though he was in France and not in Russia, 'even if I'm not Tolstoy or Dostoyevsky.'

Both he and Radighin were content to pile all the blame for the crimes of communism on Stalin, but when someone suggested Lenin was also a murderer and founder of the secret police, neither would say a word but simply shook their heads.

Sinyavsky made it clear he would never talk badly about the Soviet Union in public, nor participate in any political propaganda movements. Not once did he either raise his voice or gesture except to laugh at the stories of his friend Radighin, especially an account of how Radighin had tried to escape abroad and was given ten years hard labour. Scarcely hilarious, but these were Russians. He and Sinyavsky met in the concentration camp. After his release Radighin emigrated to Israel but hated it, finding it more communist than the Soviet Union. He was on his way to New York to join some relatives.

After dinner the conversation inevitably turned to the concentration camps, although with a certain wry humour. Both Sinyavsky and Radighin asserted that the camps were infinitely worse than the Nazi concentration camps, of which they had no firsthand knowledge. They estimated that in the Soviet camps there were from two to three thousand political prisoners and approximately fifteen thousand semi-political prisoners, by which they meant people who had been arrested for economic crimes, black marketeering, fraud and so on, and about six million prisoners arrested for common crimes.

Sinyavsky was consistent at least in his gloomy predictions for reform in Soviet Union. Even the slightest relief would endanger the privileged situation of the cadres, he stated flatly. The new and very large class of privileged hardliners would make sure that nothing changed. Letting Solzhenitsyn out, Sinyavsky said, was simply a gesture of self-defence.

'But I have never been anything but apolitical,' he sighed. Indeed, he talked a lot about God and said that the soul must suffer to attain redemption. He was something of a mystic, and he was so disheartened at the fate of Russia that he had come to the conclusion that only religion could save her ailing soul.

He did not explain why his trial was so political if he considered himself apolitical. Someone suggested that he had endangered the dissenters by making himself a centre of political dissent whether he liked it or not. His answer was extremely vague, and one had the impression that he was too self-centred to worry about others.

Many of his views on Russia and the future, China, and so on were quite primitive. There was a lot of tension at the Sino-Soviet border, as there has been on and off for centuries, and the Chinese threat was very real to Russians. Someone quoted Solzhenitsyn as having said that the Russians are Asians, and thus ultimately must get together with China against the West, and that war between the Soviet Union and China was not likely to take place. Sinyavsky came out with a rather extraordinary statement that he supported China and its present stance – because if the Soviet Union did not have to contain the Chinese, it would take over the whole of Europe.

Both Sinyavsky and Radighin quoted from the questionnaires which were circulated in the concentration camps on the subject of China. One question was, 'If war was declared would you be for or against the Soviet Union?' Most of the political prisoners answered more or less as follows, 'If there is a war with the West, we are for the West; if there is a war against China, we are for you.' Radighin claimed that he said that he was against them in either case. He seemed quite fearless.

Thereza was curious to note that Prince Viryubov seemed as nostalgic for Russia as the two more recent exiles, although he was born just a year or two before the Revolution broke out. In fact he ended up defending socialism while Sinyavsky was defending czarism, at least as far as the treatment of writers was concerned. It was an echo of the sentiments the Romanov grand duke had expressed to Andrei at Tatiana Yermoleva's salon.

Here was the ultimate irony, the perfect contradiction: czarist relics who defended their conquerors, and Soviet exiles who railed against Stalinism but were homesick for Russia for better or worse. It was all so histrionic and paradoxical – so Dostoyevskyan.

When Zoya finally did make her trip to Canada, in March 1975, she distinguished herself in more ways than one. As happened so often with Soviets abroad, she was overwhelmed by the luxurious varieties in a supermarket, and pocketed some item that she could not resist. She was promptly arrested. External Affairs cabled me urgently, asking what to do. There was much handwringing. The store manager did not want to press charges, but Zoya had no money to pay the fine for the offence, and there was no way External could bend the budget for this sort of thing. To make matters worse, she had been given permission for the trip by the gnomes in Moscow only because I had persuaded Ottawa to invite her to participate in the celebrations commemorating International Women's Year. This did not particularly please the Soviets, but they could hardly refuse. I owed so much to Zoya and Andrei for their friendship, I paid the fine myself. She never knew how she avoided being jailed in the free West.

On her return, Zoya never mentioned the incident; nor did I.

POEM

Marina Tsvetayeva

When I look at the falling leaves
Drifting down to the cobble-stones,
Swept away – as if by the brush of an
Artist finally finishing a picture,

I think (already no-one likes the way
I stand, or my pensive glance),
How a truly yellow, really rusty leaf
Has been forgotten up there.

Andrei Vozhnesensky and Zoya Bogulavskaya

SEVENTEEN

Turning Points

As the winter of 1975 settled heavily upon us, the pine woods of Peredelkino, interspersed with bare white-yellow trunks of birch trees and the stillness in the snow, reminded me of Canada. But as always there seemed a melancholy, even a sinister air about the Russian woods in winter. It was probably imagination, or the realization that there was a certain feeling of innocence about the Canadian winter landscape, whereas the Russian forest seemed steeped in a history that was sad, bloody, and always melancholic. The grave of Pasternak reminded me of the immense weight of Russian history.

Andrei and Zoya's dacha, fortunately, was by then properly heated, overheated even, in the Canadian fashion. And the five-hour meal was truly gargantuan, washed down by French wines purchased in the foreign exchange shop.

Almost immediately, they inquired about the 'Oscar Peterson affair.' The jazz trio had come to the Soviet Union as part of the Soviet-Canadian cultural exchanges. Everything went smoothly in Leningrad but when they arrived in Moscow they were put in a third-rate hotel. They refused to stay there and came straight to the embassy, certain that their treatment was an insulting demonstration of racism. They refused to play in Moscow.

Andrei said it was a terrible 'skandal' in Moscow. Peterson's concerts were the most eagerly awaited of any western artist in a

long time and it was particularly upsetting because so many of the sons and daughters of the communist aristocracy had bought tickets. One of those who made the biggest fuss, according to Andrei, was the daughter of Dmitri Polyansky, the first deputy prime minister. The price of tickets on the black market incidentally had gone up to fifty roubles (about seventy-five dollars).

We at once got in touch with the Ministry of Culture and Gosconcert, whose officials were in a state of panic. Rooms in a better hotel were found, but the next morning a high official was on our doorstep begging me to intervene because Peterson still refused to perform, and had demanded tickets for the first flight out of Moscow. I was not prepared to try to twist Peterson's arm since I thought it time the cultural bureaucrats were taught a lesson.

Gosconcert, which stood to lose a lot of money, the Foreign Ministry, who were worried about the after effects on relations with Canada, and the Ministry of Culture, all brought as much pressure to bear as they could, including bullying threats from a KGB type in the Ministry of Culture. But Peterson would not change his mind and the trio left without playing.

Andrei and Zoya were eager, indeed insistent, on hearing all the details, to such an extent that I began to wonder if they had been asked to get information. I told the story straight, adding that even Gosconcert inefficiency could not account for the shabby treatment of Peterson. 'The thought has occurred to me,' I said, 'that the KGB had been deliberately harassing him.'

Andrei pricked up his ears, and asked, 'Do you think they were trying to retaliate because of the Baryshnikov affair?'

I said it was possible. 'But after all, we had nothing to do with that. He just chose Toronto for his defection because he thought it would be easier than in the United States.'

'Don't believe it,' he said. 'They can't see straight. He defected in Canada, and the Canadian Mounties organized it.'

I gave Andrei a large photo of Baryshnikov and Christina Berlin, taken from the *Globe and Mail*. Baryshnikov denied any romantic attachment; Andrei remarked this was probably true since he was alleged to be 'slightly homo' – a remark that was either anachronistic prejudice or wishful thinking. Andrei was more than half besotted by Christina himself.

They were all fascinated with the amount of money awaiting glamorous defectors in the West. They had heard that Vladislav Tretyak, the goalie of the Red Army hockey team, had been offered a job in Canada. I had not heard this but I was sure he could easily sign a contract for a million dollars.

'Only a million dollars?' said Andrei in disbelief. 'We have heard that Baryshnikov has already made a million and is on his second million dollars.'

In their own dreary world, Andrei's latest book was being held up 'for lack of paper.' He had just finished what he called a 'detective opera without words' – a two-act play in verse with background music. The theme was the theft of the Weeping Madonna of Kiev, a well-known icon, and an effort to trace it through a trail of tears! It was going into rehearsal for the small stage of the Satire Theatre and, if all went well, it would move to the main stage.

Andrei wanted to direct the production himself, though the theatre director was objecting. He was also writing some popular song lyrics. One of these, 'The Year of Love,' put to music by a popular composer, was already a great success. He agreed he could make a lot of money that way – enough in fact to 'persuade' the telephone officials to put a phone into his dacha at Peredelkino.

Finally he threw up his hands in despair and said, 'I'm bored. Zoya is bored. Everybody is bored. It bores me to write, to give a recital of poetry, to see a book published. I'm even bored with travelling, even to the West.'

There was no longer any challenge, but he was one hundred per cent Russian and could not conceive of a life anywhere else. He supposed boredom was an essential part of Russian life, and certainly of literature. Nineteenth-century Russian novels could hardly have emerged if it had not been for the enforced leisure of so many Russian intellectuals. And boredom is an important element in all their books. He said he wanted to do something entirely different and so was working on his play with music, but even this bored him. In the end he would probably not do anything about it.

During that April of 1975, while most of Europe and North America suffered unseasonable cold and snow, Moscow emerged

from winter to enjoy equally extraordinary mild days of 20°C, and we revelled in the rushing, bursting Russian spring all around us. It added to the atmosphere of our nineteenth-century Sundays at the Voznesensky dacha. Our leisurely dialogues there were accompanied occasionally by background music from a new TV series to come out next winter with songs based on some of Andrei's poems.

Andrei's venture into the field of opera failed, not surprisingly. It had sounded to me slightly puerile, and certainly a non-starter with the censors. The director of the Satire Theatre had turned it down as too experimental. Andrei dismissed him as 'senile and cowardly.' He said the only thing worth seeing in Moscow was *Fasten Your Seatbelts* at the Taganka Theatre. It was a mildly irreverential play by Gregory Vaklanov, the originality largely due to Lyubimov, according to Andrei.

In the theatre, the old classics were just a little older and just a little more classic: museum pieces, though still beautifully acted and thus still strangely moving. There were no new plays available anywhere, although some theatres like the Vakhtangova tried to experiment a tiny bit within the limits of socialist realism. The Taganka continued to try to do a bit better, but it was just too avant-garde by Soviet criteria; at the same time it was too popular to be shut down by the authorities. Lyubimov put his personal imprint on every play with a staging that was rather too unconventional for official tastes. He tried to put a message between the lines of such classics as *Hamlet* and *Le Misanthrope* and in plays such as *Ten Days that Shook the World*, which was still playing and very popular. In it he pitted Mayakovsky and his verse against the party hacks by showing that the struggle against the czarist class system, backed by the military and the police, was not so different from the present-day power structure and its own, not so different military and police. Lyubimov's worst sin, however, was probably that his frequently ingenious and always lively, if sometimes frenetic, staging showed up the museum-stiff productions of the more traditional theatres. He was far from perfect, but he had life. The others had perfected themselves to death.

Andrei talked disparagingly of the Union of Writers. 'There is not one good writer in a position of authority,' he lamented. The

secretary, Federenko, was a figurehead and in any case primarily a sinologist. The real authority lay in the hands of the executive secretary, Leonid Martynov. The poetry section was headed by a very minor poet, Nikolaev, who nevertheless tried to do his best for poetry. His daughter, according to Andrei, was one of the best young poets, but she was too clever, he added, too pretty, too spoiled, and had been brought up in a hothouse literary atmosphere which risked stifling her talents.

'Tell me, though,' he said, changing the subject, 'did Margaret Atwood refuse to come to the Soviet Union because of Solzhenitsyn?' Atwood, perhaps our most prominent writer, had indeed done so. Many Canadian writers had felt strongly about what had been done to Solzhenitsyn. 'I suppose so, but is it still the case? Solzhenitsyn has behaved so badly in the West.'

I conceded he had made some indiscreet, even unwise declarations, but on the whole, considering the pressure he was under, I thought he had behaved with some moderation. Andrei was thinking of his revelation that Heinrich Böll had smuggled his manuscripts out of the Soviet Union. It was perhaps unwise of Solzhenitsyn to say so, but after all, Böll did not have to come back to Russia.

Andrei changed the subject once more. He and Zoya had just been to a party for Bella Akhmadulina's birthday, a huge affair with two hundred people jammed into the flat of her latest husband, choreographer Boris Messerer. When Andrei said 'husband,' he did not mean it in the legal sense.

'How is her poetry going?'

'Badly,' he replied flatly. 'She is too prosperous, too happy, and she is not drinking.'

It was a sad commentary, and something of an artistic cliché, that she only produced when she was miserable, unloved, and drinking herself into a stupor. I was practically in a stupor myself by this time, not from wine, but just from the endless chatter, the background music, the gently falling warm April rain, and the soporific effect of the feeling of boredom that gnaws at these people. So much so that they cannot stay in one place very long. Andrei was off to Tashkent the next week, Zoya to Riga. The idea of a trip abroad made it all just bearable for them.

But despite this seemingly unchanging monochromatic vista of Soviet life, 1975 was to my mind a pivotal year. A sea change began when the Soviets signed the Helsinki Declaration, including the paragraphs on human rights. This coincided with the beginning of a steep decline of the economy to even lower depths. These two factors combined to provoke more widespread secret questioning of the system. The Russian people exercised their traditional right to grumble, about the only right they did have, about the sudden and inexplicable disappearance from store shelves of even the most ordinary household products. And the dinosaurs in Brezhnev's Kremlin were deaf to that grumble, and failed to hear it growing.

In any case, they were utterly indifferent. Thereza told the redoubtable Mrs Gromyko, the wife of the longest-serving foreign minister in the world, about conditions in places we visited, about the failure of the system to provide for even the most obvious needs of the people even in towns and suburbs near Moscow.

'Oh, Thereza,' replied Mrs Gromyko, like a lady of Victorian England at teatime, 'you are inventing that. Don't take our people seriously. The Russians have always grumbled about absolutely everything.'

Thereza, fearlessly outspoken as usual, answered, 'But how would you know? I am sure you have not set foot in any of these towns, or even the streets of Moscow, for years!' Mrs Gromyko, who in her way was not dishonest, blushed and changed the subject.

The fundamental premise of Brezhnev, before he fell into premature dotage and was merely a figurehead to be wheeled out on appropriate occasions, was simple: first, improve the standard of living just a wee bit each year, making sure, however, that bread was always cheap and available; second, provide the military with everything it wanted; third, give full power to the KGB to suppress open opposition; and fourth, maintain the purity of the doctrine under the watchful eye of Suslov, the Politburo's thought police dog.

But the regime seemed incapable of doing anything right economically. An overwhelming factor in this was the concentration of nearly all of the nation's best brains in the military-

industrial complex and the space program. And given the mania about defending state secrets, there was absolutely no spin-off of technical advances into the civilian economy.

By 1976 it was clear the first two premises were in a shambles, with even bread in short and overpriced supply. And this was the crucial chink in the Marxist armour. The majority of the population was totally disinterested in 'dissidence' and the complaints of the intelligentsia. All they wanted was better living conditions. When even a moderate bit of comfort failed to materialize, the people became a new force of dissidence – a groundswell. Ironically, the intellectuals themselves, preoccupied with their own concerns, were almost as unaware of the proletarian dissidence as the masses were of the concerns of the artistic community.

During one August afternoon that year there was an interminable coming and going of writers and journalists at the dacha, all unknown to me and introduced rather vaguely as 'Sergei' or 'Pavel,' and so on. The full text of the Helsinki Declaration had just been published in *Pravda* and they all seemed mystified as to what the human rights sections meant, why the Soviet government had signed the document, why it had been published, whether it was a trick to flush out secret dissidents, and so on.

In the fall, when Andrei returned from a month in Italy, he was full of his trip, which had been sponsored by the cultural branch of the Italian Communist Party. However, apart from a ceremonial meeting with the head of the Italian party, Enrico Berlinguer, who made no impression on Andrei except for his small size, he seemed to have circulated largely outside the sphere of his sponsors.

It was his first trip to Italy and he was enormously impressed by the Italian antiquities and overwhelmed by Venice. On several occasions he met with the renowned novelist Alberto Moravia, who told him he had recently written a pornographic novel, as yet unpublished. But he would not give Andrei a xeroxed copy to take back to Moscow. The Russian intelligentsia were fascinated by the whole concept of sexual liberty in the West. Andrei did manage to come back with a couple of copies of *Playboy* and he said he would shortly become the most sought-after person in Moscow. In addition, he had a pornographic drawing by the

German writer Günter Grass. When I asked him how he got it past the Soviet customs, he dismissed this airily: 'They don't bother me.'

He tried to see Ugenio Montale, the Nobel Prize winning poet, in Milan but the latter, now rather old, was too sick to see him. He professed great admiration for Montale, not a poet greatly respected in the Soviet Union. Andrei seemed to have spent a good deal of his time telephoning long distance, mostly to his editor at Doubleday in New York. (I wondered if this was at the expense of the Italian Communist Party.)

Zoya was to leave shortly for a month's visit to France in connection with the French publication of a new novel of hers, *Advokat* (*The Lawyer*). She was very pleased with the English version of her story 'The Movie' which had appeared in the *Malahat Review* of Victoria, British Columbia.

I wondered if this easier coming and going denoted a more relaxed attitude of the Soviet authorities to the artists. Andrei said it was erratic. 'There are some "liberal" signs, perhaps. The ease we have in publishing work which is not exactly orthodox, for instance. And Bulat Okudzhava has been permitted to recite his verse publicly. But apart from that, things are very tough, particularly for younger, not yet established, writers.'

I noticed a curious piece of fretwork on Andrei's desk. He said it was immensely valuable. He had recently visited the site of the assassination of Nicholas II and his family and discovered the authorities were about to tear down the building. He claimed to have rescued the piece of fretwork from the basement room where the czar and his family were murdered.

None of us could foresee the day when an unlikely 'democrat' named Boris Yeltsin would be the one to raze that building to the ground.

In July of 1977 William Styron, Robert Lowell, and Edward Albee were in Russia on an American-Soviet writers' exchange program. Voznesensky telephoned me about eight o'clock in the evening from the Union of Writers to say that he was at a very boring reception but wanted to bring Lowell and Albee out to his dacha. Could we come? I asked where was William Styron? He had 'got

himself involved' – no further explanation. Since we were free that evening we got at once into our car and drove out to Peredelkino, arriving shortly after the others.

Robert Lowell looked very drawn and tired. Actually he was rather drunk and worn out by a senseless fight with the Soviet bureaucracy. He had never been to the Soviet Union before and was astonished by the backwardness and appalled at the difficulty of doing almost anything – from getting a meal to arranging a trip to Leningrad. Actually the following day his trip to Leningrad fell apart because of the incompetence of Intourist and the Union of Writers. The latter, suddenly realizing they had Lowell on their hands, sent him in a car back to Peredelkino to spend the day with his 'friend' Voznesensky.

It was hard to explain to Lowell that the Soviet Union was a better place than it had been twenty, or even ten years before, and that it needed a certain perspective. He had taken an immense dislike to everything about the place, and it was hard to argue with him. I had no intimation that Lowell was very sick. We talked a good deal about the art of translating and he admitted that he was really an adapter rather than a translator. He knew very little Russian, for example. He had translated Voznesensky from a literal translation and then listening to Voznesensky recite the poems in Russian.

Edward Albee had a much more mature understanding of Soviet problems and was primarily interested in the Sino-Soviet conflict. He seemed fascinated by the idea of the Chinese giant and its threat to Siberia. We talked also a good deal about the Soviet theatre, particularly about the Taganka and the playwright Vasili Aksyonov, one of those writers who tried hard to adjust and still produce enough to get an emigration visa to the United States.

In the middle of the evening Yevgeny Yevtushenko came in. He and Andrei had not been on speaking terms for some time. And here was Yevgeny barging in with an Irish girl with whom he was now living – and William Styron. Andrei rose to the occasion and welcomed his rival and his guests. The girl said she was a communist, working as a translator in the Progress Publishing Company in Moscow. This hardly helped the situation. And the atmosphere

grew distinctly chilly when Yevtushenko demanded champagne and, finding there was none, began distributing insults, first to his host, then to virtually all Russian poets. The Siberian peasant was suddenly visible through his transparent western guise.

Styron was an absolute charmer, highly embarrassed when he realized the situation. Lowell handled it by falling asleep. At the end of the party we drove Lowell and Elizabeth Hardwick back to their hotel in Moscow, the poet sound asleep. He died two months later.

'LILI DEAR! INSTEAD OF A LETTER'

Vladimir Mayakovsky

Tobacco smoke gnawed the air.
The room –
a chapter in Kruchenyk's hell.
Remember –
behind this window
the first time
I, frenzied, was stroking your legs.
Today you're sitting there
heart in iron.
Another day –
perhaps
I'll be driven out cursed.
In the bleary hell the hand broken with trembling
can't get into the sleeve.
I'll run out,
I'll throw my body in the street.
Wild,
I'll go mad.
Chopped by despair.
Don't
Dear,
Sweet,
Let's say goodbye now ...
Tomorrow you'll forget
that I crowned you,
that I burned out with love a blossoming soul,
And the whirling carnival of restless days
will scatter pages of my books ...

Could the dry leaves of my words,
greedily breathing,
make you stop?
Let them at least
carpet with last tenderness
your departing step.

The famous ménage à trois:
Osip Brik, Lili Brik, and Mayakovsky, no date

EIGHTEEN

Lili

When we first met her, she was already a legend. Nearly eighty years old, Lili Brik was almost the only living link with the earliest period of the Revolution. With her lively wit and good memory, she was able to bring alive the extraordinary era of artistic blossoming that exploded in St Petersburg in the years before the First World War.

She was easily the happiest person at the dinner we gave in 1970 for Andrei Voznesensky before his aborted tour to Canada, and she had gone to great efforts to appear elegant. In spite of her age, and her dreadfully dyed red hair, she did reflect her reputation as one of the great beauties of the twenties. As if to underline her 'permission' to see us, she brought a rare copy of a book in Russian, *The Letters of Mayakovsky to Lili Brik*.

It was she, almost single-handed, who had devotedly created the legend of the poet Mayakovsky in the 1930s, braving Stalin himself. She had been Mayakovsky's great love, in one of the most unusual stories of Russian romance. She was also a sometime artist and film-maker, but her real genius was her ability to inspire the creative talents of others, not only Mayakovsky, but other artists, who enshrined her in their work.

Lili was born in 1891, the daughter of a well-to-do Jewish lawyer in St Petersburg. She and her younger sister Elsa were steeped in Russian and French literature, and moved almost automatically

with the group of young writers and poets who were feverishly renovating and modernizing Russian literature. A very beautiful, intelligent, and cultured woman, she married a distinguished literary critic, Osip Brik, in 1914.

Her world of writers was thrown into turmoil by the war, followed all too soon by the seething revolutionary movements of every classification, from the Bolshevik and Menshevik factions of the Communist Party, to democratic republicans and liberal monarchists.

Her sister Elsa, unlike Lili, had ambitions to become a writer herself from a very early age. In 1918 she married André Triolet, a French officer on a liaison mission to Russia, and she went with him to Paris when he was recalled. The marriage broke up in 1929, but she retained his name when she began publishing novels and stories. One of Elsa Triolet's novels won the leading French literary prize, the Prix Goncourt, a guarantee of celebrity and success. Her standing in the French literary world increased after she married Louis Aragon, a fine poet, and a leading member of the French Communist Party. Aragon, along with Jean-Paul Sartre and Simone de Beauvoir, were among those French intellectuals who, by defending Stalinism and communist doctrine, did such great damage, blinding a generation of students, intellectuals, and some of the public to the crimes and stupidities of the Soviet system.

During the First World War, Lili fell in love with Vladimir Mayakovsky, who was one of the most advanced and experimental poets, and who in a passionate and basically unpolitical way became one of the leading revolutionary voices of the Bolsheviks when they seized power in November of 1917.

As our friendship with her grew, we learned that her love affair with Mayakovsky had been the dominant event in her life, to an astonishing degree. According to Lili, her relationship with Osip Brik became purely platonic, as a ménage à trois developed, with Mayakovsky moving in and out of their apartment as he pleased. Brik had also embraced the Bolsheviks, and became an editor of a leading magazine, as well as a critic. In those days their domestic arrangement seemed suitably revolutionary, and Brik appeared to accept it. But it all ended tragically in 1930, when the poet committed suicide, it was said in disillusioned despair over the darkening revolution.

That Christmas, Thereza and I went to Paris over the holidays, where we attended the Roland Petit dance company, who were performing a ballet based on the life of Mayakovsky. And one of the principal characters, inevitably, was Lili Brik. When we returned to Moscow in January, we sent her a copy of the program. Within a short time she phoned to thank us effusively, as she had heard through her sister Elsa that the ballet was being prepared, but had heard nothing more. We arranged to visit her for dinner at her home, and as usual for such social occasions, we crossed our fingers that there would be no last-minute cancellation. Two previous efforts to get together had failed for lack of 'permission.' We did not want to cause her difficulties, but she spoke quite openly about it on the phone. I say openly because we always spoke Russian on the phone, rather than French, which she spoke fluently, so that the censors would be sure we were not concealing anything. Even such a benign event as dinner with a friend, taken for granted in the West, was fraught with peril here.

As we sallied forth on the appointed night, a blizzard turned to freezing rain, transforming the courtyard of the rambling apartment block where she lived on Kutuzovsky Prospect into an almost impassable mess of snow, ice, stalled cars, and junk of all sorts. Although the building dated from the early 1950s, it looked much older, and in the usual Soviet fashion the numerous small entrances were unlit and barely identified. The smell of boiled cabbage was overpowering in the corridors. And yet this was considered a fashionable Moscow address.

In fact, Lili enjoyed certain privileges as a member of the 'upper class.' In addition to the apartment, she also had a dacha at Peredelkino. These came in part of her own account, in part because of her present husband, Vasya Katanyan, whom she had married in 1945. He was none other than the leading expert on Mayakovsky, and an influential literary critic. As the name implies, he was of Armenian origin.

Fortunately the elevator worked and we reached the four-room, and by Moscow standards spacious, apartment. Lili looked handsome, and Parisian, in a French pant suit sent to her by her brother-in-law.

But the apartment was strictly out of Chekhov. The divans and overstuffed chairs with antimacassars probably dated from before

the Revolution, and preserved a Victorian flavour. The walls were literally covered with photographs of Mayakovsky and intellectuals and writers of his period. In addition, there were a number of very interesting and valuable paintings and drawings by Tishler, Tatlin, Larionov, Goncharova, Malevich, Popova, Bakst, three magnificent Georgian primitives, and a Cubist self-portrait by Mayakovsky himself. One small room, Katanyan's study, was filled with books, in Russian and French, almost all literary.

The corridors were lined with extraordinary post-revolutionary and civil war posters by Malevich. But in addition, every conceivable kind of junk hung from the ceiling by dangling ribbons. One could hardly move between the massive pieces of furniture and the Chianti bottles and knick-knacks descending from above.

After about an hour we were joined by Andrei Voznesensky and Zoya. We sat down to dinner at an improvised table in the main room, a rather civilized meal in the sense that we were not overwhelmed by endless courses of heavy food.

The main subject of conversation was, of course, Mayakovsky. A special celebration of the poet had been decreed for this year and, to Lili's indignation, she had been excluded from the organizing committee. The prudish Soviet leaders could not bring themselves to accept that their great revolutionary poet was also highly uninhibited and lived most of his last ten years in an unorthodox sexual relationship. But Lili volunteered that the real reason she was not on the committee was because she was Jewish. When I questioned this she quite stubbornly insisted.

Voznesensky was a member of the committee. He described, a bit tongue-in-cheek, how he tried to convince the committee that they should not commemorate Mayakovsky in the traditional way. Mayakovsky had wanted not a monument but an explosion. So Andrei had proposed precisely that – an explosion. 'I suggested that the army give them a rocket, just a little one,' he said, 'which could be set off from the Lenin Hills. The committee voted for a "solemn evening" of speeches in the Bolshoi Theatre.' Andrei laughed drily at his own joke.

'What I object to most in our "official" literary world,' said Lili, 'is that they do not lie honestly.' She spoke sharply, and forcefully, even though her voice had the slight quaver of the

elderly. 'I have no objection to falsehoods, but there is a big difference between honest lying and dishonest lying.'

Vasya appeared discomfitted by Lili's disparaging remarks about the whole regime. When her sister died, Louis Aragon had invited her and her husband to come and live with him in France, but Lili was never really tempted, in spite of her love of France: she could not envisage living anywhere else but Russia.

Lili threw out her arms to encompass the ghastly flat, and spoke directly to me. 'I am sure you wonder how I could prefer this to Paris. Russia is in my soul and it doesn't matter how sordid life is here.' She added that in any case she would not want to live next to her sister's tomb. Aragon had transformed an old mill he had near Paris into a kind of Elsa mausoleum.

Lili was neither an intellectual nor an ideologue. Her politics had been a bit like the politics of the students of 1968 in France, whose semi-revolution in the streets had actually provoked the fall of President Charles de Gaulle. But they were inspired only by a vague revolutionary spirit that they were going to create something new and marvellous. Like many Bolshevik sympathizers, Lili had known what she disliked – the czarist regime – but not exactly what was going to replace it. She had been caught up in the enthusiasms of the vibrant artists and intellectuals who were her world. I came to believe that she had never actually believed in the ideology, though she continued to believe in what the Revolution might have been. And no matter how awful it had become, she was first, last, and always a Russian.

The next time we were all together was at Zoya and Andrei's dacha. Andrei was just back from Paris where he launched a record of his poetry in a French translation brought out by Pierre Cardin. He was wearing outlandish new mod clothes by Cardin, and he proudly displayed a psychedelic piece of illuminated and mobile sculpture, that cost fifteen thousand francs. It was in appalling taste. 'Just right for a brothel,' said Katanyan laconically.

Lili inevitably got back into her recollections of Mayakovsky. His eightieth anniversary was to be celebrated on 16 July. This had thrown the authorities into a state of ideological *angst* as they held endless meetings to decide just how to honour their version of Mayakovsky without resurrecting the real Mayakovsky, the one

who despised them. They needed something simple, and non-controversial. A concert. 'Why not?' said Andrei. 'The end of the Twenty-Fourth Congress of the CPSU was a concert.'

'Mayakovsky would never have lived to forty, let alone eighty,' Lili said, with disdain for the whole thing. 'He had a suicidal distaste for life.' She recollected one night in Leningrad receiving a call from him at three in the morning 'to say goodbye forever.' He intended to kill himself. When she rushed to his hotel she found him lying in a dead faint, a loaded revolver at his side. He had apparently lost his nerve at the last moment but the emotion generated was so great that he had passed out.

The Mayakovsky celebration was low key, and took place without Lili. A year passed before we saw her again, when she and Vasya invited us to lunch at their dacha in Peredelkino, in July. It was much more spacious, and better equipped than that of the Voznesenskys; they had acquired the 'right' to occupy it many years before. From its veranda you could see the dacha where Pasternak lived, worked, and died.

One afternoon a rather miserable-looking old dog wandered into the grounds and was immediately made part of the group and fed delicacies. It was Pasternak's dog.

The presence of Pasternak was so great in Peredelkino that after leaving the dacha we all went to his grave a kilometre away in the little village churchyard, now neatly preserved near the fine church which has been beautifully restored. We talked of *Dr Zhivago* and wondered if it would ever be published in Russia. Everyone seemed to have read it, but Lili thought little of it, preferring as I did his poetry and another prose work, *The Childhood of Luvers*.

Lili felt in a reminiscent mood, recalling those lost days of Pasternak and Mayakovsky so much more clearly now than she could recall the events of last week. She remembered Pasternak vividly, and the mystery of how he, of all Soviet poets the most likely victim of Stalin, had nevertheless escaped the purges of the 1930s and of the postwar years. Lili believed that Stalin had a secret respect for poetry, which he had wanted to be able to write since his seminary days. Pasternak, in his curiously pure and

disinterested way, had always refused to sign the collective letters which were regularly required of writers supporting the regime on various issues, and insisted on writing his own separate letter. Thus he had written a separate letter to Stalin on the death of the latter's wife, Alliluyeva, and it had touched a chord in Stalin, who had replied. Pasternak answered and the correspondence went on. Lili said Stalin had probably never read Pasternak and would not have understood him if he had. But he seemed to have a strange respect for his reputation as a poet, and for his indifference to his personal fate.

I had just read the memoirs of Olga Ivinskaya, who lived with Pasternak during his last years and went to jail after his death. Lili spoke very badly of Ivinskaya, saying she had done a lot of damage to Pasternak and given him consistently bad advice. She said that Olga had been employed by the magazine *Ogonyok* before she met Pasternak and had gone to jail for stealing from it. Lili implied that there was some justification for the Soviet charge that Ivinskaya had misappropriated some of Pasternak's royalties, but it was hard to separate the obvious dislike she had of the woman from the facts.

According to Lili, Mayakovsky loved Pasternak and greatly admired his poetry, which he could recite at length. In the early twenties Pasternak reciprocated in his liking for Mayakovsky and his poetry but in the thirties turned against his memory after Stalin had elevated Mayakovsky to what amounted to the official poet of the Revolution. 'I suppose this was partly political on the part of Pasternak,' she sniffed, 'but mostly jealousy since he was very conceited and considered himself the only poet in Russia.'

Those days in Peredelkino had a special magic, especially in the gorgeous days of autumn, *babe leto*, as the Russians call it – our Indian summer. And they always filled me with nostalgia for the Canadian fall, closing up the cottage in the Gatineau or Muskoka. Peredelkino seemed light years away from Moscow: the peace and quiet there among the birch and beech trees, their silvery leaves and white trunks a sharp contrast to the pine and spruce, made me think too of Russia as it once had been.

The only other guests at the gargantuan spread they had prepared for us were Vasya's son from a previous marriage, Vasinka,

and his wife Inna. These long and almost langorous visits passed in a comfortable, womb-like refuge, where we talked of everything from the defection of Baryshnikov to the antics of Joan Kennedy. Vasya lightly accused Canada of 'stealing Baryshnikov.' But was it so lightly? Inna made it clear that the loss of this incomparable dancer was a terrible blow – not just to the regime, but to all Russia. When we talked of the deportation of Solzhenitsyn and the life of Rostropovich in England, their worry, and their sorrow, was plain. Andrei's story about Joan Kennedy's visit to his apartment in Moscow provided a cosmopolitan break from it all: how she got rather drunk, and on departing left her purse, with passport, money, personal letters, and other items. A terrified Andrei rushed to her hotel to return it, causing a great to-do.

But as always the conversation would find its way back to Mayakovsky. Lili talked of his 'disease' – the determination to kill himself. She said he himself called it a disease, and if he had not committed suicide in 1930 he would have done it at some other time. He had been a loyal Bolshevik but by 1929, she said, he was convinced that the Revolution had fallen into the hands of the 'clerks' and bureaucrats, the people he had so hated in the old regime. If he had not committed suicide in 1930 he would certainly have fallen foul of the regime and disappeared in the purges, like so many other writers.

She remembered the night of Mayakovsky's suicide. It seemed to bother her not at all that it involved another woman in his life. Lili said he had spent the evening with the actress, Veronika Appolonskaya, and the writer, Valentin Kataev, whom she described as a talented monster. They all quarrelled bitterly and Kataev left. Mayakovsky then begged Appolonskaya to come and live with him for three weeks. She refused; he replied, 'Then go.' She got up and left and on the stairs heard what she afterwards realized was the fatal pistol shot.

It was not long after the death of the poet that Lili received what was to be a momentous letter. General Primakov was military attaché in the embassy in Tokyo at the time of the suicide, and he wrote a note to her expressing his admiration for Mayakovsky's poetry. She replied and one day when he was home on leave he knocked at her door unannounced and, according to

Lili, it was 'le coup de foudre' – love at first sight. 'He was terribly handsome and dashing,' she said, plainly seeing him again in her mind's eye.

She had by then divorced Brik. Brik had remarried but they were still friends, and he put his stamp of approval on the general. When Primakov was posted back to Moscow in 1931 they were married. Not long after, Osip Brik disappeared into the gulag.

Primakov was one of the authentic military heroes of the Revolution and the civil war. He was a 'red Cossack' and a swashbuckling cavalry man of the type glorified by Isaac Babel in *Red Cavalry*. His specialty was deep raids into enemy territory. Lili described how his life was saved once because he had in his breast pocket a solid gold cigarette case with diamonds inscribed to 'my most beautiful darling from Nicholashka.' It was a present from Czar Nicholas II to the ballerina Kashina, with the additional inscription 'to the most courageous of raiders – Uvalich.' A bullet hit this stolen treasure and was deflected from Primakov's heart.

In late 1953 Lili and Primakov were living in Leningrad. She was disturbed at the growing criticism of Mayakovsky and the tendency to dismiss his poetry as incomprehensible. Therefore she wrote a letter to Stalin suggesting that this should be stopped because he was the greatest poet of his epoch. A month later she got a telephone call from Yezhov in the Kremlin asking her to come at once to see him. Yezhov was not yet head of the NKVD but fourth secretary in Stalin's small personal group. Absolutely terrified, she nevertheless at once went to Moscow and had four and a half hours with Yezhov, whom she later described as 'a good actor in a bad play.'

On Yezhov's desk lay her letter to Stalin and on the page something was scrawled in red ink in Stalin's handwriting which Yezhov read to her and then permitted her to read. The gist of it was that he agreed with Lili that Mayakovsky should be given the treatment due him as a great poet of the Revolution. He particularly instructed Yezhov to pass these instructions on to Nikolai Bulganin, then mayor of Moscow, and to the editors of *Pravda*. Of course this was the word of God and from then on the cult of Mayakovsky started to grow. But Lili added there were

curious pockets of resistance. For example, the editors of *Pravda* did not want to accept the verdict of Stalin. They did not question it openly, but they grumbled and dragged their feet.

In 1936 Primakov was arrested, in the beginning of a purge that in 1937 included Marshal Tukachevsky, General Uvalich, and most of the general staff. Lili never saw or heard of him again. He went to work and never returned. She asked Marshal Tukachevsky what had happened but the marshal confessed ignorance. A few days later the police appeared at her flat to requisition Primakov's goods and admitted he had been arrested. She phoned again to Tukachevsky to ask if he could do something and he promised to try, but the same day he too was arrested. When the news was published that General Primakov had been arrested for plotting against Stalin her first reaction was incredulity, then disappointment that Primakov had not taken her into his confidence, then panic. She went to everyone she could think of to help, but she later realized Primakov was the first to be arrested and the first to be shot. It was only years later she came to understand that there probably never was a plot.

Then came the turn of the generals' wives. One after another they were arrested and deported to Siberia where they nearly all died. Almost the only exception was General Yakir's wife and many years later she was the source of inspiration for her son Piotr Yakir, who in his zeal to avenge his father's death became one of the leading dissidents when Khrushchev revealed the enormity of Stalin's crimes. Arrested in 1972, he was broken by savage interrogators. His 'confessions' and implication of others shattered dissident morale.

Every day Lili expected the police to arrive for her too, but they never came. In anticipation she destroyed every paper, every memo, every note she had, many of them of great historical and literary value. But in those days almost anything could be considered incriminating. Even the legendary cigarette case was 'derequisitioned' after the arrest of Primakov. She shrugged her shoulders and said flatly, 'What was taken illegally had to go illegally.'

One day she heard a rumour that the police were coming that night. In a panic she destroyed the remaining mementoes of the

literary life of the twenties by putting them in boiling water and, after reducing them to a pulp, going around the city sticking bits of them in various garbage cans.

But in the end, the only one to escape that horrible round-up unscathed was Lili herself: her contact with Stalin about her idol Mayakovsky saved her.

With Lili's memory fading, it was difficult to sort out some of the tangle of dates and marriages and relationships. Mayakovsky lived with Lili and Brik from 1915 to 1927, at which time Vasya Katanyan moved into the household. After Mayakovsky died, of course, arrived General Primakov. Brik survived the gulag and reappeared. When he died in 1945 Lili married Katanyan but it wasn't clear to me if Brik, whose name Lili continued to carry all that time, was still living with them and how Brik or Katanyan got on with the dashing Cossack general. I couldn't imagine the general sharing Lili with anyone else.

On one occasion in 1975 Lili invited us to her dacha to have lunch with the widow of the Chilean poet Pablo Neruda. I'm not sure whether Matilde Urrutia was officially married to Neruda but they had lived together for many years. She had been accepted as his widow, and had charge of all his literary papers and documentation. She still lived in Chile in spite of her husband's membership in the Communist Party and his support for the Allende regime. He died very shortly after the fall of Allende.

I asked her about the circumstances of Neruda's death. She said that although at the time of the military coup he was living at his villa by the sea, in the fighting their house in Santiago was partly burned and was ransacked after his death. She categorically denied the allegations being made by many leftists that he had been assassinated; in fact he had been suffering from cancer for several years. She simply laughed when I told her that Andrei Voznesensky had written an ode to Neruda in which he bewailed his assassination. She said the events of the Pinochet coup had had a depressing effect on Neruda at the end of his life, but there was no question but that he died a normal death.

I asked her if she had had any difficulty with the military regime. She replied in the negative, adding that there had been no problem about rebuilding their house or keeping their seaside

home, 'Viña Del Mar,' and his papers had been left undisturbed. Furthermore, she had been able to travel to Europe every year since the Pinochet regime took over. Mrs Neruda was in the Soviet Union at the invitation of the Soviet government to attend a ceremony baptizing an oil tanker with the name of Pablo Neruda. The Chilean government made no problems, even though it knew where she was going. Curiously enough, the Soviet authorities made very little out of her presence, lodged her at a second-rate hotel, and practically ignored her. This was odd since Soviet television, for example, never missed an occasion to interview some Chilean refugee and attack the Chilean regime. She said that negative reports about the military regime of General Pinochet had been grossly exaggerated.

These visits by western communist luminaries were almost always fraught with political hypocrisy. The visit in December 1977 of Louis Aragon was a supreme example of Soviet doubletalk. Lili could talk of nothing else, almost spluttering with anger and disdain. Lili told how Aragon had phoned her from Paris at the time of the invasion of Czechoslovakia in 1968 and said he would commit suicide if the French Communist Party did not condemn the Soviet invasion. 'He had a passionate attachment to pure ideology,' she commented. 'After that conversation with Aragon, I believed I would never again get an exit visa.'

But when Elsa died shortly after, to her astonishment she did get permission to leave the Soviet Union. Max Lyon of the French communist daily *L'Humanité* happened to be in Moscow when her sister died. He simply put her in a taxi and went to the various ministries necessary and said he was not leaving without Lili. She got her exit visa. She was met at the Paris airport by Aragon, who talked like a man possessed about Czechoslovakia, and not a word about Elsa. When Lili taxed him with this he looked at her in surprise and said, 'Mais Elsa et la Tchécoslavaquie, c'est la même chose.'

This extraordinary remark reminded me how rarified the atmosphere can be with ideologues. I found it hard to reconcile Aragon's poetry and his attachment to communism. In August 1939, the day after the signing of the Ribbentrop-Molotov pact, Aragon wrote a passionate paeon of praise to Stalin, saying that the Nazi-

Soviet agreement was the final assurance that there would be no war in Europe. And he never lost his faith. His denunciation of the Soviet invasion of Czechoslovakia was a mere deviation which he and all the other French communist intellectuals would quickly forget and forgive.

Through her entire life Elsa had stood steadfastly by her husband and by the French party, the most influential communist party in the western world. On the other hand, Lili, having actually lived through the Russian upheaval and having had most of her friends and associates assassinated by Stalin, was a realistic, even cynical, observer of the scene, and occasionally a sarcastic critic.

Aragon's visit coincided with the celebration of the sixtieth anniversary of the Bolshevik Revolution. At the end of his visit *Pravda* announced that he had been received by Brezhnev, with whom he had had a friendly conversation. The visit of Aragon was important to the Soviets because he was such an important member of the French Communist Party, and had taken such a strong anti-Soviet line 1966 at the time of the Sinyavsky-Daniel trial and in 1968 over the invasion of Czechoslovakia. At that time he had publicly promised never again to set foot in the Soviet Union as long as one Soviet tank remained on Czech soil. Hence the decision of Aragon to come to Moscow was welcomed by the Soviets, particularly at this time when differences had appeared between the Soviet and the French Communist parties over the emergence of 'eurocommunism.' a kind of watered-down Marxism for the West. His visit was interpreted in the Soviet press as a sign that Aragon had seen the light, had made the necessary ideological adjustment, and had come down on the side of Moscow in the dispute between the two parties.

Lili told us that all of this was utter nonsense. The real reason for the visit of Aragon was purely personal. His marriage to her sister Elsa had been a façade: he was a homosexual, openly so since her sister's death, and his current boyfriend was a French theatre producer who was invited to stage a play by the Greek communist poet, Yannis Ritsos, in Moscow. Aragon decided to accompany Ritsos and the producer to Moscow.

Lili said with contempt that Aragon had not been received by Brezhnev; the latter had simply shaken his hand at a large recep-

tion. She and I agreed that the idea was to exaggerate the importance of his visit for the French press which, from what I saw, did not question the veracity of the statement in *Pravda*.

What made Lili seethe with anger was the deeper hypocrisy: the Soviet government officially condemned homosexuality as a criminal offence. It was hard to believe the Soviet authorities were not fully aware of Aragon's proclivities and the real reason for his visit to the Soviet Union. I regarded the Aragon case as a vivid reminder of the depths to which the Soviets would stoop to gain even a small political advantage. Lili's anger and indignation were more personal. Lili's stepson Vasinka had produced a documentary of the Ukrainian film director Parajanov, who had been jailed several years before ostensibly for homosexual activities, but in reality for Ukrainian nationalism. Lili was furious at this persecution of Parajanov, and so the treatment of Aragon made her even angrier.

She was still fuming when Vasinka arrived rather late. He had been delayed by his work on a series of twenty films being prepared for American television. They were about the war on the Eastern Front, with Burt Lancaster narrating. They sold the film to the Americans for $200,000 and were disgusted afterwards to find out that Burt Lancaster was getting $250,000 for his two weeks' stint. Vasinka added, however, that Gregory Peck had asked $500,000 and Kirk Douglas $400,000.

With artists and neighbours dropping in, those days at Lili's dacha reminded me vividly of a scene out of Turgenev's *A Month in the Country*. With the arrival of Volodia Pinkov, a young Leningrad actor who was to star in a new version of Mayakovsky's *Klop* (*The Bedbug*) at the Satire Theatre, Turgenev gave way to Soviet reality, and the topic of conversation turned to defections, from ballet dancers to hockey players. But Pinkov, who was meeting Lili for the first time, was clearly in awe of her and gradually got up enough courage to ask questions about Mayakovsky.

Lili recounted the story of an extraordinary encounter. A man had telephoned to introduce himself as the former personal chauffeur of Czar Nicholas II, and 'chef de fil' of Mayakovsky during the First World War. He asked to call on her to talk about

Mayakovsky. She received him and found a man of eighty-eight in perfect health. He had climbed the four flights of stairs to her apartment in Moscow rather than risk the decrepit elevator. He had in fact been head of the garage at the Winter Palace although he was a man of considerable education. When the war broke out he was entrusted with the formation of a semi-military truck service and Mayakovsky was one of his drivers, having been excused from military service. He said Mayakovsky was a terrible driver but a marvellous personality who kept all the other drivers going with the recitation of poetry and songs.

During the last few months of the Kerensky regime this intriguing man had entered the apartment building of a certain general, not a reactionary and rather kind to his men, and noticed lingering at the door several persons he knew to be of the police. He had overheard one say that they were going after the general. He alerted the general, took him out the back way and to Mayakovsky's apartment where he stayed for several days until he could make his escape.

After the October Revolution the chauffeur was arrested and spent fifteen years in jail. It was not too clear what he had done since, except to write his memoirs, two hand-written volumes which he had left with Lili, promising to bring ten additional volumes later. She said they were rather primitive but quite interesting. This voice from the past had obviously deeply moved her.

And it moved the others to an uncharacteristically vehement discussion of inequality and poverty. Inna said truculently that there were very great faults in Soviet society but one thing she thought superior was the lack of feeling of shame about poverty. She had been very poor in her time but she never felt less a member of Soviet society than anyone else. This precipitated a violent argument. 'Poverty is poverty,' snapped Lili, 'and nothing can hide it. Most of the people of the Soviet Union are horribly poor. How many could afford the kind of meal we have just eaten, for example?'

'And what farm labourer thinks he's as good as Brezhnev?' added someone else. 'You get into a big limousine, you eat well, you have leisure time, all sorts of privileges, and you automatically

become separated from the rest of humanity, whether you call it capitalism or communism!'

This was the first time I saw these people get really excited about a question. It was odd, now that I noticed it, how they usually talked so languidly of matters that in Canada would be so urgent: deportation, censorship, imprisonment and worse, all the commonplaces of life here.

In fact, Vasinka mentioned that during the jamming of the BBC and the Voice of America they had come to rely on the broadcasts of the CBC. The Canadian network had a good reputation for honesty and non-interference in Soviet affairs. All they wanted from the West were facts; they could interpret events themselves. Someone else then took up this theme, mentioning that the kind of thing which was not helpful was a recent BBC broadcast foretelling widespread changes in the Soviet government. The guess was all wrong, to start with, but of no great interest to the average Russian listener anyway.

We were at Lili's dacha another Sunday afternoon, with winter overstaying its welcome that spring of 1975. Apart from the family there was a well-known film writer, an actor from the Satire Theatre, and someone she introduced as Kantanov, whom she described as a bureaucrat whose avocation was poetry. During the entire afternoon there was a constant coming and going of writers and actors. A dismal drizzle did not improve the mood, and perhaps made the guests even more openly critical than they might otherwise have been. Everyone despaired of the empty shops, the poor crops, the hopeless economy.

I had just been reading Tolstoy's memoirs of his youth and recalled his returning from a long stay in St Petersburg to his estate in Yasnaya Polyana. He noticed a young peasant serf trying to plough with a wretched old nag which could only go a metre or two before it would have to rest. Tolstoy offered to put the old horse out to pasture and give the peasant a new one. The peasant refused politely. Tolstoy then asked the estate manager for an explanation. Had he offended the serf? The manager replied: 'Oh no; if you give him a new horse he will have no excuse for not working hard.'

Everyone laughed and said that described the situation today.

The end of serfdom, the Revolution, whatever else, had not altered the outlook of the average Russian. 'Most of us are peasants,' one said, 'and Russian peasants at that. We just don't like to work hard.' I suggested that might change if there was real incentive – decent housing, consumer goods, and so on. They all seemed sceptical.

So passed those wonderful visits to Lili's world. During the winter of 1977–8 she went out little, but Thereza went frequently to see her in her apartment. But as soon as summer arrived she and Vasya moved back to Peredelkino. At the age of eighty-seven, she broke her hip and was confined to bed, but was as lively as ever and still eager to talk about the poetry scene in the twenties and the thirties. I found her very frail, her mind occasionally wandering, and slightly depressed at the thought that she might never walk again. But she was still interested in the world and in particular in reviews of a new book about her and Mayakovsky which had just appeared in Italy.

One Saturday morning in 1978 Vasya Katanyan telephone to tell me that Lili had died in her sleep. I at once went out to give him moral support. The body had already been removed, and there were a few friends, among them some people from the Satire Theatre, Konstantin Simonov, and others. Vasya said he did not know what happened but she suddenly seemed to give up the fight and just faded away. There was nothing much I could do, so I came back to Moscow, giving Simonov a lift. He spoke quite movingly about Lili and what she had done for Russian poetry by saving and preserving the image of Mayakovsky.

On Monday the funeral ceremony took place at the New Moscow Crematorium in Nikolskoe, a small village about an hour's drive to the east of the city. I was the only foreigner present among a group that included Simonov and a number of lesser writers, representatives of the Satire and Mayakovsky theatres, and numerous friends. The crematorium was starkly functional and under cold and persistent rain seemed the antithesis of Lili's spirit.

Lili was Jewish and had specifically asked to be cremated and not buried in the lovely cemetery in Peredelkino where Pasternak is buried. But there was nothing Jewish about the brief funeral

ceremony. She lay in the coffin dressed for some reason in the national costume of a Georgian woman. In spite of her age she had been quite coquettish right to the end and still dyed her hair that hideous red. But she looked peaceful and rather beautiful.

The master of ceremonies read a brief eulogy of Lili and then various persons spoke about their love for her. A poet whom I did not recognize read a very moving poem about Lili by Olga Bergholz. Members of the family and close friends embraced her, the master of ceremonies pushed the coffin into a lift, closed the lid, pushed button, and it was all over.

This marvellous relic of the past, this link with a more glamorous and exciting era in poetry and literature, this brave and obstinate spirit was gone. She had witnessed and participated in the pre-First-World War explosion of artistic expression in her country. She had lived through two world wars, the Revolution – the event which most affected our civilization in this century – civil war, the horrors of Stalinism, and the gradual descent of the Russian Soviet empire into cruel banality and senseless decrepitude.

Thereza was not in Moscow when Lili died. She loved her and when I described her death and funeral, she said, 'I want to go like that.' And she did, in December 1983.

In September I went out to see Vasya in Peredelkino. He lived there alone now, and the dacha was still and lonely. There was a light mist, a touch of winter in the air. The yellowed leaves of the birches were falling gently. The spruce and pine seemed blacker than usual.

It was a sad afternoon. Vasya seemed lost without Lili and almost automatically started showing me mementoes and photos of her when she was young and beautiful. Then he drew out of a drawer a number of early editions of Mayakovsky from 1915 to 1927, all of them dedicated to Lili. But the new collected works of Mayakovsky, edited by Vasya, then being prepared for publication in Moscow, suppressed all the dedications and all references to Lili.

I sighed in exasperation. 'What is the point?'

'It's at the express instructions of Suslov, the Politburo's guardian of ideological purity,' he said with heavy irony. The reason

was simple: Suslov wanted to give the impression that all Mayakovsky's poetry was inspired by the Revolution, and not by love for a woman. Therefore Lili would have to become a non-person.

The following spring Vasya also died and was cremated in Nikolskoe. Again I was the only foreigner present at this melancholy ceremony. Vasinka and Inna had received permission to take over Lili's flat in Moscow and the Peredelkino dacha, and I saw them there frequently over my remaining years in Moscow. They did what they could to keep the dacha and the apartment as they had been for the previous half-century, a relic of long ago. But the spirit had gone. The apartment was a museum, almost a mausoleum, the dacha a pleasant antiquated cottage in the lovely woods of Peredelkino.

It wasn't until now, as I am writing this memoir, that I have learned from Vasinka, through friends, that in fact Lili committed suicide by taking an overdose of pills. She had been frustrated at being finally bedridden, and Vasinka believed she simply decided it was time to leave this life. Perhaps some part of her had been waiting, through the years, to finally be with her beloved Mayakovsky again.

COMING FROM AFAR

(Extracts)

R.A.D. Ford

We should give thanks to those
Whose prayers have led us back
To the roots of speech. For this
Is the key to the mystery.
This is the magic of the soul.

Seeing is the joy. But the letters
Are both seen and formulate
The self. Each syllable of each
Tongue leads us away
From darkness. Otherwise
The shadow of ignorance overwhelms.

Moscow, 1975, with Nina Kandinskaya and Thereza

NINETEEN

The Murder of Nina: The Life of Painting

For Thereza and me, passionate admirers of early twentieth-century painting, and in particular the Russian artists who were in the vanguard of Cubism and abstract painting, Vasili Kandinsky was our ideal. Working as a member of Der Blaue Reiter, the first German expressionists centred in Murnov, near Munich, before the Great War, he was already advancing into abstract painting and experimenting with linear and Cubist art. In 1914 he returned to his native Russia. In spite of the war and the Revolution, he continued to push forward the boundaries of inventiveness.

In 1918 he became a senior official in the Ministry of Culture, working with and encouraging the extraordinary group of modern painters who were truly in the vanguard of modern art – Alexander Malevich, El Lisitsky, Natalia Goncharova and her husband Mikhail Larionov, Alexander Exter, Kliun, Ender, Tatlin, and so many others. Marc Chagall, working partly in Vitebsk, partly in Moscow, rejected abstract painting and concentrated on his own special vision inspired by Russian village life and the rich traditions of Jewish lore.

The fantastic explosion of talent in those years was at first encouraged by the Ministry of Culture, but the party bosses and the communist bureaucrats who soon took over the running of the ministry suspected that these apparently meaningless daubs were somehow subversive, or at least bourgeois, since they were

appreciated only by educated connoisseurs. This attitude led Kandinsky to emigrate in 1922. He went first to work with the Bauhaus group in Germany, then to Paris where he remained until his death in 1944.

We first met Nina Kandinskaya, the painter's widow, in Paris in July 1968. The city seemed curiously calm and empty after the violent student and workers' riots of May and June. We called on two old acquaintances, Claude and Ida Bordet, who shared our enthusiasm for modern Russian painting.

The Bourdets were fascinating people in their own right, and warrant a brief divergence here. Ida's family were Armenians who owned the major share in the oil industry in Baku before the Revolution. They succeeded in escaping to France where Ida spent most of her life, while remaining very Russian and Armenian in her soul. She died recently. Claude is the son of Edouard Bourdet and Catherine Pozzi, the former the most popular playwright in France in the late nineteenth and early twentieth century, and he left a large fortune to his son. His mother was a poetess of considerable talent. She was the protégé of André Gide, one of the most famous men of letters of the period, and allegedly the mistress of Paul Valery. Claude was educated in Zurich, London, and Paris, and was completely trilingual.

Already fashionably leftist before the Second World War, he joined a left-wing resistance group in Paris after installing Ida and his family in the Midi. Early in January 1944 he and his cell of resistance fighters were captured by the Gestapo and sent to Büchenwald. He survived, but barely.

After he recovered, he helped found the left-wing newspaper *Combat*, of which he became editor. He left it in due course, flirting with various leftist organizations. Then he ran unsuccessfully for the Legislative Assembly, as a candidate of a splinter group of the Socialist Party. Rich, highly cultured, intelligent, he typified a unique French phenomenon, with one exception. He was never viscerally anti-American, or blindly supportive of the Soviet Union. Unfortunately Bourdet frittered away his wealth, his connections, his immense talents in lost causes. But he was a faithful friend, and it was he who took us to visit Nina.

Nina Kandinskaya had kept the apartment-studio almost as it

had been when Kandinsky worked in it. The spirit of the most innovative of modern painters was everywhere and the pictures and drawings overwhelmed us. It was stupefying to see the Kandinskys on the walls, stuck in corners, leaning against furniture. She was not only a passionate defender of her husband's reputation, but a shrewd businesswoman who knew full well the value of these works. However, she clung to them parsimoniously, only occasionally selling a painting to buy a new jewel or precious stone, for which she had a mania. Occasionally, during our years of friendship, Nina gave Thereza a pen and ink drawing or etching, and once a copy of Kandinsky's *Xylographies*, containing five woodcuts depicting traditional Russian scenes. This is now in the London, Ontario, Regional Art Museum. The only other copy in North America is in the Guggenheim Museum in New York.

Nina was a small, deceptively fragile-looking woman in her late seventies, but still coquettish, her features retaining whispers of her youthful loveliness. She had never questioned her husband's genius and stood loyally by him in his artistic experimentations, in his decision to return to Russia in 1914, and in his subsequent decision to flee back to Europe.

Over the years we visited her often in Paris, and she came to stay with us several times in Moscow. Always fearing for her relatives, she made these visits discreetly. But she loved to speak Russian and to reminisce about the Revolution and about Kandinsky's work in the Ministry of Culture. It became clear to us that he probably would have left even if the brief period of Bolshevik enthusiasm for new 'anti-bourgeois' art had not evaporated. He simply was not a bureaucrat.

Nina and Kandinsky's relatives were tolerated because of the immense reputation of the painter abroad, because he was dead and therefore no threat, and, I suspected, because many Soviet officials were secretly proud of him. But his work was stuck away in the attics of the Pushkin and Treyatkov museums, and hidden for safety by admirers.

Gradually the closest relatives died off, and Nina felt it was safe to see us more openly, with other guests. She asked if we could introduce her to some important artists and writers. We invited Andrei and Zoya, the composer Nikita Bogoslavksy, Madame

Antonova, director of the Pushkin, and the wonderful actress Madame Zuyeva, whose performances at the Moscow Art Theatre were a delight to see, even if they were in mouldy Chekhov.

'Chekhov is a genius,' said Madame Zuyeva drily. 'I love him. Every word he wrote. But I have had indigestion for years now.'

Antonova nodded with silent understanding. 'And our museum will have to have an annex soon if the flow of pictures continues about groups of beautiful young girls dancing joyously with a background of lush acres of wheat. Have you ever seen such dancing workers? Or for that matter, such wheat?'

Beyond that, there was a tacit agreement to avoid politics, and as the afternoon drifted by in a timeless and languid discussion of arts and letters and gossip, I felt once more that sense of being in a scene created by Chekhov or Tolstoy or Turgenev. Time somehow slipped back one hundred years and the Revolution had never taken place.

Nina had a curiously passionate ambition to receive the Legion d'Honneur. Charles de Gaulle had resigned the presidency in a fit of pique when the population rejected his governmental reform plans in a referendum, and Georges Pompidou had succeeded him. An extraordinary man, Pompidou came from a poor family in the Cantal, in the Massif Central, one of the poorest areas in France. Through dint of his own efforts he had became a professor of French literature, author of one of the most discerning anthologies of French poetry, and, with his wife, a patron of the arts and the main force behind the Beaubourg Museum of Modern Art, renamed the Pompidou Centre after his early death from cancer.

Fully aware of the importance of Nina Kandinskaya's treasures and determined to keep them in France, he flattered her and probably cajoled her into agreeing to leave her collection to the Beaubourg. And she got her Legion d'Honneur. This cost the French government nothing, pleased Nina enormously, and was a win for posterity.

Nina also owned a large villa in Gstaad, where we visited twice. Thereza acted as a kind of intermediary between Nina and Valeria, the niece of Kandinsky, and a cousin. The relatives were always torn between the desire to have news of Nina and the outside world, and fright of the Soviet authorities. Curiously

enough, what Valeria wanted above all was Kandinsky's book *The Philosophy of Art* in Russian. She had a copy in French but could not read it. Thereza managed to discover a Russian edition published in Paris and brought it to her, to her great joy, mixed with her fear of being caught with seditious literature.

In July 1980 we were in Geneva for a meeting with some Canadian government colleagues to discuss my future assignments after leaving the Moscow post. I was officially retiring at sixty-five but was to continue working as a member of the Independent Commission of Disarmament and Security, headed by Olof Palme, the Swedish prime minister. After the meeting Thereza and I went to Gstaad to see Nina. We were appalled to find her quite alone in her large villa, surrounded by precious Kandinskys. She came to lunch with us at the Palace Hotel, dripping diamonds. Thereza told her she should be more discreet or else have someone with her at the villa.

'Oh, no one would touch an old woman,' she said with careless disdain, 'and in any case I have never been able to tolerate having anyone living with me.'

We spent most of the day with her in her villa and left the next day for Moscow. The following night someone broke into her villa and strangled her. The pictures were not touched, only her jewels were stolen. Either the murderer was unfamiliar with the value of the paintings, or all too familiar and aware that they could not be sold, except perhaps to unscrupulous private collectors. In either case, it was a highly professional job. To the great embarrassment of the Swiss police, the murderer was never caught.

We were horrified at the news of the sad end of a remarkable woman. She was almost the last link with the great epoch of early twentieth-century modern painting. And it was she who had fought to establish Kandinsky's reputation during many long years until he was finally accepted as one of the great modern masters. In that, she was not unlike Lili Brik.

Thereza flew back to Paris and attended her funeral, which followed the Russian Orthodox rite, at the Cimetière Nouveau in Neuilly. She wrote long letters to Kandinsky's relatives in Moscow describing the ceremony and also the complicated legal questions which arose over Nina's estate.

Lawyers from the French government approached Thereza to solicit her help in establishing the legitimate owners of the estate. They had found her name, numerous letters, and her Paris address in Nina's apartment. Nina had left all Kandinsky's paintings to the Musée Pompidou in Paris but had failed to compose a proper will disposing of the apartment and the bulk of her estate. The French lawyers concluded that the niece was entitled to most of it as the only ascertainable direct descendant of Kandinsky, but they knew only her name, Valeria Krylova. Nor did any of them know Russian or indeed anything at all about the Soviet system. Thereza soon found herself in the position of acting as intermediary between the French lawyers, Valeria, and soon enough the Soviet authorities, who were quick to realize how much was involved. The Soviet government moved in and sent the French lawyers a power of attorney signed by Valeria authorizing the Soviet lawyers to act on her behalf. Thereza was appalled and tried to find a way to overcome the authority given to the Soviet lawyers, but it proved impossible. Valeria got nothing. And in the end I believe most of the money, after French inheritance taxes had been deducted, went to the Soviet government – which was just about the last thing Nina would ever have wanted.

Another curious result of Nina's murder was the intervention of the Swiss police through Interpol. Letters and diaries found in the Gstaad villa and her apartment in Paris showed that Thereza had been a close friend and that we were among the last people to see her alive. I was in Moscow but Thereza, having returned to Paris for the funeral, was subject to repeated questioning on behalf of the Swiss police. It was very polite but persistent, since the Swiss were embarrassed not only at having been unable to find any trace of the murderer, but also at this blow to the reputation of one of the country's most fashionable resorts. To the best of my knowledge the mystery has never been solved.

When I had arrived in Moscow for the first time in 1946, my knowledge of Russian painting was limited to what I had seen in books of icons, principally because of their role in the development of the Russian Orthodox Church, and the importance of

this in the direction Russia took. The adoption of the Byzantine rite, a variation of the Greek alphabet (much better suited to the peculiarities of the Russian language than the Roman, by the way), and the strong influence of Greco-Byzantine church architecture, led inevitably to the art of icon painting as an integral part of the Russian variation of Christianity.

I also knew something of the Russian painters who had worked in those early exciting years just before and just after the Revolution. Mikhail Larionov and his wife Natalia Goncharova I knew mainly because of their fame as stage and costume designers for the Ballets Russe of Monte Carlo, made immortal by Diaghilev and Nijinsky. Mikhail Fokine, the driving force behind the ballet's creative explosion, said that he considered Goncharova's costumes and decor for *Le Coq d'Or* to be 'some of the finest ever seen on the stage.' Larionov, Bakst, Tatlin, and a younger painter, Alexander Tyschler, were also employed by Diaghilev to produce the backdrops, designs, and costumes for the Ballets Russe, which were part of the essence of some of the greatest ballets of modern times.

Painting in Russia had missed the sudden burst of creativity seen in the other arts in the late nineteenth century, but this time it was part of the general artistic fervour. Not surprisingly, the artists went abroad to France and Germany, where there was the greatest possibility of associating with like-minded colleagues, and of finding the personal path each was instinctively seeking. A few newly rich businessmen recognized what was happening: by 1914 some of the greatest private collections in the world had been put together by people like Ivan Morozov, a sugar millionaire, and Savve Mamontov, the steel and iron king, who had filled mansions with superb Cezannes, Degas, Dufuys, Matisses, and Picassos. All were confiscated after the Revolution but were preserved, after a fashion – hidden in the dark recesses of museums or banished to the attic of the Hermitage. Like Kandinsky and Chagall, Larionov, Goncharova, and Bakst fled Russia in the early twenties.

I cannot say we knew Chagall well, but we did come to meet him in Vence in the Midi region of France in the early seventies, when he was already an old and charming man lovingly tended

by his daughter Ida. When he first left Russia in 1910 he went to Paris and was quickly assimilated into French modernism. He was born and worked in Vitebsk, which under the czars had been part of the Jewish Pale. But in 1910 he more or less illegally went to St Petersburg and late in the same year travelled to Paris because, as he wrote, 'to be able to live in St Petersburg one has to have not only money but also a special authorization. I am a Jew, and the czar has fixed a certain residential zone from which Jews do not have the right to leave.'

Just before war broke out in 1914 he returned to Vitebsk to marry his childhood sweetheart, Bella. The war prevented him from leaving Russia and after the Revolution he moved to Moscow and participated in the Jewish revival temporarily encouraged by the Bolsheviks. In addition to his magnificent paintings largely inspired by Jewish village life remembered from boyhood, he participated enthusiastically in the creation of the Jewish Art Theatre in Moscow and in 1920 he created seven large decorative panels for the theatre. It was opened in 1920 in a small building on Bolshoi Tchernyshevsky (later renamed Stankevich) Street. There was a kind of workshop for the artists on the third floor, and on the second, a small hall, containing ninety seats, in which Chagall's seven panels were installed. Shortly afterwards the theatre moved to Malaya Bronnaya Street, with the panels.

In 1922 Chagall and his wife left Moscow for Paris and after the Second World War settled in Vence. He must have sensed that along with communist repression, anti-semitism was in the air again. In the early 1930s the Soviets commenced the campaign against 'decadent, formalist' painting, and Chagall's panels were removed from the theatre hall and stored in the rehearsal room.

The great actors Michoels and Zuskin were instrumental in saving many of Chagall's works. Some members of the Jewish Anti-Fascist Committee, at great personal risk, rescued the panels in 1941, and took them to Kuibyshev as the Germans approached Moscow. They brought the pictures back to the capital after the German armies were in retreat.

Alexander Tyschler, a devotee of Chagall, persuaded the Tretyakov Gallery in Moscow to keep the panels in their cellars, and here they remained, in a perilous condition, but more or less

intact. In 1949 Stalin had the theatre closed, and persecution of the members of the Jewish Anti-Fascist Committee began. For forty years the panels remained in dusty closets, and no one saw them until Chagall managed to get permission to visit the Soviet Union in 1973 and by some miracle saw his panels. The experience of seeing them again, in a deplorable state, was overwhelming for him.

No one outside the Soviet Union really knew what had become of the hundreds of paintings and drawings Chagall had left behind in 1922. In 1985, after the first glimmers of Mikhail Gorbachev's *glasnost* appeared, a remarkable woman, Christine Burrus, whose husband used some of his fortune to support the Fondation Pierre Giannada in Marbigny, Switzerland, undertook the task of rescuing the panels, and any other works of Chagall which might still have escaped destruction. Some of the paintings he had made in Russia from 1908 to 1922 had found their way out to the West, but most of them were considered to have disappeared. It took Burrus five trips to Moscow between 1985 and 1991 and endless negotiations with the then minister of culture, Nikolai Goubenko, and the director of the Tretyakov Gallery, Yuri Korolyov, finally to persuade the Soviet authorities to lend the officially held Chagalls and many that turned up in private collections, for an historic and splendid exhibition in the Fondation in July 1991. And the Fondation restored the panels to their original brilliance. It was a great moment for modern art, and a monument to the richness of Jewish culture in Russia, scorned by czars and commissars alike.

What we did not know for many years was the existence of a vast gallery of the other avant-garde painters of the first thirty years of the century. During the years of Stalin's terror, I heard of nothing, not surprisingly. It was only after his death in 1953 that I began to get some hints that some of the great paintings of the twenties still existed. This information came from a highly improbably source.

George Costakis was hired by the embassy in 1944 as a general 'fixer,' essential to the day-to-day survival of the embassy. When official channels failed, which was almost always, the fixer would

get a car repaired, find milk, eggs, or caviar, get the electricity service up and running, and delve into the goings-on of the 'secondary market.' Every embassy had someone like this. The fixer was a vital cog in Moscow life.

George and his elder brother, who worked as a driver in the British embassy, were born in Russia of Greek origin. George had managed to keep his Greek passport, although he was married to a Russian and had never been to Greece. But this tenuous claim to Greek nationality was sufficient to permit his exclusion from many of the troubles of Soviet citizenry.

George had had very little formal education and only learnt English after joining the embassy. But he was intelligent, what we might call street-smart, and endowed with an extraordinary innate eye for painting. By 1951 he was busy scouring the 'commission shops' for bargains. These were second-hand and antique shops where private citizens could dispose legally of any property they had managed to hang on to through war, revolution, and terror. A good Greek merchant, Costakis had a nose for a profitable deal, and managed to get together a fair collection of Dutch and Flemish paintings.

Knowing his liking for art, in 1954 I gave him the three magnificent volumes on modern painting and Impressionism, Post-Impressionism and Cubism and abstract work published by Skira. He was overwhelmed. For Costakis it was love at first sight, and he sold off all his old masters, and began to collect works by the extraordinary group of painters that included not only Kandinsky and the others mentioned earlier, but Malevich, Exter, Kliun, Ender, and Tatlin.

Searching out and acquiring whatever remained of their work became an obsession with Costakis, and by the time we returned to Moscow in 1964, his apartment was stuffed with treasures. My book and his own eye helped him to identify the masterpieces. Thanks to his Greek nationality, he was allowed to have *valuta* foreign currency, and hence could buy very cheaply. His efforts were abetted by the lack of general knowledge about these great artists – one major painting was found covering up a broken window.

Perhaps inevitably, in later years Costakis became so engrossed

in building up his collection that his work at the embassy suffered, as western journalists and other visitors trekked to his doorstep in wonder and awe at his cache. Great excitement was generated in western art circles by a public showing of his collection in Munich, officially approved by the Soviets. The Ministry of Culture seemed interested in the affair only because of the fact, inexplicable to them, that these daubs represented money.

By 1977 Costakis had decided the time had come to cash in on the wealth he had accumulated. The Soviets were beginning to eye his activities, and his collection, more attentively. He made a deal with the Soviet government whereby he could leave the country with his family and two-thirds of his collection, the remainder to be donated to the Tretyakov Gallery. He held onto the best for himself. He settled down in Athens, opened an art gallery, and sold enough of his paintings through Sotheby's to become a millionaire.

The accumulation of his collection was a remarkable feat, for which the world of art owes him much. But it could never have been possible without the advice, guidance, and diplomatic protection the Canadian embassy offered him over nearly thirty-five years. And even more important for him, he could receive his pay in dollars, as he was not a Soviet citizen. After his retirement to Athens, his pension was paid for by our government.

But he refused to acknowledge this. After his departure, the Montreal Art Museum offered to buy the bulk of his collection, and to guarantee that it would be kept intact, for $15 million. He refused to consider less than $40 million, beyond the limits of the Montreal gallery, and a vastly inflated estimate of its value. Instead he put it up for sale at Sotheby's, where it sold for less than the museum's offer, and was dispersed – something which he had always vowed would never happen. He died in March 1990.

In the Soviet Union, the only public trace I discovered of these great Russian painters was a small exhibition in 1964, in one of the old quarters of Moscow. It was only when I arrived that I realized it was the house where Mayakovsky had lived briefly, and it had been turned into a museum dedicated to him, largely

thanks to Lili's efforts. The exhibition, organized by Nikolai Khardiv, an expert on Mayakovsky and his group, was showing works by Larionov and Goncharova, mainly of the period before they went to Germany in 1910, but also, to my surprise, several Cubist paintings by Goncharova. She had died some time previously in Paris, and Larionov died towards the end of the year.

It was the last showing of 'formalist' art to take place in the following twenty years. But this ghostly brief appearance of Larionov and Goncharova led me to try to find out more about the living painters. There were, of course, hundreds of artists belonging to the official union who were churning out endless variations on canvas, lithograph, and marble or stone of Lenin and the few still mentionable heroes of the Revolution, portraits of contemporary bosses, pictures of the happy workers building the proletarian paradise, and innumerable conventional landscapes.

But I knew there were others, like the rebellious writers, who were seeking a way out of these stereotype moulds. There was, for instance, Anatoli Zverev. He was a friend of Costakis, an odd character, a recluse, left alone by the authorities as harmless. He lived only to paint, and all he wanted was a bit of money for food and vodka, and paper and paints. One of his best works, a large oil painting of the church at Peredelkino, was painted on the cardboard back of a reproduction of a Tom Thomson landscape. It is now in the London, Ontario, Regional Art Museum.

Zverev was a special case. The first genuine dissident painter I met was Yuri Vasiliev, who had been featured in *Life* magazine a few years earlier during the period of Khrushchev's 'liberalism.' We met him at Nikita Bogoslavsky's apartment, and it was apparent that the latter used his own privileged position to help shield the painter. Vasiliev was a huge, sloppy bearlike man, happy then moody when drunk, straight out of Dostoyevsky. Quite uninhibited that first evening, he told me he had had a very rough time as a result of that article in *Life*.

'Everybody who was mentioned in it got hell,' he said, 'even people in the Union of Artists – though those guys had nothing to do with it. I guess they thought the censors could have stopped it. They could *now*, but even a couple of years ago things were much easier.' He took another slug of vodka. 'I got the worst treatment.

The Murder of Nina: The Life of Painting / 263

They threatened all sorts of dire fates, because I was a member of the party. Setting a bad example for everybody. Anyway, I'm still a member, sort of. But I keep painting the way I feel.'

When we visited him in his studio, we found it to be just a two-room flat on the ground floor of a prewar building on Ulyanovskaya Ulitsa, in an area which might have been described as lower middle class if this had not been a classless society. Vasiliev met us in the street, in order to escort us in by a roundabout way, the front entrance being a litter of caved-in sidewalk and broken pipes. He pointed to the mess and said, 'A typical *Krokodil* sidewalk. It's been like that for months.' *Krokodil* was a satirical magazine. But the building itself was in relatively good shape, and the studio clean and well kept. He was clearly not being persecuted on any daily basis.

Vasiliev's wife, his third, was to be heard in the kitchen, but she never appeared. Only his son from a previous marriage peered in shyly. The studio was full of paintings and sculpture, including a number of Calder-like mobiles hanging from the ceiling. The sculptures were mostly in stone, very abstract, rather in the style of Henry Moore. He had a collection of hands he had sculpted of several famous Russian intellectuals, of which he was quite proud. The paintings he showed us and described at great length covered a variety of styles, from a realistic 'Sailor of Sevastopol' through Cubism and pointillism to a weird kind of surrealism. Most of his work was not terribly good, and rather out of date. But a few were distinguishably original, and we bought one.

'How do you survive?' I asked, referring to politics.

He pointed to the 'Sailor of Sevastopol' and shrugged. 'A few things like that keep them satisfied. And I have a fairly big clientele among the intelligentsia. The ones who have the money and aren't afraid.' Then he added with a cryptic smile, 'Maybe they even like my paintings.'

His patrons, it seemed, were Bogoslavsky, Rostropovich, Bella Akhmadulina, Kondrashin, and none other than Yevtushenko. 'And lots of others.'

We finished the evening with the usual Russian spread, but without the western delicacies that Voznesensky or Bogoslavsky could command. He did not have access to that kind of privilege.

After that we visited from time to time, but he never came to the embassy. 'Not permitted,' he would say laconically. But he agreed to come to our home for a dinner with Yevtushenko. 'What can they do to me? Tell me not to go another time.' But he never did come and he frequently harped back to the *Life* piece and the trouble it had caused him. At the same time, he was very proud of his recognition abroad.

What struck me as tragic about Vasiliev and the other artists who were either outright dissidents or working on the fringes of official art was their almost total isolation form modern painting in the western world. They would still lapse into pointless, fruitless experimentation that their western contemporaries had long abandoned. Vasiliev wanted desperately to be modern.

They all knew that socialist realism was the antithesis of real art, and were often fearless in their pursuit of some ideal, often poorly expressed but desperately important to them. But they were so completely out of touch with their peers that they were simply floundering around rather helplessly. But when the native talent of these painters flashed through, it had a vigour and freshness which the more sophisticated painting in the West often lacked. And every time that talent bloomed, the artist was harassed by the authorities, usually on the charge of parasitism. It was an immense problem for painters to acquire even the simplest things, such as paints, brushes, canvas, a studio, or anywhere to give a public exhibit. These efforts were almost invariably raided by the police.

Some could operate freely, but only in the privacy of their studios, the latter generally acquired through or rented from the Union of Artists, of which they became members of the graphic arts section. This permitted them to work officially and often lucratively through the illustration of books, stage sets, exhibition designs, and so on. But most lived almost on charity, or the semi-secret patronage of highly placed persons. It was rumoured that Yuri Andropov, the head of the KGB at the time, was a collector of modern art. I tried to help in a small way by buying the works of the 'unofficial' painters.

We met Alexei Rukhin at Vasiliev's studio. He was a Leningrader, and only occasionally came to Moscow. A great bear of a man,

uninhibited, and quite fearless in his remarks about the regime, he was considered one of the best of the dissidents, both as a dissident and as a painter. He had one or two small paintings with him, which were very fine – so fine that we expressed interest in buying them, and he actually brought them over to the embassy for us. When we went to Leningrad we paid him a visit. His house was in a maze of small streets in an atmosphere of poverty and neglect strongly reminiscent of *Crime and Punishment.* His small studio was jammed with paintings, some very good indeed, others of more dubious quality. We bought one large mélange of pieces of metal and dark brown and yellow daubs of paint which seemed a kind of Dostoyevskyan afterthought.

Like most normal Russians, he was enormously hospitable within his limited means, and delighted to have a foreign patron. I wondered who protected him in the notoriously orthodox climate of Leningrad. He replied ambiguously that it was very difficult at times. 'But,' he added, 'probably they think I'm crazy. Anyway, I am safe as long as I don't go public.'

I gave him a copy of one of my collections of poems, *The Solitary City*, and friends later told me he was very proud of it and had it propped up on a small table. He would have been pleased to know that his painting is now in the London, Ontario, Art Museum.

But he was never to know. A year or two later I heard that he had disappeared in a mysterious fire in his studio. Since the rest of the building was undamaged, my Moscow friends were convinced it was the work of the KGB. But why Rukhin, who seemed harmless enough, no one could explain. One had to remind oneself constantly that being harmless was no defence.

At the other end of the spectrum of contemporary painters was Ilya Glazunov, who occupied a range of action and tolerance not enjoyed by any of the other unorthodox artists. He seemed to have no difficulty in attending embassy receptions, in spite of the fact that many of his works had religious, historical, and Slavonic themes. Hence he was regarded with some suspicion by the unofficial painting community. This suspicion was increased when he was allowed to stage a big exhibition in Moscow in the Manege. Particularly puzzling was the fact that it included a huge picture with religious themes. I was told he had the personal protection

of Brezhnev, and had painted the leader's portrait, as well as very flattering portraits of the wives of the other top leaders.

I liked Glazunov personally, though I hadn't much of an opinion of his work. I asked him once if his slightly surrealist work had been influenced by Magritte. 'Never heard of him,' he replied curtly.

I replied that he was well considered in the West for his surrealism.

'Oh. Like Dali,' he said. 'But I have nothing to do with anyone else.'

Vasiliev, who also liked Glazunov but detested his art, told me he was a strange case, a passionate Russian chauvinist, a Slavophile and anti-western. 'Like Solzhenitsyn,' Vasiliev elaborated, 'but not a dissident, and not anti-Soviet.'

Probably he served some obscure purpose. At any rate, he paid for whatever he was due by writing an attack on Yuri Lyubimov for 'desecrating Pushkin' in a new version of Tchaikovsky's opera *The Queen of Spades*, presented at the Paris Opera.

It was in January of 1975 at Lili Brik's apartment that I met Mikhail Kulakov, a Leningrad painter who had moved to Moscow. Kulakov was a very attractive man of about forty, brought up in a family of intellectuals in Leningrad. He entered the Academy of Fine Arts there at the age of seventeen. Almost at once he began painting abstracts. His professor, who was a convinced communist and spent half his time trying to convince his pupils of the beauties of the system and of their duties as artists to support it through socialist realism in art, was equally convinced of the great talent of Kulakov. The latter persuaded him to permit his abstracts to be put up in the professor's apartment in order to try to see what was in them. The professor was denounced by an informer, criticized viciously in *Leningradskaya Pravda*, expelled from the Communist Party, and later committed suicide.

For a while Kulakov, as a result of this experience, abandoned painting and made a living designing theatre sets and so on. Then he became a close friend of Victor Sosnora, the Leningrad poet who was one of the better contemporary Russian writers. Under his influence Kulakov began painting again. He moved to

Moscow and made a precarious living by the occasional commission from the Sovremennik and Satire theatres, the design of an occasional book, and the very rare sale of a painting to local connoisseurs. One of his backers was the physicist Peter Kapitsa, who was responsible for a one-man show by Kulakov several years ago at the Nuclear Research Centre at Dubna.

Kulakov lived in a large apartment building of fairly recent construction near Sokolniki Park. The apartment was not his but had been allotted to an attractive Italian woman of about thirty, named Marianna. She was in Moscow on a three-year contract to translate various works from Russian into Italian for Progress Books. She and her mother and Kulakov were crowded into two minuscule rooms. One consisted of a couch, table, and chair, and stacks of pictures and drawings; the other was a bedroom.

Marianna had met Kulakov, fallen in love with him, and on returning to Italy had joined the Communist Party in order eventually to wangle a job with Progress Books in Moscow in order to be with him. As soon as she was allotted an apartment she invited Kulakov to move in with her. Since Kulakov was not officially a member of the Union of Artists, his position was rather precarious and the police on several occasions threatened action against him. For his part, he maintained a low profile, saw no diplomats or foreigners, and shunned association with the active unofficial painters who had recently organized protest exhibitions.

Kulakov made no secret of his hope eventually to be able to go abroad and I suspected he saw his big chance in Marianna, although he also appeared to be in love with her. She had just returned from Rome where she had had long and successful sessions with the Curia in an effort to get her previous marriage annulled so that she could marry Kulakov. Since she admitted to being a member of the Italian Communist Party it struck me as curiously Italian that the Holy See would succeed in getting her a divorce so that she could marry a Russian. In fact she seemed rather embarrassed at being a member of the Italian Communist Party and explained privately to Thereza that it did not mean the same thing in Italy as in other countries. At any rate, she said quite flatly that she could never live permanently in Russia, communist or not.

Kulakov showed us a great number of his paintings, abstract and semi-abstract, almost all with religious motifs. One whole series was devoted to interpretations of the life of St Matthew, and nearly all had words of the scriptures in old Slavonic worked into the paintings. He told me that he was not personally a church-goer but he had a deep spiritual attachment to the basic values of the Christian religion and, being opposed to communist materialism, was inevitably drawn back to the scriptures.

Kulakov was also a black belt in karate. He had a large library on karate in several languages, including one in English on South Korean karate. He wore his hair in a crew cut because of karate competition regulations. One series of his paintings evoked Zen themes.

We became good friends with Marianna and Misha and visited them frequently. As we got to know him better, he talked more of the deadly atmosphere in Leningrad, particularly sad somehow because of the great beauty of the city. He had decided to leave, in spite of his attachment to St Petersburg, which he called it, even in those days, in part because of the suicide of his art professor, for which he felt responsible. And it was in part because of the persecution of the poets Victor Sosnora and Joseph Brodsky.

Sosnora managed to escape the harassment and exile to the gulag which Brodsky underwent, but he was under constant surveillance. Every word he wrote, according to Misha, was put under the magnifying glass to see if there was a double meaning. As a child Sosnora had been evacuated during the siege of Leningrad to the Kuban. When the Nazis overran it he lived with a partisan group and witnessed their capture and execution; he himself, barely seven, was wounded. After the war he worked as a simple labourer in Archangel and then in a blast furnace in Leningrad.

Even though he had little formal education, Sosnora started writing verse at an early age and in 1962 published his first book of poetry. On the basis of its success he was able to abandon manual labour to devote himself to writing. His verse owed much to Mayakovsky and the futurists but drew deeply from his childhood experiences during the war, with searing realism.

Misha was very fond of him, and I regretted that political cir-

cumstances made it impossible for me to meet either him or Brodsky.

In the spring Marianna called to say that she and Misha had decided to get married. We were not invited to the ceremony in one of the Palaces of Weddings, but to the wedding banquet afterwards in Marianna's apartment. There were about ten people crowded around an improvised table and vast quantities of *zakuski* and food and drink. It took a little time for the guests, other artists mostly, to get over their initial reserve at the presence of a foreign ambassador and his wife. After that everyone seemed to talk at once, the confusion compounded by the continual coming and going of friends dropping in to extend congratulations, some drifting on again, others managing to squeeze into corners of the small flat.

But the most impressive person was Peter Kapitsa, after Sakharov one of the most famous and respected of Soviet physicists. He and his wife, who appeared to have extended their patronage to Kulakov, were impressive looking, he particularly, a big man with strong features and a most commanding presence, but in conversation gentle, polite, and well versed in literature and music. He had spent some years in England before returning to the Soviet Union. He refused to talk politics, but when I asked him if it was all right to invite him to the embassy he said he liked Thereza and me as people but he had avoided trouble up till then. This was not the time to start. He was a scientist. He did not like politics. The system was inefficient, even ludicrous, but he had all the facilities he needed to do his job, his research. He loved Russia. He was getting old. He didn't need more problems. But the fact that he was at the wedding banquet at which KGB certainly knew I was going to be present, indicated some tolerance in the attitude of the authorities towards him.

Sometime later Marianna, having completed her contract with Progress Books, returned to Italy, and Misha received permission to accompany her. Her first act on reaching Rome was to tear up her Communist Party card. I hear from them occasionally and Misha has had moderate success as a painter, in a very competitive society.

POEM

Anna Akhmatova

The twenty-first. Night. Monday.
The outlines of the capital through the mists.
Why should some idler have invented
That love really exists.

And from laziness, or boredom,
Everyone believed it, and thus they live:
We wait for meetings, fear partings,
And sing songs of love.

But some have discovered the mystery,
And silence has enveloped them. ...
I came upon it unexpectedly
And have been as if ill since then.

Detail of the memorial commemorating the 900-day siege of Leningrad

TWENTY

Internal Exiles

Andrei Vosnesensky has just come back from a series of recitals in Paris, where he used his limited foreign currency for the most absurd purchases, including an extravagant pair of glasses. 'I don't need them now,' he explained, 'but maybe next year.'

His latest project was a series of colour lithographs incorporating very simple designs with phrases from some of his poems. He was hoping to produce a visual, electronic, spoken picture, consisting of constructed lines of a poem which would flash on and off and be recited out of a speaker in the frame. This monstrosity caught the imagination of an American art critic, so perhaps it will end up in the Guggenheim Museum!

In 1978 Andrei became, of all things, obsessed by the idea of China. He normally avoided political questions. But he had recently read an article in a Soviet newspaper which claimed that the British had said that the United States had been responsible for turning the Chinese against the Soviet Union. I said I thought it patent nonsense. How could the Americans, back in 1959, when they had no relations of any sort with Beijing, turn China against the Soviet Union? The answer was that the British had said so; therefore it must be true. Zoya supported Andrei, saying that they had complete confidence in the English.

I was struck by the fact that these two highly literate and intelligent people believed such an extraordinary bit of nonsense. But

they were adamant. The final proof, in their minds, was the fact that the original source of this information was none other than the BBC. The British would no doubt be flattered. But it was a reminder of how deeply history and its grudges are etched in the minds of these people. Unlike North Americans, who tend to forget all world events every thirty years, people in the old world remember. For them, the imperial power of the British was but yesterday.

But a lunch with the American columnist Joseph Kraft reminded me that cultural and historical misunderstanding here was a two-way street. He had spent the previous evening with Joan Baez, Voznesensky, and some other writers. I was disturbed by the conclusion Kraft had drawn that the regime was mellowing its attitude towards the arts, because it let a poet like Voznesensky have a fairly free rein, and tolerated a drama producer like Yuri Lyubimov. I tried to convince him that these two were very special cases. Like the painter Glazunov, they had reputations abroad, were very popular in the Soviet Union, and it satisfied the Soviet authorities to use them to let off a little steam. However, if any younger or less well-known or popular writer or artist tried to produce what they did, the result would be repression. One had only to look at the work of the last ten years to see how completely sterile intellectual life in the country had become.

Detente was floundering, and peaceful coexistence was more and more obviously a Soviet catchword. Even though its true meaning had been explicitly spelled out by the Kremlin, it was still being misunderstood in the West. On the Soviet side of the Iron Curtain it meant the avoidance of direct confrontation of the two superpowers in areas of vital security interest to each. But the Kremlin spelled out quite clearly that the ideological struggle between two incompatible systems would continue – 'peacefully.'

As far as the Soviet cultural community was concerned, peaceful coexistence had been correctly interpreted as foreshadowing more strict application of the laws of socialist realism and the suppression of dissent. There was a brief outburst of optimism after the signing of the Helsinki Treaty, but most were justifiably cynical about the human rights provisions. The most courageous, or foolhardy, who formed the Soviet Committee for the observa-

tion of Human Rights, were quickly subjected to harassment, arrest, and dispatch to psychiatric hospitals in Siberia.

But gradually, the intellectuals were becoming aware of the other side of the communist disaster: the tragic failure of the whole economic system, and its horrible repercussions. Not just a dismal standard of living, but far worse: the ecological catastrophe, the criminally dangerous nuclear power stations. The party bosses had managed to keep these terrible family secrets hidden in their vaults with decades of propaganda and absolute control of all forms of communications. But that changed with the technological communications revolution all over the world. Information, more than any other factor, was to bring the Soviet system to its knees.

Thereza used to say that she made a little prayer every morning that the Kremlin would keep ignoring their real problems, since the only danger the Soviet Union posed to the West would be if it actually became an economic power as well as a military one. Her assessment was brutal: 'Even if they throw the bums out, they won't know how to make it work.'

In the spring of 1979 an unauthorized publication called variously *Metropole* or *Almanak* was published which included the poems of a number of well-known writers, among them Voznesensky. He became very elusive, as did all other contributors. We were accustomed to these periodic disappearing spells, and finally on Labour Day he resurfaced and explained the *Metropole* affair.

One evening in the fall of 1978 he had had dinner with a group of writers, including Aksyonov, Okudzhava, Akhmadulina, Triffonov, and others, and he had agreed they could include some of his verse in a new collective volume. Then he went to the United States for about three months as poet-in-residence at the Kennan Institute in Washington. On his return he was alarmed to find that the anthology had turned into the magazine *Metropole*, with political overtones he had never intended.

'I have never engaged in politics,' he said, and he did not want to start now. In fact, most of the stories, poems, and essays were totally inoffensive. The 'crime' was that the journal's publication had not been authorized 'up above.' The damage, however, had

been done. He was called to account and all lectures and travel abroad forbidden. 'It cost me a lot of money,' he said rather naively. 'Those that had nothing to lose were not punished. I was punished because I make a lot out of my poetry readings.'

This situation continued until June, when suddenly he was told to accompany a group of Soviet journalists flying to the North Pole. In a country where Siberia meant internal exile, the North Pole might mean anything. But it seemed they were to greet some Soviet trappers who had reached the Pole on foot. He described it as a remarkable experience – an inspiration for further poetry. Then in July he was permitted to give a recital in the main concert hall in Tbilisi and now appeared to be home free, so to speak. At any rate, he was able to come to see me and he hoped to accept an invitation to go to Rome in October.

Zoya, who always appeared to be safer from the Soviet point of view than her husband, had not been affected by the *Metropole* affair. She travelled to France in July in connection with the French publication by Gallimard of one of her novels. 'Everywhere I went,' she said, 'in private and in public I was constantly asked about the importance of *Metropole* and the dissident movement. I told them there was no such thing as a dissident movement. No one in all of Paris believed me.'

Why did the authorities react so strongly? Andrei thought it was primarily because they always saw anything, no matter how minuscule, that was not under their total control as the beginning of a move towards anarchy. And anarchy was the traditional bogeyman of Russian culture. 'Perfectly stupid,' he said, 'but that is how their minds work.'

The armed intervention in Afghanistan in December 1979 and the almost universal condemnation of the Soviets by the world community had a further chilling effect on the Soviet intellectuals, who mostly disappeared into the woodwork. In the case of Canada, the chill was even more pronounced after the expulsion of a number of members of the Soviet embassy in Ottawa for espionage. Then came retaliation by the Soviets through the expulsion of a member of our staff in Moscow, further retaliation by Ottawa, and then another retaliation by the Soviets against our embassy, this time taking the form of the withdrawal of most of

our locally engaged Russian staff. The signal to Soviet citizens was clear: fraternizing with Canadians was not a good idea.

Perhaps the return of Pierre Trudeau to power in the April 1980 elections made some difference in the atmosphere. I had been called back to Ottawa for consultations and Thereza and I had lunch with Pierre at the Sussex Street residence. I made sure that this got around so that the Soviets might soften their attitude towards the embassy, which in fact they did in spite of our continued boycott of the Moscow Olympic Games.

A sign that things were getting a little better was an invitation from Andrei in June, for lunch at Peredelkino. He confessed that it had been a very bad winter for all writers and he had unashamedly kept his head down. They were all depressed by Afghanistan and by the deterioration of relations with western countries. But he claimed things would get better even though the American scene looked very gloomy. 'Reagan will not be president, will he?' Andrei inquired with an unaccustomed air of trepidation.

I replied that, on the contrary, at the moment the chances looked very strong that he would be elected. There was a long silence broken by the poet saying: 'And that will mean war.' We heard this kind of reaction from other Soviet sources, very worrying at the time.

Zoya had just undergone an operation for a kidney ailment. Andrei claimed that in spite of her being in an exclusive paying clinic (that is, a semi-private institution where high fees are charged for the upper classes who do not want to submit to the delays and inefficiencies of public medicine), the level of medical care was very poor. She was given gas through a mask for the operation but afterward she did not recover consciousness. He described how the doctor and the anesthetist slapped her cheeks and blew in her mouth to restore her. This primitive method eventually worked. Zoya was still in Moscow recuperating.

Andrei was more interested in talking about his current girlfriend. She was a twenty-seven-year-old beauty from Santo Domingo who worked in the cultural section of the Dominican embassy in Paris. They had met in the bar of the Rasputin, a Russian restaurant in Paris. She had never drunk vodka before and proceeded to get violently sick. Andrei seemed to think this

a normal way to start a romance. She was apparently from a rich family but very leftist. She shocked Andrei by saying she admired Stalin. He was going to France again in October for the publication by Gallimard of a new book of translations of his poetry but he seemed more interested in his affair with the Dominican Republic.

Why the Soviets tolerated these activities is a moot question. Presumably he toed the line in matters of importance. He was popular at home and abroad, but that didn't prevent them from persecuting an international giant like Sakharov, for instance. Andrei remained something of an enigma.

He and Zoya were going to take their summer holidays on the Baltic coast that year. It was the fashionable thing to do, as opposed to the unfashionable Black Sea coast, but he said this was not the reason. They were avoiding the Black Sea because of the rumours of radiation there. When I pressed him about the meaning of this he said there was a strong rumour that the sun's rays this year were dangerously 'radiated.' He claimed to have heard of people being affected. I thought it sounded odd, but decided it gave insight into the credulity of even the most intelligent Russians. But at that time we had not yet heard the news of the Chernobyl disaster.

Andrei told me that Rodion Shchedrin had gone into a state of deep depression verging on madness. I was surprised, as just a few weeks before we has attended the premiere of his successful new ballet based on Chekhov's *The Seagull*, in which his wife Maya Plisetskaya danced. Andrei shrugged. There seemed to be no explanation.

'Perhaps,' Andrei suggested drily, 'Shchedrin has simply become unbalanced by the boring, stultifying state of the arts.'

Kyrill Kondrashin had told me about Shchedrin's dreadful time composing *Anna Karenina*, which dragged on and was only completed because Shchedrin was under such intense pressure to do it. He was miserable, slaving away on another museum piece, while the contemporary music in his mind suffocated.

Kondrashin himself defected in 1979. He always gave the outer impression of being a stiff Soviet conformist, but in private he was a good deal more relaxed and critical of things Soviet. I had

always considered his wife much more anti-Soviet than he, however, so I was surprised to learn that she had decided to return to Moscow.

Kondrashin had told me of the constant quarrelling and manoeuvring of Moscow's musicians, and the underhand methods used to get to the top, or bring those at the top down to the bottom. False rumours, petty sabotage of performances, behaviour not completely unknown in the West, I suggested. 'Oh you have no idea how complicated things can be in the musical world here,' he sighed.

He was marginally pleased at the relative liberalism which allowed a lot more modern music in the late 1970s, but could not bear any more what he called the terrible sterility of thought and the dearth of originality. He was dismissed from his job as conductor of the Moscow Philharmonic in 1976, though he occasionally conducted it as a guest, and had also gone abroad as a touring conductor, including a stay in Canada. In Russia he would show up at any daring new cultural manifestations, from concerts to the theatre, such as the opening night of Voznesensky's play *Look Out for Your Faces*. But he was gradually frozen out of opportunities to work in the Soviet Union. I understood completely when I heard he had left for good, and was conducting the Concertgebouw in Amsterdam, and I wondered if he, too, would suffer the peculiar homesickness of a Russian for his mournful, melancholy land.

It always came back to this blanket of melancholy and boredom. Would Russia ever truly be free of that, even if she were politically free? Was it bred in the bone, or in the prison this nation had become? I thought back to those early days, and remembered again the haunting, Cossack beauty of Bella Akhmadulina as I saw her across the room at the Stevens's warm gathering. She, perhaps more than even Andrei and Yevgeny, embodied the wild spirit and the profound gloom of her people – and in her poetry had the courage to embrace it all.

Most of the previous year Bella had been in what she described as semi-exile in Georgia. She had been in serious trouble because of the contribution she had made to *Metropole* and also because of a poem, circulated in *samizdat*, denouncing the forced exile of

Sakharov to Gorky. Her husband, Boris Messerer, the best stage designer of the Bolshoi Theatre, had been dismissed and she had been unable to publish anything in Moscow.

Since I had heard they had returned to Moscow, I decided to test the waters by issuing an invitation to dine at the embassy. They accepted, and when they actually turned up, I assumed this punishment had ended. Bella said in a way that was true. For her, it was a real punishment not to be published, but life in beautiful Georgia, she said, was hardly punishment. 'What a crazy nation,' she exclaimed, 'when you can be exiled in your own country!'

Thereza remarked that it depended on the place you were exiled to – it was hardly as pleasant in places such as Kamchatka, Gorky, or any number of small provincial towns.

'Yes,' Bella mused, 'after all, in czarist times lot of aristocrats who fell out of favour were exiled to live on their country estates. Anyway,' she went on, 'the pressure seems to be off and I have a recording of one of my poetry recitals coming out soon. This is a good sign.'

Messerer, who was a small, bald man, highly intelligent, attractive, talented, and obviously very much in love with his vicacious Bella, chimed in to say that while he would never get back to the Bolshoi, he had been given an assignment to stage a new production at the Moscow Art Theatre, the epitome of nineteenth-century conservatism. I expressed astonishment, but he assured me it was true. He added that Bella's case had been studied 'at the top,' where it was decided that her indiscretions could be ascribed to too much vodka. The Russian spirit.

'Communism poisoned all of us,' Bulat Okhudzava had previously said. 'We can only hope that the younger generation will find a new spirit, or religion, or ideology.'

In fact, from the occasional remarks of Soviet officials of Gorbachev's generation, I became aware that a great many middle-level officials were aware of the waste, corruption, and inefficiency. Those who had been abroad in particular were deeply humiliated by the incredible gap in the standard of living between the West and even the show cities of Moscow and Leningrad. And they were appalled when they understood the fragility of a vast empire based on a rotten base concealed by a top-heavy military.

Even at the higher levels, the brighter cadres were slowly having the scales fall from their eyes. For instance, Yuri Andropov, head of the KGB and a powerful member of the Politburo, saw the awful truth, when exhortations to work harder and better to build the great ideal society no longer inspired anything but contempt. But this inner dissatisfaction even at the higher levels was largely hidden until Mikhail Gorbachev swung wide the doors.

In October 1980 the time had come for me to leave my post as ambassador to Moscow. In view of our love of Leningrad, and recalling our arrival there in the mists of Russia in 1946, we decided to leave for the last time via that unique city. In the glorious golden-brown northern autumn we said goodbye to its incomparable vistas, and to Dostoyevsky and Peter the Great, each pointing to the East and the West, to the Slav and the European, the external and internal forces that created this enigma wrapped in mystery.

We said goodbye to the beautiful summer palace at Tsarskoe Selo and Paul's Pavlovsk, and to the old Mariinski Theatre, one of the most beautiful opera houses in the world – all the symbols of the refined beauty and the blind excess of the czars that led so inexorably to the Finland Station, and the ugly horror and blind excess that followed.

Thereza even said goodbye to Tchaikovsky with a forgiving pang of regret. As we were leaving the Astoria Hotel, the director beckoned us into his office and made a little speech about our well-known love of his city and our fidelity to the old Astoria. He then presented us with the key to the room we usually occupied, a hugh old bronze affair engraved in Latin characters 'Hotel Astoria – St. Petersburg.' It was the kind of touching human gesture which had so often reconciled us, through many difficult years of struggle with the Soviet authorities, to the marvellous, courageous, and talented Russian people.

We sailed to Helsinki, that other city on the Gulf of Finland with its many nineteenth-century Russian buildings, a relic of the hundred years of Russian rule. I reflected there on that huge country across the waters, the behemoth whose system I detested but whose people I admired and respected. Trying to sort out my feelings I found myself repeating some verses of Sergei Yesenin:

All too soon we will depart
For the land of peace, that blessed abode.
Perhaps I too will need to gather
Up my frail baggage for the road.

Treasured birch trees of
My soil! My lowlands wide.
And the host of things I'm leaving
With regret I cannot hide.

In this world too much I've loved
The wraith that clothes in flesh the soul,
Peace to the aspens, arms outspread,
Mirrored in the stream below.

Much in silence I have thought,
Many songs myself bequeathed.
And in this grim world I'm glad
That I have lived and breathed.

. . .

I know in that other country
There are no fields golden in the haze.
That is why I cherish those who have
Spent on earth with me their days.

Yesenin was not talking of parting; he was talking of death. And one of the features of the Russian character for centuries, and even more prominently in the twentieth, has been the preoccupation with death. Not that they are fatalistic about it, but aware rather that it lurks in every corner and can never be pushed away to the back of the mind. And their tragic, relentless history has surely justified them. For them, death and suffering are never far, but they approach them both with an astounding physical and spiritual courage. Few people have gone through such agonies and come out, not unscathed, but spiritually intact.

The other deep impression that remains is their searing dichot-

omy. There are few people more human, more understanding, more hospitable, when they are allowed to be, who have also demonstrated such ferocious cruelty to their fellows. And this dichotomy is apparent in their struggle to find themselves. Few other people would have taken the academic theory of a stern German ideologue, divorced from reality and devoid of any understanding of the nature of man, and applied it so literally to a people to which it was all so completely alien. For almost ten years that magnificent bronze key inscribed 'St. Petersburg' lay before me on my desk. It seemed impossible that some day that name could live again, that the Russians would awaken from their long nightmare and return to the community of man. My fervent hope is that now they will find their true integrity: neither Slavophile nor European, but Russian, unique, a world unto themselves.

LOSS

Yevgeny Yevtushenko

Russia has lost Russia in Russia.
Russia searches for itself
 like a cut finger in snow,
 a needle in a haystack,
like an old blind woman madly stretching her hand in fog,
searching with hopeless incantation for her lost milk cow.

We buried our icons.
 We didn't believe in our own great books.
 We fight only with alien grievances.

Is it true that we didn't survive under our own yoke,
becoming for ourselves worse than foreign enemies?
Is it true that we are doomed to live only in the silk
nightgown of dreams, eaten by moths? –
 Or in numbered prison robes?

Is it true that epilepsy is our national character?
Or convulsions of pride?
 Or convulsions of self-humiliation?
Ancient rebellions against new copper kopecks,
against such foreign fruits as potatoes are
now only a harmless dream.

Today's rebellion swamps the entire Kremlin
 like a mortal tide –
Is it true that we Russians have only one unhappy choice?
The ghost of Tsar Ivan the Terrible?
 Or the Ghost of Tsar Chaos?
So many imposters. Such 'imposterity.'

Everyone is a leader, but no one leads.
We are confused as to which banners and slogans to carry.
And such a fog in our heads
 that everyone is wrong
 and everyone is guilty in everything.

We already have walked enough in such fog,
in blood up to our knees.
Lord, you've already punished us enough.
Forgive us, pity us.

Is it true that we no longer exist?
Or are we not yet born?

We are birthing now,
But it's so painful to be born again.

Robert Ford in front of his home in Vichy, 1984

EPILOGUE

In retirement, Thereza and I took up residence in the Chateau de la Poivrière, near Vichy in France. Thereza had come into some money and in a fit of folly bought the small chateau, a beautiful building with a thirteenth-century dungeon, one fifteenth-century wing, and one sixteenth. The interior was surprisingly pleasant and livable. Only when we moved in did we discover that it had been the German embassy to the Pétain government in Vichy. The ambassador has been a career diplomat, the descendant of an old Prussian family, and his wife was American. She had probably married him when he was a young secretary of embassy. Their ghosts seemed to haunt the place and we imagined that poor woman lost in a catastrophe she could never have imagined. And her husband's phantom was no less restless: he was murdered in an American detention camp in 1945, apparently by co-prisoners who thought he had been insufficiently pro-Nazi.

When my beloved Thereza died in 1983, I simply did not want to live there any longer. I put the chateau up for sale, and moved into a nearby, more modern home. My illness was progressing, and the house was also easier to navigate than the chateau. Now from my wheelchair, I continue to watch the destiny of Russia unfold.

I have met no one, including the most respected of Soviet

experts, George Kennan, who foresaw the speed with which communism and the Russian empire would collapse. There were many of us, including Malcolm Toon, one of the most astute American diplomats, who saw from the beginning of the Gorbachev reforms that he and the younger generation of the communist leadership knew that their political survival depended on economic and social reform. But he had no idea, any more than Kerensky had, what forces he was unleashing, that his desperate bid for the life of the party would seal its doom.

The Russian intelligentsia, happy though they may be at the changes, do not appear to know any more than Gorbachev or Yeltsin how to save the gains of liberation while remaking an economy from scratch. They need to develop not just a market economy or a democracy but a mix of western and Russian political philosophy capable of producing a social system that will inspire the trust of the Russian people, something that will actually work effectively on its own merits, unaided by terror, unfettered by dogma.

Yevtushenko told a friend recently that the future must be decided not by professional politicians, because most of these are crooks, but by so-called amateurs, like Vaclav Havel in the Czech Republic, an author and playwright, a distinguished, intelligent human being. I was pleased to hear that I too qualify as an amateur in his view. He once told me that I was the most cultured ambassador he had ever seen, and was grateful for my appreciation of Russian poetry. 'As a poet,' he said, 'you are better equipped to understand the Russian soul and without that, you cannot understand Russia.' Even now there are depths that remain unfathomable for me, but I empathize with those Russian souls now, suddenly flung into the modern world, and with the artists floundering in a sea of liberty.

The intellectuals seem to be bewildered and, like the rest of the population, fully occupied in simply surviving. The great outburst of artistic creativity that glasnost and perestroika were expected to bring has yet to appear.

In this new society, what was the role of the great dissidents to be now that they were no longer outlaws? Solzhenitsyn had an answer for that: he's still a dissident, now decrying the evils of the

so-called Gorbachev revolution, and the ongoing reforms, with as much passion as he levelled at communism. Returning to Russia in 1994, he immediately made his position clear: Russia was sliding into another catastrophe, creating 'a savage, cruel, criminal society, even worse than the Western models it was trying to emulate.' From the breakup of the republics and the bitter rivalry of several layers of governments, to the infection of the Russian language with the buzzwords of the new ideology – 'briefing, pressing, marketing, rating, holding, ... ' he sees nothing less than the annihilation of what is Russian.

'At the end of the twentieth century,' he wrote in his newest book, *The Russian Problem*, 'the question posed by the Russian problem is unambiguous: will our people continue to be, or not to be?'

Solzhenitsyn sees salvation, as he always has, in that almost mystical culture of Slavophilism, combined with a return to something rather like czarist times. Despite his undeniable greatness, Solzhenitsyn seems to have lost touch with his people and their needs, and journalists report that he is seen by most citizens and politicians as a legendary irrelevance in the modern crisis of Russia at best, and as a dangerous loose cannon at worst. Nonetheless it would be unthinkable to dismiss such a giant of literature and history, who has great wisdom mixed with his politics.

I agree with him that unless some order is pulled out of the anarchy of rival government levels in the republics and Russia, things will degenerate further into chaos. But I do not agree that this upheaval threatens the continuance of the Russians – and Ukrainians, Lithuanians, and other ethnicities – as people of their culture. They have survived two world wars, savage civil war and violent revolution, Stalinist purges and collectivization, repression, prison, and grinding poverty. Even after all this, there is a powerful, real common entity that is the Russian soul, and a culture with so much depth that 'marketing' and 'briefings' can certainly be absorbed without being lethal to Russian traditions. Perhaps, ironically, I have more faith in the human bedrock of Russian Slavophilism than does Solzhenitsyn.

Yevtushenko, in typical style, is still on top and beating the odds. This was how a Canadian journalist, Olivia Ward, described

him after publication of his first novel, in the summer of 1994. A *roman-à-clef* called *Don't Die Before You're Dead*, it's a story that includes a fictional journey into the thoughts of Mikhail Gorbachev during the abortive coup, and Yeltsin's when he received the orders in Sverdlovsk to bulldoze the scene of the death of the czar and his family. People lined up to buy it and get autographs.

Ward, one of the best journalists working in Russia today, found Yevtushenko ensconced in Peredelkino, reflecting wryly on the new preference for lurid crime books, science fiction, and tales of steamy sex. For him it's a commercial censorship replacing the doctrine of socialist realism. But Yevtushenko can afford to be ironic about it all. Ward has found other writers and poets bitter about the craze for money and escapism, the tossing aside of art.

Andrei and Zoya still spend a great deal of time in Peredelkino. Though they are on the whole doing well, I understand that they are struggling somewhat to find their balance and place in the tumultuous new era. As politically precarious as Andrei's former status may have been, it was nonetheless status. He has not been spared a certain amount of gainsaying of his political and poetic authenticity and ability in the new atmosphere of free criticism and recrimination. It remains to be seen how he will emerge in the new Russia.

One poet has escaped this painful period of adjustment to a new world in perhaps the only way possible: Robert Rozdestvenzky died in August 1994, at the age of sixty-two after a long illness. So long walking that thin line between dissidence and obedience, so long holding on to the values that he and Mayakovsky shared, opposing socialist realism but apologizing for it to survive – it is a loss not to know what he might have written once freed entirely from the chains of the party.

Bella, rather uncharacteristically, seems to have handed over the running of her life to her husband, and retired into a kind of poetic reclusion, I am told. It may be ill health, as visitors report her to be exhausted and breathless. Bulat Okudzhava has left Russia to live in the United States.

For even the well-known writers, the idea that they must seek out publishers and exist on royalties rather than state subsidies is

hard to accept. As for the struggling new writers, while they are free to compose whatever they want, they must be discovering that life in a free society, politically and economically in tatters, is not what they dreamed of.

Nikita Bogoslavsky, I was sad to hear, was in a miserable state. In my day he had been a rouble millionaire, but after the collapse of the economy and the party, he lost car, chauffeur, and other comforts and found himself with nothing but worthless roubles. His songs and operettas were left behind by history. Friends said he was on the verge of poverty. And his case was far from unique.

An actor I knew vaguely sent me a letter from East Berlin, before the fall of the wall, saying he had a French visa to visit a friend in France, but to have a visa to leave the Soviet Union he had to have an 'invitation,' and asked if I would send him one, adding that he was going to stay in Paris with the TASS correspondent. I had visions of this fellow using my invitation to come and install himself with me in Vichy. But he called to say the visit had been cancelled, and he told me wistfully that the Russia of the intelligentsia that I had known had completely changed. The long afternoons and evenings enriched by talk of philosophy and literature were over. The only subject of conversation now was how to get rich, or more to the point, how not to die of hunger.

Vasinka Katanyan came to France on cinema business and spent three days with me at La Poivrière in 1987, a time of euphoria as all the barriers to free speech were beginning to tumble down. Starry-eyed, he and the other artists now saw unlimited horizons for free expression – and for money. But they had no idea what writers and artists were going to face in the free market.

Knowing the protected life privileged artists had, I tried to get him to explain how a producer of documentary films was going to operate in a market economy. He would have to pay rent on the dacha and apartment, find financing for his equipment, studios, and so on, and then find someone to buy, distribute, and broadcast his films. He simply went blank, then opaque, and eventually replied airily that all this would soon work itself out. But I guessed that he had not really thought this through. Letters

I received from him subsequently were increasingly despondent, mostly about the cost of living and the shortage of everything. But he was still in the dacha and the apartment and I suppose there was work at least in TV studios. But in the new Russia, I doubted that his Order of Lenin would carry much weight.

The painters had a field day in the West as it became the vogue to buy almost any canvas by a former dissident Soviet artist, and auctions in London, Paris, and New York brought inordinately high prices. But this fashion will die, and the good ones will be sorted out from the great mass of indifferent artists. We have yet to see a master appear, but these artists have to absorb the western experience of experimentation in the lost seven decades, before new Kandinskys, Popovas, Chagalls, and others appear.

In both ballet and opera, so long buried alive by Stalinism, there have been more contemporary works, as the artists feel their way along experimental paths. But the problems of the great state-subsidized theatres, operas, and ballets are already apparent. Financing such operations even in the most opulent of societies depends to a large extent on the help of governments. When this is total, and is abruptly withdrawn, and one must suddenly cope with the banal everyday problems of finding and paying for everything, including costumes and ballet slippers, the shock must be traumatic, and one fears for the future of those musical monuments such as the Kirov and the Bolshoi, and the great orchestras which have been, in spite of everything, a part of world culture.

Maya Plisetskaya published her memoirs in the fall of 1994, a scathing denunciation of the communist regime and everything it did to stultify the arts, to destroy artists of all kinds. And she confirms the desperate financial straits of the Bolshoi and other companies.

The philosopher Alexander Vasiliev, who was expelled in the mid-seventies, had great difficulty in adjusting in the West to democracy and its material values. Now all of his peers are facing the same disorientation within their own nation. There must also be in each intellectual a desperate search for an explanation of what went wrong, how it was possible for talented people to accept, and often truly believe in, a system so alien to the human spirit for seven decades.

Len Karpinsky, for example, revealed the pain of his disillusionment in an interview in the early 1990s. He was the perfect communist, the son of a hero of the Revolution: his father had been a close associate of Lenin (and gave his son the first name of Lenin, shortened to Len). He had every privilege available to the communist upper class: the best education possible in the Komsomol, the Young Communist League, and easy access to almost any job he wanted. Yet he became one of the earliest supporters of *glasnost,* and *perestroika.* Like Gorbachev, he believed this was the only way to save the communist system. A journalist by profession, he became the editor of *Moscow News,* the voice of Gorbachev reform. But by 1992 he found himself overtaken by events, already passé. All his intellectual strength, he said, had been devoted to denouncing the totalitarian ideology. But he, and all of his generation who had been secretly revolted by the system, were completely smothered by the national failure. They had no idea of how to escape from this miasma, how to repair the damage, how to reconstruct the country physically and offer hope of spiritual rebirth. He found it agonizingly difficult to adjust to the obvious fact that communism could not be reformed, and that the doubts about the whole system that led him to support Gorbachev inevitably led to the demise of the entire structure.

Gorbachev, with his winning ways, deceived so many people in the West by giving the impression he would replace the communist system with democracy. But this was never his intention. And even after his ouster from power and his relegation to head of a so-called think-tank (mistakenly subsidized by western money), he still declared his belief in socialism. And I doubt that Boris Yeltsin knows what democracy is, or that he has really forgotten all those communist basics on which he built his power.

So when a true dissident intellectual like Okudzava talks of his hope for a spiritual rebirth, a new ideology, I do not think it will take a form which we would call democracy. The core of it is certainly going to be eventually a resurgence of Great Russian nationalism, already emerging in the 1970s. Although almost all the party and government apparatus was then in the hands of ethnic Russians – plus a few others to appease the lesser nationalities – the average Russians in the heartland of old Russia were

curiously neglected. Cities within a hundred kilometres of Moscow were nineteenth-century ruins with decrepit blocks of tacky new apartments stuck next to polluting factories. Whereas in Tashkent, in the Crimea, or the Cacucasus, money was poured in.

Len Karpinsky has said the key problem is how to restore the pride Russians had in their country. The intellectuals are disoriented by the chaos of ideas and the multitude of political and economic problems that must be solved. But their traditional place in their society is being destroyed, as they are ignored in favour of the new wave of experts in finance and business. Lev Timofeyev, a prominent journalist, has said the intelligentsia is adrift because its old role of opposition to the totalitarian regimes, whether czarist or communist, has evaporated, and they seem unable to play a constructive role in planning a new democratic society.

For a people unfamiliar with any system in which they must take responsibility, the danger lies in their inability to make the necessary choices that direct their national life. I fear they will be increasingly inclined to find scapegoats for the continuing catastrophe and look longingly for someone or something which can prevent the disorder and anarchy they so deeply fear, and restore Russia to its rightful place as a great power.

The poets and writers, now that they are free to say anything they want, are being marginalized. But some intellectual is going to emerge who will play on the ancient Russian dream that their problems can be resolved in a definitive manner. This was the secret of czarist absolutism and communist totalitarianism alike: the 'little father' syndrome. The czar, Lenin, Stalin, the party, all had answers for everything, and assured order of a sort.

Yevtushenko's great poem 'Fear' could equally have been written about today's tumultous liberation, with a lurking worry that it might not last. He would almost certainly write something more hopeful, but still with the recognition that there has to be some power to prevent utter disorder.

I can envisage a kind of Slav federation, but it is Russia that will determine the pathology of that evolution, just as it was the Russians who really ran the show called the Soviet Union. If they go through another awful period of disorder and famine, which,

God willing, they will not have to, the character of the people and the nation will not change very much. But if there can be some peace and prosperity, there is some hope they can become more open, and western-oriented. But there is still that strong strain of Tartar and Mongol, the wild horsemen and the great beauties of the steppes, and that will remain bred in the bone.

Perhaps the ultimate solution will be a compromise of Russian nationalism and military strength: an army guaranteeing order within, but not intent on regaining imperial Russia; and a political system which assures internal peace and a measure of individual choice. A Russian 'democracy' is almost inconceivable without the participation of the military, even perhaps a military leader, someone whose name has yet to be heard. Whether or not that leader, or the system, is in any way democratic will depend first and foremost on the economy. If – and this is an enormous if – the economy can provide a better life on a reasonably equitable basis for the Russian people, then there will be hope for better times politically.

And that, ironically, will be one of the problems in defining a Russian democracy – the people's deep-seated attachment to egalitarianism. The peasants lived in poverty, but in community and equality: they were *all* poor. Stalin exploited their jealousy of those who branched out on their own and, by accepting modern methods, became richer than their neighbours. The mass slaughter of the prosperous kulaks in the 1930s ruined Russian agriculture but also facilitated the incorporation of the other peasants into state collective farms.

This spirit of jealousy of the newly rich and successful entrepreneurs has already manifested itself today, and it is going to play an important role in shaping whatever system arises out of the ruins of communism. It will facilitate the possibility of a great Russian nationalist leader appealing to the aspirations for equality and a better standard of living. I doubt very much that Boris Yeltstin is that leader.

In many ways the second Russian Revolution can be compared to the first and will have almost as decisive an impact on world development in the coming decades. The revolution unleashed by Gorbachev has barely begun, and what it will bring, *tolko bog*

znayet – only God knows. But let us abandon the hyperbole about democracy. Russia will succeed eventually in evolving its own system, but it will be very specifically Russian, and we must accept and understand this. Eventually, out of what the Russians call *bolata* – another expression for mess-chaos-rot – a new era will emerge. But the artists won't change the soul of Mother Russia; they reflect the Russia character. If the political solutions allow that character now to develop free of the old fears, then perhaps the intelligentsia will find a new role to play, in Russia and in the world.

ACKNOWLEDGMENTS

Thanks are due to many people who aided in the preparation of *A Moscow Literary Memoir*. Olivia Ward, Moscow correspondent of the *Toronto Star*, provided invaluable advice and made personal visits to many of the artists in this book, both to gain their blessing, and to learn of their lives in today's Russia. We thank her, and photographer Volodya, for many of the photographs. We thank her assistants Natasha and Kolya for their efforts as well.

Vasya and Inna Katanyan also gave photos from personal albums, and their appreciation for the work, on Lili's behalf.

McClelland and Stewart Publishers gave permission for the use of many of the poems written and/or translated by the author.

The Weldon Library, University of Western Ontario, London, Ontario, loaned original volumes of the poetry of Andrei Voznesensky and Yevgeny Yevtushenko, personally signed by the poets in dedications to R.A.D. Ford.

Most of the photographs are from the author's personal collection.

Special thanks to Diane Mew, who worked on the first draft of the manuscript from the original diary, and who also gave the manuscript a final careful polish in copy edit.

And thank you to Agnes Ambrus, who shepherded this memoir through as editor for University of Toronto Press.

<div style="text-align: right;">R.A.D. Ford
Carole Jerome</div>

CREDITS

Photographs

Robert Ford: Brik in her Moscow apartment; Pasternak, Eisenstein, Mayakovsky, and Brik; Igor Moiseyev and Thereza; at the embassy in Moscow, photo by Valery Plotnikov; Katanyan and Plisetskaya; in Peredelkino; Brik and Mayakovsky; Parazhanov; Thereza, Nina, and author

ITAR-TASS: monument to Peter the Great, photo by Y. Belinsky; Maya Plisetskaya dances 'Dying Swan,' photo by A. Konkov; festive demonstration in Red Square, photo by V. Mastyukov; athletes in Red Square, photo by V. Savostyanov

Izvestiia: Bella Akhmadulina, photo by V. Akhlimov

Carole Jerome: ménage à trois; Leningrad memorial

Vasya and Inna Katanyan: cast of Taganka production; Andrei Voznesensky and Zoya Bogulavskaya

Harry E. Palmer, photographer and the National Archives of Canada: author in Vichy, PA182370

Valery Vinogradov: Lubyanka prison

Special Collections, The D.B. Weldon Library, University of Western Ontario: cover of book dedicated to Ford by Yevtushenko; title page of Voznesensky volume inscribed to Ford

Poetry

'A Dostoyevsky Cycle,' 'Coming from Afar,' 'For Pasternak,' and 'Siberia' by Robert Ford are taken from *Coming from Afar* and are used by permission of McClelland & Stewart, Toronto. 'Fear' and 'A Streetcar Named Poetry' by Yevgeny Yevtushenko; 'Don't Frighten Me' and 'Poem' by Anna Akhmatova; 'Three Octets' by Osip Mandelshtam; 'Suddenly' by Semion Kirsanov; 'Not about Death' by Bulat Okudzhava; 'Garden' and 'Poem' by Marina Tsvetayeva; 'In the Mountains' and 'Forgive Me!' by Andrei Voznesensky; and 'Recollections of Siberia' by Bella Akhmadulina are all translated by Robert Ford and taken from *Coming from Afar*. Used by permission of McClelland & Stewart, Toronto.

Every attempt has been made to communicate with the owners of copyrighted material quoted in this book and to identify and credit sources for photographs. The publisher would appreciate receiving information as to any omission in the credits for subsequent editions.

INDEX

Afghanistan 276–7
Akhmadulina, B. x, 18–20, 23–4, 76, 116, 123–6, 153, 175, 219, 263, 275, 279, 290
Akhmatova, A. 18, 35–8, 64, 66, 83–4, 153
Aksyonov, V. 51, 65, 223, 275
Albee, E. 222–3
alcoholism 7, 21, 116, 175, 219, 280
Alexander Nevsky 107
Allard, Gen. J. 62
Allied powers 61
Alliluyeva, S. 173
Alma-Ata 20
Alonso, A. 95
Amalrik, A. 141–2
Andropov, Y. 63, 77, 264, 281
Angara 165–6
Anna Karenina 130, 161, 278
Apollo-Soyuz 187–8
Aragon, L. 23, 162, 230, 233, 240–2
Aragvi Restaurant 74, 109
Armenia 7, 21
'Arzhak, Nicolai' 85
Astoria Hotel 31, 99, 281

Atwood, M. 219
Auden, W.H. 21 149
August 1914 122, 173–4
Azerbaijan 21

Babel, I. 38
Babi Yar 20, 43–4
Baltic Sea 30
Baryshnikov, M. 101, 216–17, 236
Beatty, W. 72–3
Bergoltz, O. 66
Berlin, I. 36, 59
Beria, L. 63
Bessmertova, N. 101, 165
Best, J. 72
Bizet, G. 95–6
Blok, A. 37, 63, 75, 149, 189
Bogoslavsky, N. 18, 112–17, 126–8, 135, 253, 262–3, 291
Boguslavskaya, Z. 49, 138–40, 172–3, 200, 210, 219, 222, 253, 273, 276–8, 290
bolata 19, 296
Bolshoi Ballet 20, 93–102, 159, 161, 292

Bolshoi Opera 99
Bourdet, C. and I. 252
Boutrava, Mrs 96, 98
Brecht, B. 73, 75
Brehznev, L. 6, 62, 66, 77–8, 121, 150, 186–7, 220, 241, 266
Brik, L. ix–x, 51, 159, 161, 229–47, 262
Brik, O. 230, 237, 239
British Council 36
Brodsky, J. 51, 85, 148–9, 268–9
Byelo-Ostrov 30, 110
Byron, Lord 35

Cairo 21, 71
Canada 44, 52, 60, 74, 94, 137–40, 276–7
Canadian embassy 8, 30, 71–2, 276
Canadian Slavonic Papers 99
Cancer Ward 122, 140
Carmen 94–7, 161
CBC (Canadian Broadcasting Corporation) ix, 72, 244
Chagall, M. 34, 138, 172, 257–9, 292
Chairman, The 125
Chekhov, A. 72, 231, 254, 278
Chernenko, K. 63, 77
Chervukhin, A. 162–3
Childhood of Luvers, The 234
Children's Hour, The 10
China 116, 137, 209, 223, 273
Cinderella 107
Clement, R. 44
Costakis, G. 259–61
Cuba 66, 95
Czar Nicholas II 7, 21, 111, 222
Czechoslovakia 43, 121–3, 126, 135, 197, 240–1

Daniel, L. 197
Daniel, Y. 84–6, 88, 241

Dead, The 88
Demichev, P. 165, 197–8
Diaghilev, S. 257
'doctor's plot' 62
Don Quixote 97
Don't Frighten Me 84
Dostoyevsky, F. 5, 8, 75, 77, 208, 210, 262, 295
Dr Zhivago 54, 59, 63–5, 172, 234
Dudintsev, V. 64, 77, 87
Dupak, N. 127, 129–31
Durrell, L. 22

Egypt 21, 71, 86
Ehrenburg, I. 65
Eisenhower, D. 66
Eisenstein, S. 107
Ekaterinburg 7
Eliot, T.S. 22
Eluard, P. 23
Estonia 30
Eugene Onegin 61

Fasten Your Seatbelts 218
Faulkner, W. 22
'Fear' 43, 294
Fellini, F. 45
Fontanka Canal 36
Fonteyn, M. 102
Ford, Thereza ix, x, 6–9, 11, 22, 30–1, 47, 61, 72, 75, 84, 93, 141, 148, 160, 171, 207, 246, 254–6, 275, 281, 288
Frost, R. 84
Furtseva, Y. 95–8, 195–6

Galanskov, Y. 121–2
Gavrilov, A. 95
Germany 11, 31, 32
Ghaleb, M. 124
Gilberto, J. 49

Gilels, E. 108
Gilmour, E. 20
Ginsberg, A. 121–2
Ginzburg, E. 66
Glazunov, I. 265–66, 274
Goncharova, N. 251, 257
Good Woman of Szechuan, The 73
Gorbachev, M. x, 5–7, 11, 77, 100, 126, 150, 259, 280–1, 288, 293, 296
Gordeeva, E. 162
Gorky, M. 73
Gosconcert 94, 160, 201, 215
Gould, G. 112
Gouzenko, I. 60
Great Khan 21
Great War, The 35
Grigorovich, Y. 101, 165
Grinkov, S. 162
Gromyko, A. 99, 140–1, 220
Gulag Archipelago, The 142
Gulf of Finland 30
Gumilev, N. 36

Hellman, L. 10, 11, 73
Helsinki Treaty 274–5
Hines, G. 101
Hitler, A. 11, 31, 33
Hollywood 23
Hurok, S. 97

Ilichev, L. 22, 152–4
'In the Mountains' 48
Into the Whirlwind 66
Involuntary Journey to Siberia 142
Ireland 74
Is Paris Burning? 44
Israel 71, 86–7, 109, 190
Isvestiia 47, 76
Itskol, I.M. 189–91
Ivanov, G. 163–4
Ivan Susanin 31

Ivinskaya, O. 64–5

Jews 11, 85–8, 108, 189–91, 197, 258–9

Kafka, F. 75
Kain, K. 163, 165
Kandinskaya, N. 252–6
Kandinsky, V. 34, 251–6, 292
Kapitsa, P. 267
Karpinsky, L. 293–4
Kataev, V. 236
Katanyan, I. 236, 247
Katanyan, Vasinka 235–6, 242, 247, 291–2
Katanyan, Vasya 159, 161, 231–4, 239, 245–7
Katelnicheskaya Quay 113
Kazan University 53, 136
Kennan, G. 9, 288
Kennedy, Jacqueline 138, 206
Kennedy, Joan 236
Kennedy, John F. 23, 66, 206
Kennedy, R.F. 51
KGB 10, 20, 141–2, 177, 180, 200, 215, 264–5, 269, 281
Kharkov 63
Khlebnikov, V. 37
Khovanshchina 61
Khrushchev, N. 6–8, 18–9, 22, 43, 54, 63–6, 71, 76–7, 94–5, 150, 238
Kiel Canal 30
Kiev 63
Kirov, S. 31, 33
Kirov Theatre and Ballet 31, 100, 102, 160, 166
Kirsanov, S. 18, 22–3, 66, 76, 125–6, 153, 159, 161, 174
Kochetov, V. 153
Kondrashin, K. 51, 78, 108–10, 263, 278–9

Korean War 62
Koudriavtsev, N. 94–7, 161
Kraft, J. 274
Kramer, H. 34
Krasin, V. 198
Kulakov, M. 266–9
Kuznetsov affair 52–3, 179, 196

Lady Macbeth of Mtsensk 34, 107
Lake Ladoga 31
Lapin, S. 185–8
Larionov, M. 251, 257
Lashkova, V, 121–2
Lavrovsky, L. 101
Lenin, V.I. vii, 30, 32, 34, 51, 63, 77, 150, 196, 293–4
Leningrad 29–31, 33, 35, 60, 83, 100, 160, 207, 215, 281
Lenin Prize 77
Lermontov, M. 22
Levy, D. 72
Liepa, M. 100–2, 164–6
Literaturnaya Gazeta Gruzii 21,
Literary Gazette 50, 52
Little Foxes, The 11
Living and the Dead, The 88
Lomonsov University 63
London 10, 30–1, 61
Look Out for Your Faces 50–2, 279
Lorca, G. 84
Lowell, R. 222–4

'Makar Masai' 23
Makarova, N. 101, 160, 196
Malevich, A. 251
Manchuria 137
Mandelshtam, O. 37, 75
Marinskii Theatre 31, 281
Mariupol 115
Markov, G. 177, 197

Marxism-Leninism 6, 11, 45, 86, 150, 174, 190, 221
Maximova, Y. 97, 99, 101
Mayakovsky, V. 34, 37, 75, 149, 159, 196, 229–37, 242–3, 245–7, 261–2, 268, 290
McCarthyism 10–11
McNamara, R. 46
Mehta, Z. 108–9
Metropole affair 275–6, 279
Messerer, B. 280
Meyerhold, V. 38
Mikoyan, A. 78
Miller, A. 73
Miller, H. 22
Ministry of Culture 20, 43, 94–8, 108, 129, 161–2, 215, 251–2, 261
Ministry of Foreign Affairs 71–2, 74, 98, 113, 152
Moiseyev, I. 97–8
Montreal Symphony Orchestra 108–9
Moraes, V. 49
Moscow Philharmonic Orchestra 78, 107–8
Mosely, P. 32
Mother 73, 75
Murs de Malapaga, Les 45

Nagibin, Y. 20–2, 123–5, 198–9
Nakhichevanskaya, T. 21
Nasser, G.A. 71
Neruda, P. 239–40
Neva 154
Neva River 30
New York Times 34
Nights of Cabiria 45
Nijinsky, V. 100, 257
Nixon, R. 11, 149
Nobel Prize 64, 142, 196, 221
Not By Bread Alone 65, 77, 87

Novodevichy Monastery 77
Novyi Mir 53, 65, 87, 136, 179, 198
Nureyev, R. 100, 257

Octyabr 189–90
Olivier, Sir L. 73
Okudzhava, B. 18, 126, 148–9, 153, 222, 275, 280, 290, 293
One Day in the Life of Ivan Denisovich 65, 122
Ottawa 10, 60, 61, 71, 276
Our Man in Moscow x, 6

Parabola 48
Palme Commission 12, 255
parasitism 51, 85
Paris ix, 37
Pasternak, B. 22, 59, 63–5, 171–2, 215, 234–5
Pavlova, A. 100
Pavlova, N. 165
'peaceful co-existence' 274
Peredelkino 171–2, 175, 215, 223, 231, 233–4, 245, 277, 290
Peter the Great 30
Peterson, O. 215–16
Petrograd 87
Petrov, I. 99
Pilnyak, B. 38
Pisarevsky Cemetery 111
Plisetskaya, M. 51, 93–7, 100–2, 113, 159–64, 278, 292
Podgorny, N. 46
Poland 30
Politburo 7, 95, 187, 220
Pompidou, G. 254
Praga Restaurant 99
Prague 37
Pravda 37, 98, 149, 196, 197, 237–8

Presidium of the Supreme Soviet 78, 96, 188
Presley, E. 23
Prica, V. 10
Primakov, Gen. 236–9
Prokofiev, S. 34, 99, 102
'Prologue and Commentary' 49
Pushkin, A. 22, 35

Rachmaninoff, S. 107
'Rain' 19, 21–2
Red Army 65
Red Arrow 29
Reed, J. 72
Reflections on Progress 142
Requiem 36
Richter, S. 95, 108, 124
Robbins, J. 102
Rodnina, M. 183
Romanov, A. 207
Romeo and Juliet 99, 107
Rostropovich, M. 108–9, 136, 195–6, 199–201, 236, 263
Royal Shakespeare Company 22
Rozhdestvensky, R. 18, 23–4, 290
Rukhin, A. 264
Russian Problem, The 289
Russians Are Coming, The Russians Are Coming, The 46
'Russian Specialists' 23

Sakharov, A. 121, 142, 200, 278, 280
St Laurent, Y. x
St Petersburg 21, 29–31, 83, 110, 207, 229, 281–3
Salisbury, H. 20
samizdat 22, 148, 279
San Francisco 47, 51, 205–6
Scoundrel Time 10
Scriabin, A. 107
Second Russian Revolution 6, 295–6

Second World War 6
Shadow of Sound, The 53
Shapiro, H. 137
Shchedrin, R. 51, 95–7, 159, 278
Shostakovich, D. 34–5, 107
Siberia 19, 32, 44, 60, 65, 75, 79, 85, 116, 137, 197, 223, 275
Simonov, K. 10, 66, 86–7, 245
Sinyavsky, A. 84–6, 88, 207–10, 241
slavophilism, 5, 21, 83, 149, 289
Smith, W.J. 135
'socialist realism' 33–5
Solitary City, The 152, 265
Solzhenitsyn, A. 8, 65, 77, 122–4, 136, 140, 150, 153, 173–4, 191, 195–200, 219, 236, 288–9
Sosnora, V. 266–8
Stalin, J. 6, 8, 19, 24, 33–6, 59, 62, 77–9, 107, 115, 149–54, 234–5, 237–8, 259, 294–5
Stalinism 8, 10, 65, 77, 85–7, 150–4, 162, 198–9, 289, 292
Stavropol 7
Stevens, E. 19–20, 76, 126, 135
Stravinsky, I. 107
Styron, W., 222, 224
Supreme Soviet 95
Surkov, A. 76
Suslov, M. 78–9, 220, 246–7
Sverdlovsk 7
Swan Lake 61, 100, 160, 165
Sweden 30
Sweet Charity 45
Symbolism 37

Taganka Theatre 48, 50–2, 72–5, 129, 175, 218, 223
Tallin 30
Tbilisi 63, 73, 76, 275
Tchaikovsky, P. 61, 281

Ten Days that Shook the World 72–3, 75, 218
'Tertz, Abraham' 85
Thaw, The 65
Thomas, D. 21
Ticket to the Stars 65
Timofeyev, L. 294
Tito, J. 9–10
Tolstoy, L. 99, 208, 244, 254
Triolet, Elsa 23, 229–31, 233, 240–1
Trudeau, P. 177, 180, 277
Tsarskoe Selo 111, 281
Tsvetayeva, M. 18, 37, 84
Tukachevsky, M. 238
Turgenev, I. 242, 254
Tvardovksy, A. 66, 112, 136, 153
'Twelve, The' 37
'Tyorkin in the Other World' 112

Ulan Bator 10
Ulanova, G. 99
Uncle Vanya 150
Union of Writers 33, 47, 50, 52, 63, 76–7, 83, 85, 176, 178, 188, 197–200, 205, 218, 223
United States 9–10, 23, 74, 87, 216
Uvalich, Gen. 237–8

Vaklanov, G. 218
Vancouver 206
Vasiliev, A. 292
Vasiliev, V. 99, 101–2
Vasiliev, Y. 114–15, 126, 262–4, 266
Vermont 8
Vichy x, 287
Vienna 46
Vietnam 88, 137

Viryubov, Prince N. 207, 210
Vishnevskaya, G. 195–6, 199–201

Visotsky, V. 49, 174
Vlady, M. 49, 174
Volkonsky, A. 126–7
Von Walter, G. 31
Voznesensky, A. ix, x, 10, 43, 47, 48–54, 93, 113, 126, 138–40, 149, 153, 159, 172–7, 185–7, 190, 200, 205–7, 215–19, 221–4, 232–4, 253, 273–8, 290

Ward, O. 290, 296

Yagoda, G.G. 33
Yakir, P. 238
Yeltsin, B. 5–7, 222, 263, 288–90, 294
Yermoleva, T. 206
Yesenin, S. 37, 63, 75, 186, 281–2

Yezhov, N.I. 33, 237
Yevtushenko, Y. ix–x, 10, 20, 22, 43–8, 52–3, 85, 116, 122, 135–8, 149, 153, 176–80, 185–6, 200, 223–4, 262, 288–90, 294
Yugoslavia 9–10
Yunost 52–3, 179

Zarev 49–50
Zhdanov, A. 33, 35–6, 38, 115
Zima Junction 44
Znamya 63
Zoroaster 108
Zorin, V. 187
Zoshchenko, A. 38
Zverev, A. 262